Tools as Art

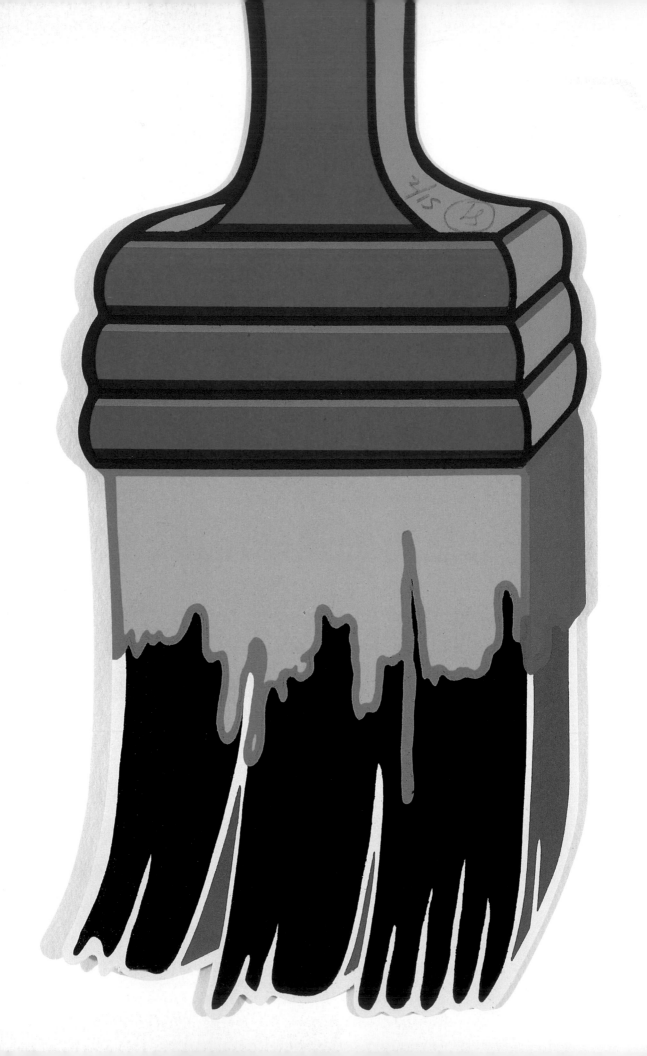

Tools as Art

The Hechinger Collection • Pete Hamill

Foreword by John Hechinger

Harry N. Abrams, Inc., Publishers

Editor: Eric Himmel
Designer: Robert McKee

———————————————

Library of Congress Cataloging-in-Publication Data
Hamill, Pete, 1935–
Tools as art: the Hechinger collection / by Pete Hamill;
foreword by John Hechinger, Sr.
p. cm.
Includes index.
ISBN 0–8109–3873–1 (hardcover)
1. Tools in art—Catalogs. 2. Art, Modern—20th century—Catalogs.
3. Hechinger, John—Art collections—Catalogs.
4. Art—Private collections—Maryland—Landover—Catalogs.
5. Art—Maryland—Landover—Catalogs. I. Title.
N8253. T65H36 1995
704.9'496219—dc20 95–890

Arman, *Avalanche; Blue, Red, Brown; Jaws; Revealed Secrets; School of Fishes; Still Hungry;*
and Untitled: © 1995 Artists Rights Society (ARS), New York/ADAGP, Paris
Harold E. Edgerton, *Hammer Breaks Glass Plate:* © The Harold E. Edgerton
1992 Trust, courtesy of Palm Press, Inc.
Red Grooms, *I Nailed Wooden Suns to Wooden Skies:*
© 1995 Red Grooms/Artists Rights Society (ARS), New York
Fernand Léger, *Les Constructeurs:* © 1995 Artists Rights Society (ARS),
New York/ADAGP/SPADEM, Paris
Jean Tinguely, *Tools 85:* © 1995 Artists Rights Society (ARS), New York/ADAGP, Paris

Published in 1995 by Harry N. Abrams, Incorporated, New York
A Times Mirror Company

———————————————

Frontispiece: **Lucas Samaras** • *Brush* • *1968. Silkscreen relief, 6 x 5"*

Contents

ACKNOWLEDGMENTS • 7

FOREWORD: THE HECHINGER COLLECTION

John Hechinger • 8

TOOLS AS ART

Pete Hamill • 10

THE PLATES • 30

AFTERWORD: ARTISTS AND TOOLS • 171

Carolyn Laray

ARTISTS' BIOGRAPHIES • 173

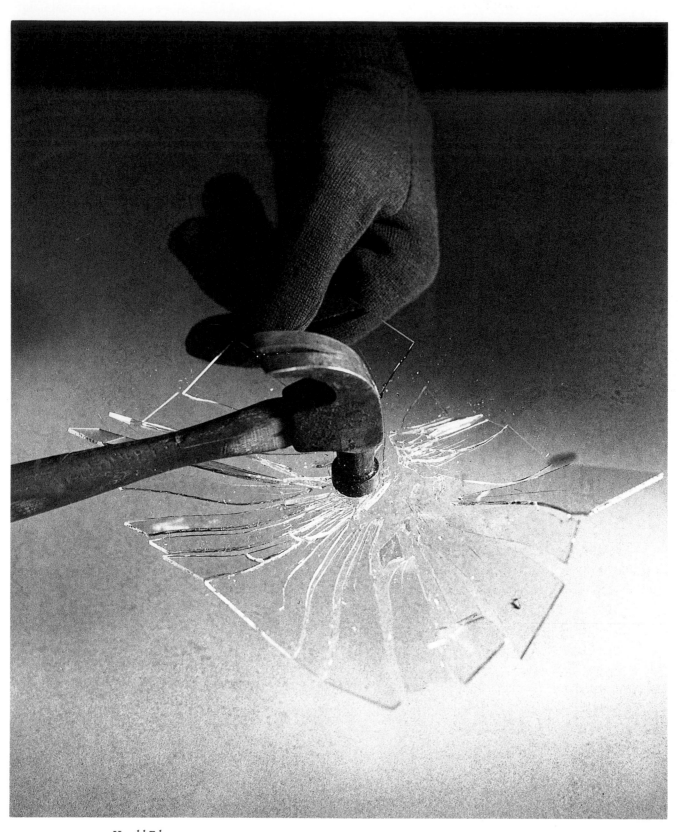

Harold Edgerton • *Hammer Breaks Glass Plate* • *1933. Gelatin silver print, 24 x 20"*

*To my wife June, the ultimate one-liner, whose excellent
eye has discovered many important works in this collection,
and who always brings me back to the basics*
JWH

ACKNOWLEDGMENTS

As I describe in my short essay on the origin of my collection, Ivan Chermayeff's innovative design ideas for our corporate offices kicked off the tools as art mania.

Over the years some of Washington's foremost professionals in the arts assured me that my narrow field of collecting has a serious purpose: Alan Fern, director of the National Portrait Gallery; Betsy Broun, director of the National Museum of American Art; David Levy, president and director of the Corcoran Gallery of Art; Tom Freudenheim, assistant secretary of the Smithsonian Institution; Sarah Greenough, curator of photography, National Gallery of Art; Anna Cohn, director of SITES; J. Carter Brown, director emeritus, National Gallery of Art; Frances P. Smyth, editor-in-chief, National Gallery of Art; Warren Robbins, president, Robbins Center; and Paul Richards, art critic of the *Washington Post*. Their encouragement has meant a lot to me, although I want to make it clear that I do not take it as an endorsement of the collection as a whole or of any of the pieces in it.

Bob Duemling, former director of the National Building Museum, invited me to mount an exhibition of the collection in the fall of 1989 that was well received by the press and the public. Jane Livingston, former curator of the Corcoran Gallery of Art and noted art historian, wrote an essay about tools as art in the catalogue of the exhibition. Their enthusiasm for my subject matter was of great importance in my commitment to building an eclectic collection.

At the National Building Museum I was fortunate to meet Carolyn Laray, curator and installer of the "Tools as Art" exhibition. She has been with me ever since as curator, and I owe a great deal to her vision, imagination, and writing ability. Carolyn, working from time to time with Bill Matthews, has done a terrific job of installing the collection in the Hechinger Company's corporate headquarters.

My assistants, Jacquie Beard and Gwen Morris and, early on, Lucille Darden, have, in addition to their regular duties, given enthusiastic support and joy over the years.

By far the greatest number of photographs in this book were taken by Joel Breger of Kensington, Maryland, who worked quickly and with skill and feeling. Photographers Edward Owen and Judy Olausen also did splendid work.

Sarah Tanguy and Jane Levine stepped in under time pressure and wrote biographical entries for the almost one hundred and fifty artists represented in the collection.

Kris Dahl of ICM has shepherded me on a number of occasions. My attorney Nina Graybill has been diligent in behalf of the project as well. Mrs. Dahl, along with Ivan Chermayeff and Jane Livingston, introduced me to Paul Gottlieb, president and publisher of Harry N. Abrams, Inc., whose quick enthusiasm for the project was the best news possible. Lastly, I want to express my appreciation for the efforts of Eric Himmel, senior editor, and Robert McKee, senior designer, whose patience, expertise, and good taste in taking a neophyte through the arcane science of book creation and publication made the experience a joy.

Lastly, I want to express my pleasure in working with Pete Hamill, whose text has added distinction to the collection by relating it to the whole sweep of art history, from Paleolithic cave art to Pop Art and Minimalism. I am honored to be in his company.

—John Hechinger

7

Foreword: The Hechinger Collection

By 1978, the Hechinger Company, which my father founded in 1911, had grown to the point where we required a new headquarters building. From that modern structure, we would manage an ever-expanding chain of stores (today there are more than one hundred) that sell hardware and building materials, known all over America as Home Centers.

Our sparkling new offices were state of the art, but in their raw form they pleased me less than I imagined they would. The long, clean corridors and windowless work spaces were efficient but sterile, and the building seemed to be a rebuke to the fantasies that a hardware store inspires. For anyone whose passion is work with his or her own hands, a good hardware store is a spur to the imagination and a source of irresistible delights (someone once called the Hechinger Company "the adult candy store"). Indeed, the phenomenal growth of my business since World War II was to a large extent a reflection of the fact that Americans were more and more eager to do for themselves what they once hired others to do for them. Nothing about our new building communicated the idea that ours was a business so dependent on such everyday creativity.

I called on Ivan Chermayeff, who had done a considerable number of graphic design projects for us, to help fill this void. He was immediately responsive to the idea that for decoration of our offices we need look no further than the items we sold in our stores. Using silhouettes of ordinary objects from our lumberyard and stores, he created more than eighty dramatically graphic and virtually abstract kodaliths (page 132)—photographic prints that have no halftones—to begin to enliven our walls. Ivan, like most designers, is dependably

seduced by the qualities of hardware, in which form and function are often irreducibly blended. In a 1988 seminar, a team of design experts judging the aesthetics of a range of industrial objects gave the highest marks to an 8-penny finishing nail, which one of them described as "a truly classic design, one of the little miracles that can't be improved upon." This paean to the common nail pleased me no end, since I have great regard for the design quality of many of the tools of my trade.

At that time, I already owned a suite of prints by Jim Dine called *Tool Box* (pages 116–17), and I hung them in our new boardroom. The Dine prints, and Ivan's kodaliths, opened me up to the possibility of collecting art that represented tools and other common items of building. I felt that if I could show my associates how so many artists had celebrated the handsaw or the hammer or the paintbrush, they would be aware of the intrinsic beauty of the simple objects that they handled by the tens of thousands. They were not only the focus of their workdays, but our company's very lifeblood. I hoped that the art would cause them to feel that what they were doing was of greater value.

This was the beginning of an adventure that was unlike any experience I had had before, for I soon came to understand that my chosen area of collecting carried me to the wellsprings of twentieth-century art. The celebration of tools in art has a long, respected tradition, from cave paintings to such famous nineteenth-century works as Vincent van Gogh's *The Weavers* and Jean-François Millet's *The Wood Sawyers*. But it is really in our own time that art about tools, and art about using tools to create art, has entered the mainstream of art history.

Like most collectors, my buying was limited by what was available and by my means, but it seemed that every work I acquired was in some vital way connected to this thematic core. I decided to concentrate my efforts for the most part on postwar American artists, and it was a great pleasure to find work by artists of renown, and by young and relatively unknown artists as well. Wherever I looked among the art of this century, from folk art to photography to the high art traditions of Europe, I could find works that fit the criterion of my collection. And if I could not get my hands on some of the seminal works of the modern tradition, it was still thrilling to realize that they would not have been out of place among the pieces I did own. (I like to think that if I had been on the jury that rejected Marcel Duchamp's scandalous *Fountain,* an unadorned porcelain urinal that he signed and submitted for exhibition in 1917, I would have voted to accept it.)

I was delighted that the diverse works in my collection displayed so many of the essential artistic values of my own time: the beauty inherent in pedestrian objects; punning wit that finds expression both in content and in craftsmanship employed to create visual illusions; imagination that transforms and combines found objects and generates new formats; the use of unorthodox materials to represent traditional subjects and of traditional materials to represent unorthodox subjects; a reflexive emphasis on the processes involved in creating art; and, above all, the conviction that common things are the proper subject of the artist.

Thus, my collection, which I had originally hoped would impress my associates with the significance and dignity of tools, has inevitably evolved into a meditation on the meaning and value of art. Not only craftsmen, but everyone the world over, judges the worth of tools and building materials by how they perform. In a sense, once a tool is in hand, it disappears. We care only about how well it functions, not its form. In the hands of an artist, however, the form of a tool is a vehicle for communicating an infinite range of ideas and associations, from purely visual analogies to complex human feelings.

The rewards of having this art in our workplace have been indisputable. It is seen daily by employees, vendors, and visitors. It delights us in those inescapable moments when work weighs heavily on our minds, and it justifies the worthiness of our chosen careers. It wakes us up and starts arguments and gets our juices flowing. It even reminds us that purposeful work is not the be-all and end-all of existence. (In our lobby is a Jean Tinguely kinetic sculpture made out of tools and chains that bangs away, creating absolutely nothing, expressing the purposelessness of modern machinery.) I hear regularly from my associates which pieces they love and which they hate. In fact, there was general malaise when pieces were taken off the walls to shoot the photographs for this book.

The Hechinger Collection, now numbering almost three hundred pieces and still growing, is owned and personally funded by me but, except for a few works at my home, is hung in the Hechinger Company's corridors, offices, and cafeteria, which were so boring when first observed. As a whole it expresses the protean spirit of modern art, for it is both an art collection in the workplace and an art collection of the workplace.

—John Hechinger

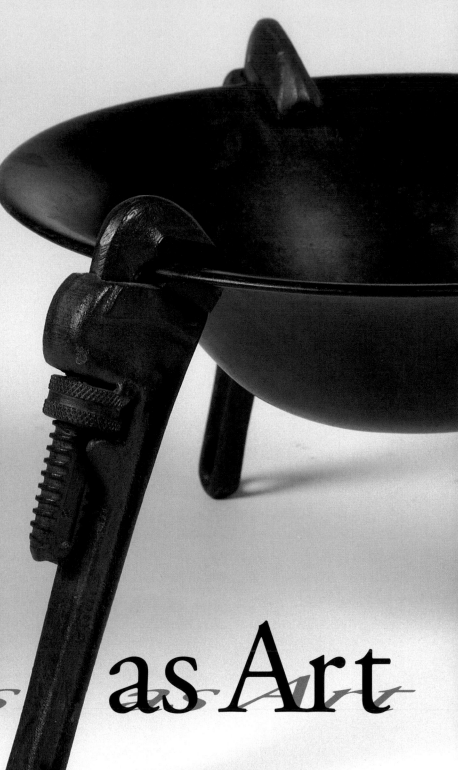

Pete Hamill

Tools as Art

Chris Collicott
• Wrench Bowl • 1986.
Patinated steel,
12 x 16"

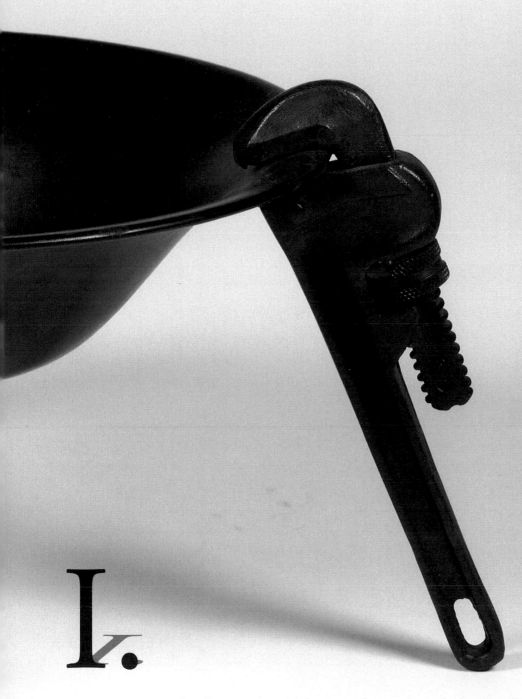

I.

Primitive Man was hardly primitive. To begin with, he created tools.

In basic theory, his tools were not much different from the tools we use today; they were extensions of the hand and the mind. In time, these extensions of man became as essential to his life as food and sex and breathing. We don't know with any precision how this happened; there are no records and relatively meager archaeological and anthropological evidence about the long journey of *Homo erectus* through the Neanderthal stage to *Homo sapiens* and the beginning of modern man. But most historical conjecture is based on common sense.

Before designing his tools, Primitive Man must have imagined their use, conceiving of some more efficient way to knock down an animal, to cut it and skin it before consuming its flesh and then donning its scraped hide for warmth. Then this earliest designer must have shaped a tool to satisfy that need. Form, as usual, followed function.

From his needs and his imagination, Primitive Man devised a variety of tools: axes, spears, harpoons, traps, the first pots, the first water jars. Fire, too, was a tool, and cooking one of its consequences. Primitive Man discovered salt and other spices and remembered the way he found them; aimless foraging would evolve into agriculture. As *Homo erectus* gave way to *Homo sapiens,* about 100,000 years ago, language began to evolve into a more refined instrument of expression; we have no idea what those words sounded like, but they had certainly moved beyond the grunts and bellows of primates. More important for the survival of the species, language was also a tool, a means of passing to others all that hard-earned information about the world, along with the secrets of lore and craft.

While Primitive Man was inventing language and agriculture, he was also creating art. The work of *Homo sapiens* still adorns the walls of caves in Lascaux, France; Altamira, Spain; and other places around the world. The works in Lascaux are now thought to be 17,000 years old, products of the Ice Age, when most of Northern Europe lay under 100 feet of glacial ice and the seas of the earth had dropped 300 feet. In this winding series of connected caverns, the anonymous painters celebrated the world they knew. On the walls near the opening (accidentally discovered in 1940), they placed three gigantic wild bulls called aurochs, each about 16 feet long. They are immense, powerful, dominating; these were not animals for whom Primitive Man felt contempt. Scattered through the caverns are almost fifty more of these spectacular animals, which were common to the forests of Africa and Eurasia, and were the ancestors of domesticated cattle. But the bulls are not alone. On other walls, the viewer can also see reindeer swimming across a river, bulls in stampede, deer, jungle cats, and the first known evocation of human tragedy: a wounded bison and a dying hunter.

That painter, or, more accurately, those painters (for the works seem to be the products of different hands) had immense skill and obvious mastery of their tools. They are believed to have used green twigs with finely shredded tips as brushes and to have blown paint through reeds or hollow bones in the first known version of the spray can. They obviously possessed powerful visual memories, since no bulls or reindeer or jungle cats stood posing in the caves for close observation. They also had devised some system of illumination while they worked and had erected some form of scaffolding. Their paints were made from iron oxides mixed with water, the colors of the earth transformed into the tools of man and art.

Equally astonshing are the caves of Altamira, in Spain, and the newly discovered underground sites near Vallon-Pont-d'Arc in the Ardèche section of southern France. The 15,000-year-old paintings of Altamira show us reindeer, ibex, bison—and human figures. Among the more than 300 paintings discovered in December 1994 on the walls at the Ardèche site are depictions of bears, rhinos, an owl, a hyena, a panther—animals never seen at other sites.

In all this work, the ease and confidence of the draftsmanship are a marvel; clearly these paintings could not have been the sole works of the nameless artists who painted them. They knew how to define form through the subject's basic shape, abstracting its essence from its many details. They knew how to portray action, too: the animals run, the men cast spears; in some, the tails of animals are blurred to show movement. And materials matter: the colors are bright reds and brown ochers, pleasing to the eye, the forms often outlined in black.

The artists were flexible as well: the designs are often adjusted to, or guided by, the irregularities of the cave surfaces. It's difficult to believe that some itinerant hunters happened to walk into a cave one rainy morning and started painting to pass the time. These artists must have worked in other media first, on bark, on skins, perhaps adorning the human body; that work, like the parade floats designed by Leonardo, are lost now to time and

weather. But the great cave paintings remain, and the overall effect is as sophisticated as any work on display today in the galleries of Paris, New York, or Tokyo. We don't know the names of those artists, but they speak to us across the millennia. On the wall of the Pech-Merle cave in the Lot region of France there is the silhouette of a human hand, probably shaped by blowing paint through a tube. In one way, it is a tribute to the most essential human tool, the hand. It says: I could make this tool, my hand, into a fist, but instead I choose to use it to make art. In another way, it is the first human signature and looks as modern today as a painting by Jim Dine.

As people settled down, organizing farms and then cities, they began to use their tools in new ways. In various styles in widely separated communities, human beings started choosing among the things they needed and the things they desired. In every emerging society, distinctions were made in the uses of tools. Brian Hayden, in his book *Archaeology: The Science of Once and Future Things*, stresses the differences between practical technology and prestige technology.

> *Practical technology is based in the principle of making tools and performing tasks in the most efficient and effective fashion possible. The less time and work involved, the better. In contrast, what I refer to as* prestige technology *is based on the principle of displaying or showing off one's wealth, power, or control over labor and resources. Therefore, as much time and labor as can be spared are used to produce these items. The more time and work spent in obtaining them or making them, the better.*

Prestige technology includes the most prestigious of all human activities: the making of art. The materials of the Mesolithic artists, Hayden says, included "imported shells, shell beads, ornately carved bone or stone tools, sculptured amber, thin and fragile stone bifaces, cutting tools of jade…." The arrangement of beautiful objects, the encouragement of adornment and luxury, a taste for the

rare and exotic: all fed the impulse. So did the elevation of the banal into the special through elaboration. Stone axes that were adorned with special markings and designs had obviously lost their function as tools, as had intricately carved harpoons and lances. They became symbols of authority or prestige among chiefs of clans or early shamans. This would not be the last time in the history of art that common objects would undergo metamorphosis.

As the old egalitarian cultures faded away, the artist became part of the emerging social elite. The hunter who also painted gave way to the human whose basic occupation was the creation of things of beauty, magic, or power. About 6000 B.C., in what is now Iraq, the first cities emerged and the first written language was created. Civilization had begun. Equipped with tools and art, driven by intelligence and imagination, fear and desire, the need for power and the need for joy, civilized people permanently altered the face and the rhythms of the world. Up ahead was history. Up ahead lay Luxor and Karnak and the pyramids of Giza. Up ahead were the glories of the Maya and the Inca, Palenque and Teotihuacan, Athens and Rome, Giotto and Piero della Francesca, Donatello and Michelangelo. The artists of 6000 B.C. could not have imagined Caravaggio or Vermeer, Turner or Cézanne. The first musicians, playing down the street in the temple or the bazaar, could not have heard, even in imagination, the possibility of Mozart. They did not know that up ahead were the Alhambra and the cathedral at Chartres, the Louvre and the skyline of New York. They could not have conceived the works of Picasso and Matisse.

All were made with the tools of humans; as were gunpowder and the machine gun, the dark chambers of Auschwitz and the poisonous clouds of the atomic bomb. Across the centuries, human-made tools have been used to create unimaginable horror. But they have also produced what might be humanity's only true redemption: the mysteries, humors, and astonishments of art.

II.

Every great collection is a kind of collage. The object of desire can be stamps, or books, or nineteenth-century valentines. But the impulse is the same: to possess and then display. Collectors first assign a personal value to certain objects by the act of choosing them. Then they want to spread their enjoyment to others by displaying their possessions.

In the unique collection of John Hechinger the long, parallel histories of tools and art have been joined for the first time. As befits a man who operates a hugely successful chain of hardware stores, the individual objects of his desire are works that revolve around tools. He has acquired pieces of nineteenth-century folk art. He has chosen works by twentieth-century artists with grand reputations: Fernand Léger, Anthony Caro, Claes Oldenburg, Richard Estes, Jim Dine, Ben Nicholson, Red Grooms, Lucas Samaras, James Rosenquist. He owns photographs by such modern masters as Berenice Abbott, Walker Evans, and Aaron Siskind. He has found and purchased works by lesser-known artists of the past quarter century, guided by their superb accomplishments and his own taste.

Taken together, the works form a wonderful collage, a gathering of apparently disparate objects bound together by theme and choice. They have a Proustian power that unleashes many confused emotions: celebration, affectionate humor, even joy—along with regret, loss, and at times an overwhelming nostalgia. For an American with memory, they recall vanished times, when you saw men carrying toolboxes to work, when carpenters and plumbers worked in tiny shops and made house calls, when a machinist was spoken about in terms of awe. Those years seep through these works of art. With only minor variations in design, most of the tools considered by the artists have been used

by human beings since before recorded history. But like the adorned ax or the decorated harpoon, these tools have now lost their original function, although in most cases they retain their original form. In short, they have undergone metamorphosis, the way a bicycle seat and handlebars were once transformed by Pablo Picasso into the head of a bull. They are simultaneously tools and not tools. Through the workings of art, they have become new objects.

Hechinger has not hidden this art away for his own private edification. He has chosen to display it, primarily to the men and women of his own company. This art is a daily presence in their lives. It assures them that what they do—distributing tools to human beings—is of immense value. Men and women use their tools; artists celebrate their existence and transform them into art.

The twin sense of celebration and transformation is apparent on a visit to the lobby of the Hechinger Company in suburban Washington, D. C. The lobby is all clean planes, with stairs moving to the second floor, doors leading into the offices, a receptionist behind a desk to the right. Hundreds of American corporations are housed in buildings like this. The difference here is the art. The first work that demands attention is straight ahead: an assemblage of what seem to be hundreds of silvery fish, moving through watery light (pages 32–33). They have a crowded, sinuous grace, moving as the viewer moves, picking up the light pouring through the glass doors. Up close, the fish reveal themselves to be simple visegrips, available in any hardware store. The piece is by the French artist Arman, who calls it simply *School of Fishes*, for that is what the visegrips have become. Those grips will never again clamp sheet metal or hold veneer to wood; they are fish now, forever.

Another piece by Arman stands against an adjoining wall. It is a sunburst of handsaws, all moving toward a darker central core (page 35). Again, the light bounces off the shiny blades; we see that they are saws, but their teeth seem to be

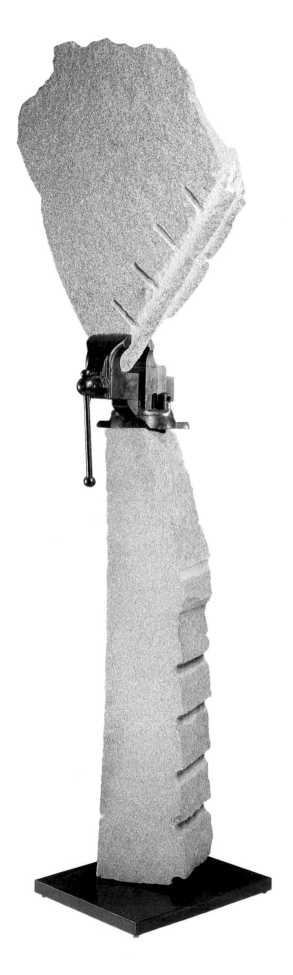

arrayed like the multiple teeth of sharks. Arman calls the piece *Jaws*. The reference to the movie might raise a smile, but there is also something oddly sinister to the image. To an ambushed swimmer, the mouth of a shark must look like an arrangement of saws.

Over to the left, on a black pedestal, is a machine by the wonderful Swiss artist Jean Tinguely, a friend of Arman (page 39). Its components are familiar: a green hammer, a length of chain, various wheels, a hacksaw, flanges, pipes, a small motor, a screwdriver. A spanner wrench lies flat at its base. When its motor is switched on, the piece moves. At regular intervals the green hammer strikes an anvil with a deadening precision. As always with Tinguely, the first sight of the piece makes the viewer smile; but as the hammer strikes its hollow anvil again and again, a darker mood takes over. In one sense, this is a parody of the cuckoo clock, another of Tinguely's assaults on all notions of Swiss precision and efficiency. But since the machine makes nothing, it also seems like a monument to meaningless work, a sculptural version of the impersonal machines in Chaplin's *Modern Times*. And layered into the piece is the possibility of autobiography, for Tinguely's father was a factory worker.

Standing freely in the lobby is a piece by the sculptor John Van Alstine. Two slabs of granite are held together—miraculously—by a vise. The top slab is pitched at a precarious angle; to gaze at the piece from any position is to experience anxiety. Surely the top slab, as irregular as a flint tool, will topple off its rough-hewn plinth and shatter on the floor. But no: the *tool* holds it, defying gravity, imposing its strength, its force, its design on these quarried hunks of nature. The piece is called *Kouros*, urging upon us images of Greece, antiquity,

John Van Alstine • *Kouros* • *1989.*
Granite and vise, 103 x 29 x 22"

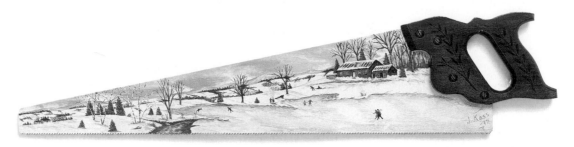

Jacob J. Kass • Untitled • *1981. Acrylic on saw, 7 x 26"*

Lee A. Schuette • *Crosscut Saw* • *1982. Wood, 11 x 34 x 2"*

F. L. Wall • *Hacksaw* • *1984. Walnut, 12 x 42"*

Phyllis Yes • Untitled • *1980. Acrylic on saw, 8 x 32"*

Artist unknown • Trade Sign • *c. 1875. Painted wood, 8 x 31"*

Oleg Kudryashov • *Broken Saw* • *1987. Drypoint and watercolor construction, 23 ¹/₄ x 32 x 12 ¹/₂"*

the light of the Mediterranean. But it suggests several other levels of response. Herbert Read, in *The Art of Sculpture*, borrows the word "mana" from anthropology, defining it as "the name given to that power immanent in all things, not merely men and animals but even inanimate objects like rocks and sticks." Van Alstine, in this piece, grants his slabs that sense of mana, giving them their power, while also imposing the presence of man, the sculptor, *himself,* through his carving of the stone and the intervention of the clamp. The modern sculptor can come at stone with traditional tools: the drill, the hammer, the chisel, the punch. But he now has the option of adding that vise.

The lobby serves as a kind of overture to the rest of the collection. Throughout the building, works of art are placed in areas where people work, dine, or otherwise intersect; the spaces outside elevators are reserved for art; so are the blank walls beside the lavatories. The placement is not rigidly methodical; this is not a museum. But the works feel integrated with the workplace, providing a daily portion of surprise or humor or mystery to those who work among them.

The works of art can be seen in isolation, or as components of a giant design, or as variations on a theme. For example, there are handsaws throughout the collection, but not one of them emerges from its encounter with an artist in the same way. Each saw is like a familiar melody embraced by a jazz musician, who proceeds, as if in the heat of some spectacular jam session, to improvise into and against that melody.

Here is a saw painted on with acrylics by Phyllis Yes (page 16); she subverts the stereotypical masculinity of the tool by adorning it with delicate, lacy, "feminine" designs (as she does, elsewhere in the collection, to a paint can and brush). Here is an

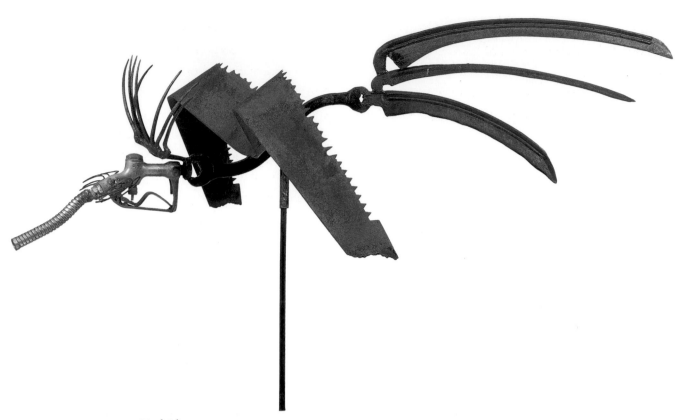

Mark Blumenstein • Saw Bird • 1979. Metal and hardware, 48 x 48 x 48"

antique saw painted by Jacob Kass (page 16) with a snowy country scene featuring houses made by the people who once wielded such saws; it should be aesthetically corny, but the combination of saw *and* painted scene calls up a genuinely *felt* image of the vanished American Arcadia. The saw placed into a mixed-media painting by Tom Hebert (page 140) has another feeling to it: the relentless force of mass-produced housing, as endless suburban tracts are slapped together without regard to permanence or beauty.

Some artists are inspired by the form of the saw. Susan Firestone's screenprint silhouettes of rotary saw blades now cut a hole for the sky, then become a moving form, blowsy with cloudy shapes, like a hurricane glimpsed from a satellite (page 131). Chester Arnold restates the melody with his beautifully rendered charcoal drawing of a saw decisively cutting into wood (page 142). But there's no way to

escape the function of the saw: to tame nature. The astonishing two-handed metal saw appropriated by Nancy Irrig for her 1989 landscape—a saw as long and varied and bucolic as the Shenandoah Valley— must have been handled by great burly men who cleared forests (pages 56–57). The heroic age is not present in the decorated saws of Howard Finster (page 56); they seem never to have been used for anything except his painted cartoony mountains, trees, birds, faces, his hieroglyphic tools, his flat houses and church steeples, and the hand-lettered messages that read like postcards from a more primitive world. That pastoral America is being rapidly left behind by the muscular yellow trailer roaring for freedom in the vigorous macho saw painted by Rico Solinas; you can almost hear the Eagles on the radio, and road voices crackling on the CB, while the landscape itself backs away from this triumphant human-made mastodon.

In almost all of these pieces, the artist takes possession of the object, makes of it something unique, obliterating its mass-produced nature. When Lou Horner paints her saw with surreal fragments of memory, she makes this the only saw of its kind in the world (page 57). John Schlesinger superimposes a silver print of a grasping hand on a circular saw and transforms it into the mechanical, cutting eye of a ruthless camera (page 81). The fractured, torn, marked surfaces of *Broken Saw* (page 17), by the Russian artist Oleg Kudryashov, seem like the savaged flag of some ruined worker's republic. Mark Blumenstein finds a saw in the discards of rural America, along with a pitchfork, sickles, the nozzle of a gas can, and transforms them into a monstrous, comical bird (page 18).

Throughout the collection, there are tools that deny their traditional function. Lee Schuette's wooden handsaw will never cut wood, or anything else (page 16). F. L. Wall's exquisite version of a hacksaw, made entirely of walnut, is at once a tribute to all hacksaws and their negation (page 16).

His oversize screwdriver, made of ash, mahogany, walnut, and cherry wood, feels almost religious in its solemnity, right down to its open crypt in the handle which contains a tiny machined screwdriver (page 37). His *Plane*, with wood shavings adding to the illusion, and *Summer Tool* (page 34) are no longer tools; they are melancholy tributes to lost crafts, out of a simpler country with simpler forms. But the cast-glass wrench, hammer, anvil, and dust broom by Jeffrey Chapline are not destined for the toolbox of a worker (page 151). The lathe made entirely of maple wood by Allen Adams (page 20), complete with table and hand tools, isn't there to shape metal or wood, nor is the full-size drill press made of inscribed paper by Pier Gustafson ever to be used to punch holes in metal (page 105). All have become subjects of the artist, as permanently separated from function as the apples on Cézanne's table. We cannot bite into those apples; we cannot use these tools.

Over and over again in this collection, tools inspire smiles and laughter. The shapes of tools,

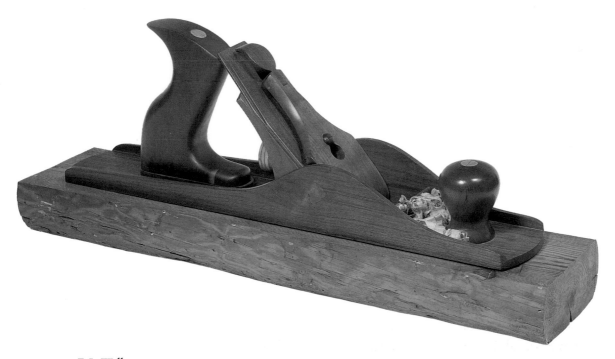

F. L. Wall • *Plane* • 1978. Cherry, maple, walnut, and yellow pine, 48 x 20 x 14"

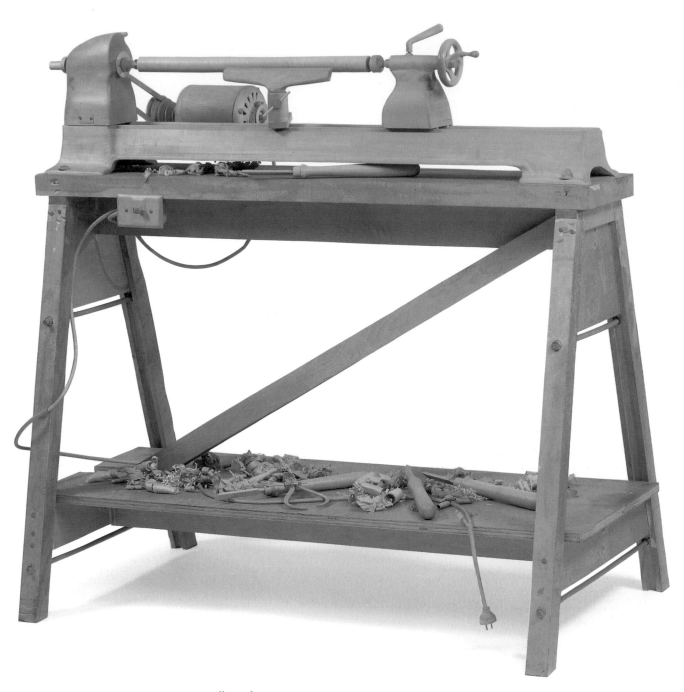

Allan Adams • *Lathe* • *1979. Maple, 48 x 52 x 28"*

made banal and commonplace through millennia of use, are rediscovered through puns, wit, surprise, or the shock of recognition. The delightful papier-mâché sculptures by Stephen Hansen have the simplicity of great cartoons—and the deeper messages. His *Man on a Limb* (page 21) is sawing through a plank that might indeed once have been a limb; the initial easy laugh subsides into a contemplation of what man has done to trees since the days of the

nomads. In *Toothpick* (page 62), by Robert Wideman, the picks curve around in absurd calligraphic arcs to point at the wooden shaft, the place made for strong hands. But in the America of cyberspace, the days of pick and shovel, when great brawny armies moved across the land, building roads and taming wilderness, are behind us; to the young, a pick is something used on teeth.

The same rueful humor is found in *Tool Dictionary* by Colleen Barry-Wilson (pages 40–41). The sheaves of her "book" are handmade papers, textured, flecked, imperfect, human. Tools are not human. But the hand tools hung upon or embedded in the pages are also the products of man, who used similar tools to make machines that eventually would remove the human hand from the process. We initially smile at the display of the tools, their incongruity in a "book," the dense placement of their rough shapes where we expect words. But then an odd sense of longing rises from the combination of paper and tools; some of these objects are becoming as obscure as the horseshoe. They are passing from common human experience. The young don't know their names. And dictionaries *name*. As do poets.

A ghastly sense of humor informs Chester Arnold's *Correction* (page 22). In the foreground, a perfectly rendered claw hammer is frozen in the act of prying a nail from a paint-spattered plank. Another gnarled, badly hammered nail is awaiting removal. But in the middle distance, thick black smoke pours from an unseen disaster, perhaps a plane crash that has taken place offstage, in a valley beneath the mountains of Magritte or Bierstadt. The hammer itself seems surprised, even shocked; the tabloid headline would almost certainly be "Whoops!" Obviously, something has gone drastically wrong. But the painting also recalls W. H. Auden's great poem, *Musée des Beaux Arts,* inspired by Brueghel's painting of Icarus falling to his death in the sea, while a variety of citizens go about their daily tasks:

> *About suffering they were never wrong,*
> *The Old Masters: how well they understood*
> *Its human position; how it takes place*
> *While someone else is eating or opening a*
> *window or just*
> *walking dully along...*

Or hammering a nail into a plank, high in the mountains.

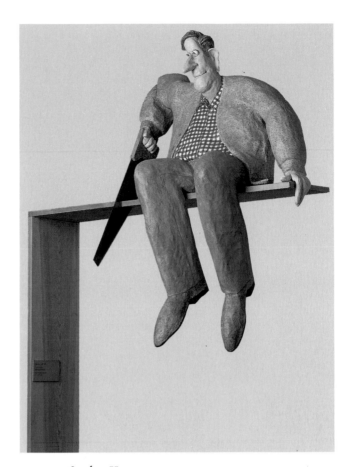

Stephen Hansen • *Man on a Limb* • *1985.*
Papier-mâché, 48 x 72"

Arnold's poetry of the accident is recognized by another artist, Pierre Flandreau, in his small painted bronze of missed nails called *Homage to Chester Arnold* (page 67). Of the seven nails in this piece, only one has been hammered cleanly. The others, like the bent nail in Arnold's plank, have been mauled. Most of the time, the nails tell us, human beings fail. We can laugh at such failures (for they sometimes have a slapstick bawdiness), but as in all high comedy, there is an underlying element of tragedy.

Other pieces in the collection sparkle with wit and surprise, with very few dark undertones. The ceramic plate by Maria Porges called *The Birth of Power Tools* (page 101) shows us a plain hammer with an electric cord attached to its wooden handle and a lightbulb replacing its head. This has a naive charm that is also very intelligent; something like

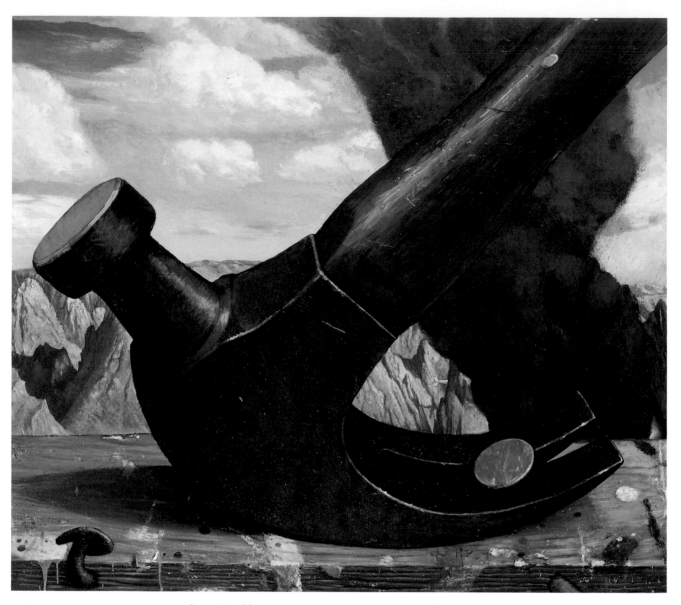

Chester Arnold • Correction • 1987. Oil on linen, 46 x 54"

this process must have involved the imagination of a now-forgotten inventor. The same artist's *Table Saw* (page 101)—in which a saw becomes a table, complete with stool and hot bowl of soup—has a Beatrix Potter coziness that is like a child's first encounters with tools. And, of course, this tool, the saw, has made many millions of tables.

The *Chair Maker's Chair* (page 49), by Daniel Mack, is constructed of raw tree limbs and tools and is a kind of monument to all those nameless craftspeople who have made chairs across the centuries. It conjures a thousand workshops, where

hands and tools transformed raw materials into objects of use and of pleasure. Its rickety structure, its fragility, its cobbled materials make it impractical, the first step toward prestige technology. It also makes us smile, not at the chair but at ourselves. We know that even the most skillful craftspeople among us couldn't shape this wonderfully absurd object. Its elusive secret isn't craft; it's the imagination of the maker.

Some pieces are glorious sight gags. The double-headed *Siamese Hammer Joined at the Handle* (page 97), by Vladimir Salamun, is one of those works of

such obvious simplicity that many viewers must ask: Why didn't I think of that? They didn't; Salamun did, and here it is, questioning the very essence of the hammer while simultaneously celebrating it. There is humor, too, in the first sight of Richard Bronk's *Ship of Tools* (page 149). The form of the toylike ship is as perfect as one of Tamayo's melons. But it's the superstructure that delights the eye, composed as it is of a miscellany of hand tools. They draw you in. Then, on closer examination, an unstated but ultimate human destination seems possible; the tools are encrusted and barnacled, as if they'd been subjected to centuries of immersion in the sea. Childhood and age coexist here; from water we come, they seem to say; to water we shall return.

Such cosmic possibilities are not present in *Insomniac Bed* by Scott Lesiak (page 111). Who has not spent agonized hours in that bed, pounded by the dumb, throbbing hammers of sleeplessness, stress, jealousy, uncertainty, rage? In that bed, it is always four o'clock in the morning; an hour goes by and you glance at your watch, and only three minutes have passed. And when it's over, when the bout with insomnia has passed, it's possible again to laugh at the stupidities that caused it. Lesiak's bed must surely exist in the staterooms of Bronk's ship.

Other pieces are astonishing in their simplicity. *Zen Saw II* (page 69), by John Mansfield, is visual satori: a saw made of rice paper and balsa wood is cutting deep into stone. Logic and experience tell the viewer this can't be done; paper and wood can't slice into rocks. But here is the proof, an act of Zen disruption performed by imagination and craft. We see it. And we will never look at stone the same way again.

The same magical disruption of reality is present in the all-glass *Hammer and Nails* by Hans Godo Frabel (page 24). The skill of the glass artist is evident; but beyond the demonstration of immense control of craft is the way the piece plays with a viewer's sense of conventional reality. Since the Iron Age, human beings have driven metal nails into wood with metal-headed hammers. But here the weight of the hammer—essential to its power—has been removed. The penetrating function of the nail is gone. And yet the piece urges us to try it, to test what the artist is showing us through his choice of material, to lift that anti-hammer and try to drive that anti-nail into wood, wondering which would shatter first. In this—as with the best pieces in any collection—the viewer helps complete the work of imagining.

There are many pieces in this collection that could be described by the vague categorization of "folk art." They contain no references to other art, no italicized ironies, no evidence of a camp sensibility. They are simple declarative sentences. As such, they express a sense of confidence and pride. There is a beautifully blunt wooden handsaw, made in about 1875, probably to advertise the skill of a craftsman who made real saws (page 16). The man is forgotten, along with the people to whom he sold saws; his sign remains. There is a painted tin silhouette of a lock (page 70), made around 1880, with the word "hardware" lettered on it. Nothing fancy, thank you. No embellishments, no baroque flourishes. Just "hardware." With his simple sign creaking in the breeze, a mundane citizen sold hammers and locks and keys and chisels to people who went out and built their piece of America.

The makers of such works are part of the "folk." They lived, they worked, they made things, and they died. But we can glimpse their lost America in the store shingle shaped like an ax and the stillson wrench carved from wood. Most evocative of all is the nineteenth-century traveling tool board, carved from wood (page 25). It's as carefully designed as one of those custom-made Halliburton suitcases used by photographers, with a place for every instrument of the craft. But again, the past exerts its power. This board was once filled with the tools of an itinerant carpenter or a salesman of tools. Surely he was a traveling man. Surely he lifted this

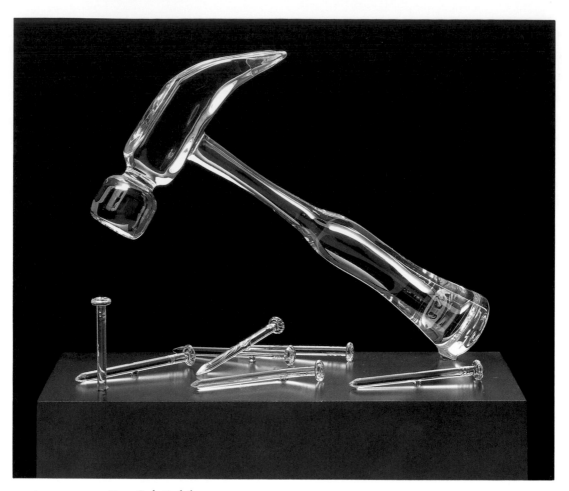

Hans Godo Frabel • *Hammer and Nails* • *1980. Glass, 9 x 12 x 6"*

loaded board onto horse-drawn wagons or heaved it onto the racks of trains. In many strange towns and cheap hotels, he must have laid it on the floor and kicked off his boots and taken a desperately needed bath. And in the fresh morning, he must have laid it on another stranger's counter or table or bar and opened it as if performing magic. The tools have vanished, along with the people; the board remains, beautiful and haunted.

If some of the folk art is self-referential—what Norman Mailer called, as the title of one of his books, *Advertisements for Myself*—so is much of the modern art. This is not new, of course; since the time of the Renaissance, painters have examined the dailiness of their lives, the studios in which they worked, the tools they used. Arman's untitled assemblage of tubes of paint imprisoned in

Plexiglas acrylic sheet (page 165) is a kind of jail scene; these paints will never be used for any voluptuous purpose, will mark no canvas, paint not even a saw. But the cans of paint in Wayne Thiebaud's lithograph (page 58) are alive with the presence of the unseen painter; the tops are open, paint sticks are plunged into the paint, the color itself has a *poured* look. They invite the act of painting—either by a house painter or by an artist.

The opposite effect is caused by Dies de Jonge's sturdy *Brush and Tub* (page 94). The entire piece is carved from wood, the bristles of the brush delineated with an etcher's precision. They don't urge participation; they are too perfectly accomplished to ask anything beyond admiration for the artist's skill. They are to painting as a totem pole is to hunting.

The artist's own tools appear in other pieces of the collection. We see a hand-colored lithograph of a staple gun by Bill Wilson and the same artist's vigorous oil of a brush loaded with umber and red paint (pages 161 and 164). The latter contains the same idea seen in Lucas Samaras's earlier *Brush* (frontispiece), but Samaras executes his in a more controlled, precise style, every drip as calculated as a piece of stained glass. Arman's *Blue, Red, Brown* is made of actual brushes whose bold streaks of paint are a kind of homage to the friend of his youth, the avant-garde painter and performer Yves Klein (page 104). And there is great respect for the physical work of painting in David Furman's glazed and enameled ceramic version of brushes in a rusting tin can (page 94). The brushes still contain paint; they haven't been cleaned; they, and the artist, must be taking a break. The work goes on.

The varieties of contemporary graphic expression are to be found throughout the collection, from Hans Namuth's photographs of tools to the vigorous, painterly expressionism of Ke Francis in *Reconstruction Vision.* All seem to have escaped the clichés of 1930s WPA–New Masses romanticism about the nobility of workers, or their status as permanent victims; none exhibit the grim orthodoxies of Socialist Realism. If anything, the collection as a whole reminds us of still another reason for the collapse of the Stalinist enterprise: it was completely devoid of wit, style, irony, or nuance. Stalinism was an unadorned ax. In Ed McGowin's *Workers Waving Goodbye* (page 102), the men seem to be saying goodbye to communism or some other soiled ideal; they could be following Lech Walesa out of his Polish shipyard. They are certainly not the workers of Jacob Lawrence's lithographs. But the artists are not shilling for capitalism either. In Charlie Brouwer's *He Always Carried His Own Ladder to the Job* (page 61), the irony of modern

Artist unknown •Traveling Tool Board • *Late nineteenth century. Wood, 72 x 13 x 2 $^{3}/_{4}$"*

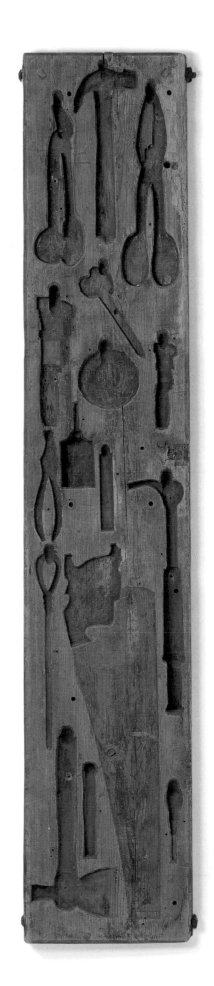

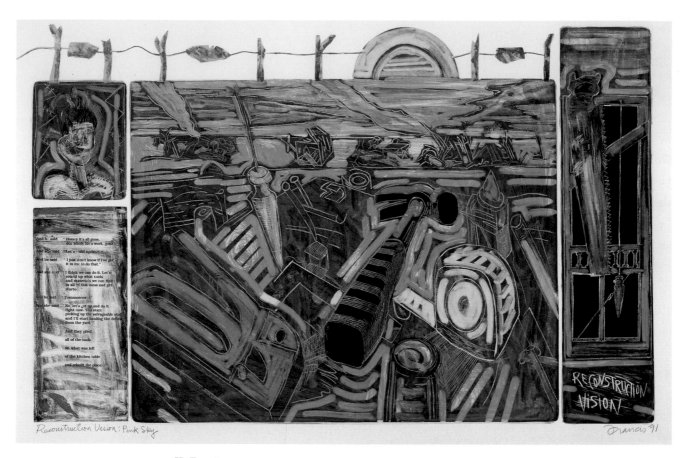

Within the image, handwritten text reads: "Reconstruction Vision: Pink Sky" and "Reconstruction Vision" and "Francis 91"

Ke Francis • *Reconstruction Vision* • *1991. Monotype, 30 x 40"*

work is darker. The man is empty. He has become the ladder, his own life merged with and lost to the work.

Of all the works in this collection, those made by Jim Dine (pages 134–35) are among the most successful mergers of tools and art. His wrenches, spoons, awls, clamps, shears, and forks are impeccably drawn. He is, of course, among the finest contemporary draftsmen. But he has added washes of color to the lithographs, applying them by hand. Sometimes the colors suggest nature: skies, trees, the sun, the sea. More often he expresses the sheer joy of his own tools—his paint, his brushes, his paper, his hand. He doesn't deconstruct tools; he doesn't fracture them and reassemble them in some witty way. He allows them their own existence and he is as faithful to them as Thomas Eakins was to

the nude. But he expresses his emotions about them. These pictures by Jim Dine combine precision and delight in materials.

Those qualities are also present in the three sculptures by Michael Malpass, *Globe* (page 170), *Big Mike* (page 132) and *Newtonian Sphere III* (page 27). Each of these works demonstrates an extraordinary control of craft. Even the most accomplished welder must wonder about the way they were made, the perfection of the spheres, the seamless interlocking of the abandoned tools, scraps of metal, and other discards of the collapsing New York industrial base that Malpass collected and made into art. Malpass, who grew up in New York in the 1950s and 1960s, when it was a big, wonderful, hard-working town, scavenged the debris of that lost city for his materials. By the end of the

1970s, a million blue-collar jobs had vanished. Factories were closed. Lofts once peopled by machinists and tailors and sheet-metal workers were now lived in by fashionable painters and their stockbroker patrons. Malpass searched his city for evidence of what had been lost. He literally created worlds from what he found. They are like tiny compact planets dragged in from some distant points in the universe. If we are examining them from a great height, the planets are devoid of nature, but their steely surfaces, one endless megalopolis, suggest an immense complexity; we wish we could speak to the inhabitants, hear their dreams, listen to their poetry, see their works of art. If they are dead, we want to know why. But Malpass, a poet of post-industrial nostalgia, knew that we had already encountered them; as the great cartoonist Walt Kelly once said, "We have met the enemy and he is us." The Malpass sculptures could be maquettes for the world that lies ahead, the scary earth of the twenty-first and twenty-second centuries, jammed with uncountable billions of people, the trees and the grass gone, the oceans poisoned or dry, the doomed inhabitants slaughtering each other over food or water or belief. If that is what awaits us, mankind will not be saved by tools or art.

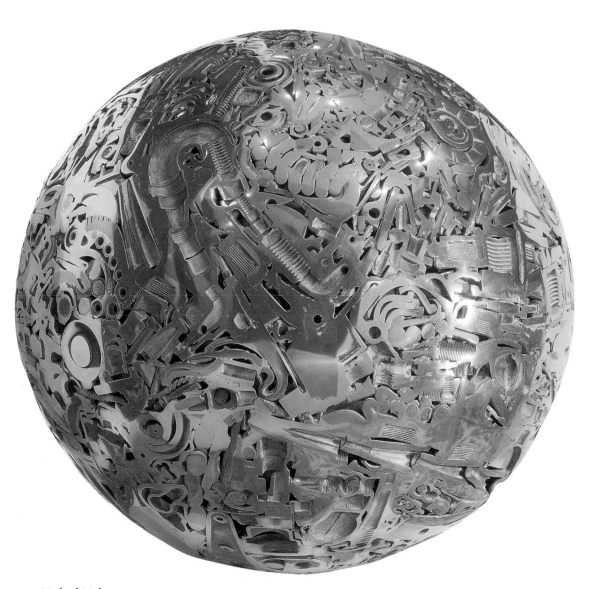

Michael Malpass • Newtonian Sphere III • 1989. Bronze, brass, copper, and silver, 28" diameter

27

III.

Most of the work in this collection was made by modern artists, men and women who have appeared in the latest stage of the long journey from the walls of Lascaux and Altamira. They have one apparent advantage over those earliest artists: they know their predecessors' works, if only through what André Malraux called the Museum Without Walls, that extraordinary collection of the world's art available in reproduction. Everything is the artist's property, every style, every tradition. Most often now, artists go to an art school and are given degrees after completing their studies, just like economists or lawyers or businesspeople. In school, they study craft. They study history. They are not forced to submit to the rigorous apprenticeship of the Renaissance guilds. In most cases, they do not starve in a Left Bank garret. And except for purposes of publicity, they are no longer romantic outlaws. Since the late 1950s, as Harold Rosenberg and others have pointed out, the audience for art has changed; the middle class, once so despised by Western artists, has accepted the work of the avantgarde; the very rich, and institutions, still buy it by the acre and the pound.

Modern artists can now sift through most of the work of the millennia, to be enriched, challenged, or disheartened by what they see. They can study the draftsmanship of Botticelli or Hokusai, peer at the colors of Turner or Rothko, marvel at the mastery of Rembrandt or Brancusi. In the course of a single afternoon, they can travel from Donatello to David Smith. They can see how great artists, from Picasso to Pollock, met the challenge of photography. They can trace in elaborate detail the careers of the twentieth century's greatest masters. They can sample the endless theorizing that has accompanied each new turn in art's yellow brick road. In short,

they have the entire history of art to draw upon, to appropriate, to plunder. They also must deal with that history as jailer.

"Every intelligent painter carries the whole culture of modern painting in his head," Robert Motherwell said in 1977. "It is his real subject, of which everything he paints is both an homage and a critique." In a way, the Hechinger Collection illustrates the truth of that observation and its implications about the future. Here are a large number of artists, many of them young, most of them aware of the great packed history of art, confronting the problem of subject matter. To what, or to whom, do they make an homage? What should be the focus of their critique? Today, when there is no reigning style in American art, when all aesthetic monarchs are dead and there is a great democracy of styles, the issue of subject matter is more critical than at any time since the end of the Second World War.

For many artists—and for their potential audience—it is not enough to say that painting or sculpture is its own subject matter. Young artists *and* their audiences have been subjected to a bewildering assault of theories. These came in a feverish rush after the era of Abstract Expressionism and Pop Art (terms that were themselves so vague that they were used to describe the work of Franz Kline *and* Mark Rothko, Jasper Johns *and* Roy Lichtenstein). It was not enough for a young artist to master a difficult craft and raise it to art. He or she was expected also to navigate through the reefs of theory. What were the differences between Formalism and Minimalism? Why was Hard Edge an advance on the rugged gestures of the Action Painters? Was Color Field an organic evolution from Pollock? And what about Art Brut, Arte Povera, Earth Art, Conceptual Art, and God help us all, Performance Art? Was everything art? When a man who called himself an artist ordered coffee, was *that* art? And how could a young woman choose between Neo-Expressionism and Neo-Geo?

Or Realism, Neo-Realism, Photorealism, and Naturalism, not to mention New Objectivism and Representationalism? If I am young, talented, and hip, do I make an installation or a video? Or do I rent a bulldozer from John Deere and carve signs in the naked countryside? There is horror in the world: Do I follow Sue Coe and Leon Golub in the assault on injustice? Or am I a Deconstructionist, obliged to reveal the hidden meanings of my "texts"? Am I a semiotician reducing my art to a series of signs? If the signs can be read, am I selling out? And what if the whole enterprise is empty Western arrogance, a meaningless shuffling of words? Shall I bow to Jean Baudrillard, engage in forgery, explain that the work is a glorious appropriation, and describe myself simply as a Postmodernist? Quick, Henry: the simulacrum.

Pluralism and egalitarianism were triumphant in the wake of the social upheavals of the 1960s, but so was confusion. Too many artists ruined themselves trying to stay ahead of the curve. Fashions seemed to shift every autumn, and in the 1980s there were fortunes to be made by those with gifts for changing styles the way some changed clothes. Other artists made harder decisions: to go their own way. They ignored the heart-numbing obscurities of theory. They turned their backs on the winds of fashion. They made art. They refused to be driven by the audience or the gallery owners or the museum directors; first and foremost, they made art for themselves. If it did not give them pleasure, it would do nothing for anyone else. The lesson of Picasso, who had made so much of twentieth-century art possible, remained true. "When we love a woman we don't start measuring her limbs," he said in 1935. "We love with our desires—although everything has been done to try and apply a canon even to love."

Among the many things of the world that have excited artists' desire are those extensions of hand and mind called tools. No canon can explain—or codify—their enduring attraction to human beings. They are at once instruments of work and of play. In many ways, a trip through a hardware store resembles a visit to an art supply store, and both are adult versions of the toy stores of childhood. The objects on display first stimulate the imagination. Visitors look at a tool—an electric drill or a sable brush—and in their minds they begin making things, or repairing them, or improving them. They erect imaginary bookshelves, make marks on canvas or paper, add struts to furniture, invent sculptures twenty-seven stories high. They lift the tools. They handle them, heft them, examine them, and yes, fondle and caress them. Sometimes they take them home. The objects are given special places in workshops or studios. They are used. Sometimes they make tables.

And yes, sometimes they make art. As they began to do 30,000 winters ago, when people roamed the world and for the first time used flint to adorn their stone axes. The art in this book is above all an art of continuity. It tells us something about who we are, and where we have come from. It even suggests, with a smile or a whisper, where we might be going.

The Plates

David Stromeyer • *Tool de Force* • *1983. Painted steel, 12'6" x 17' x 17'6"*

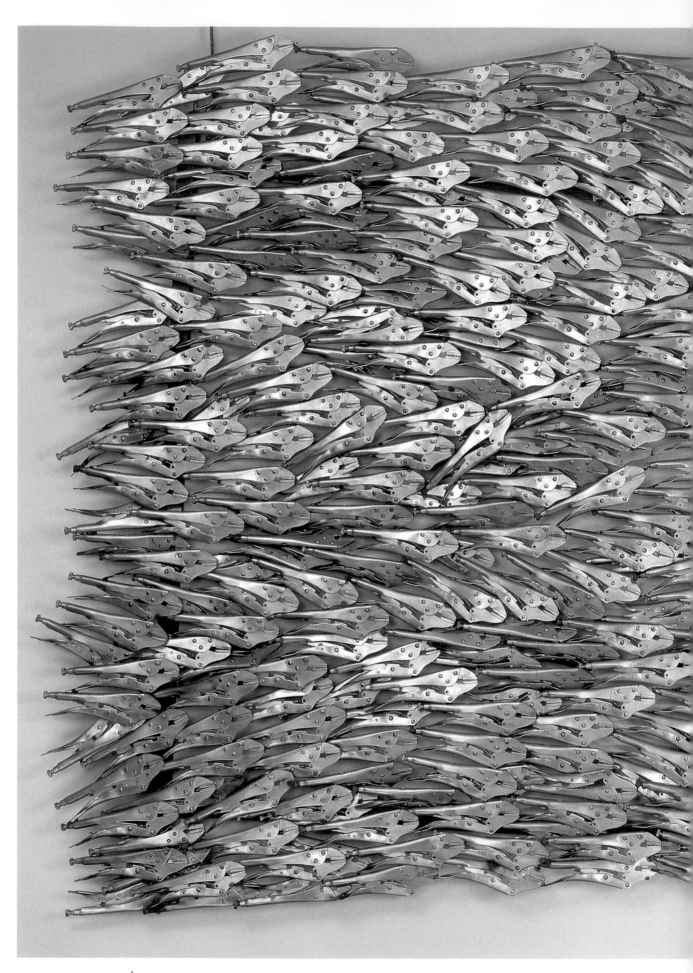

Arman • *School of Fishes* • *1982. Welded steel and visegrips, 64 x 96 x 3"*

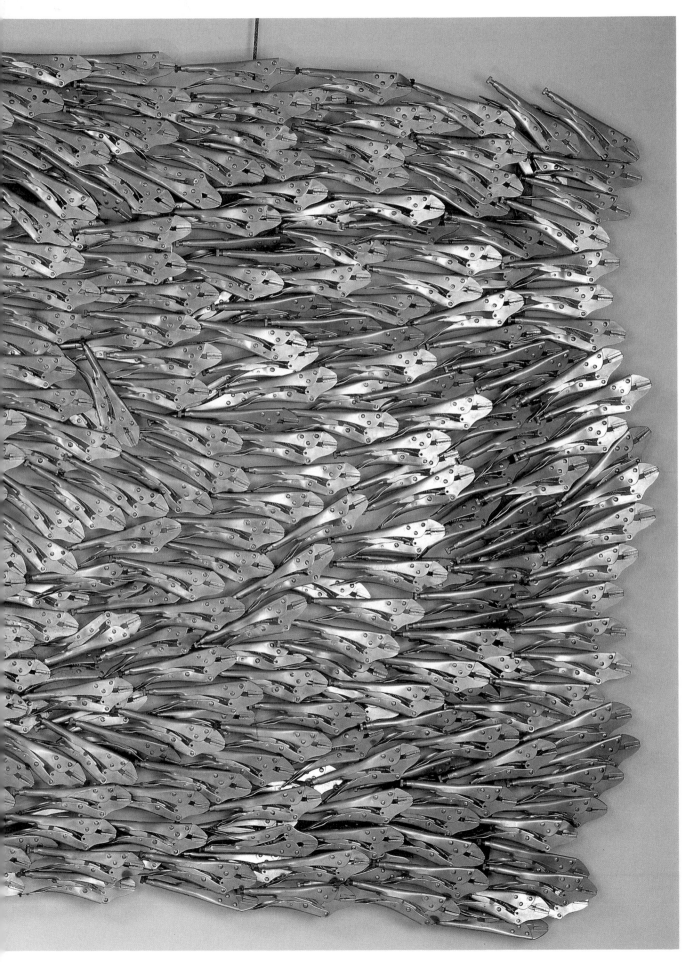

F. L. Wall • *Summer Tool* • *1983. Oak, 41 x 18 x 16"*

Opposite: **Arman** • *Jaws* • *1984. Welded steel and saws, 82 x 72"*

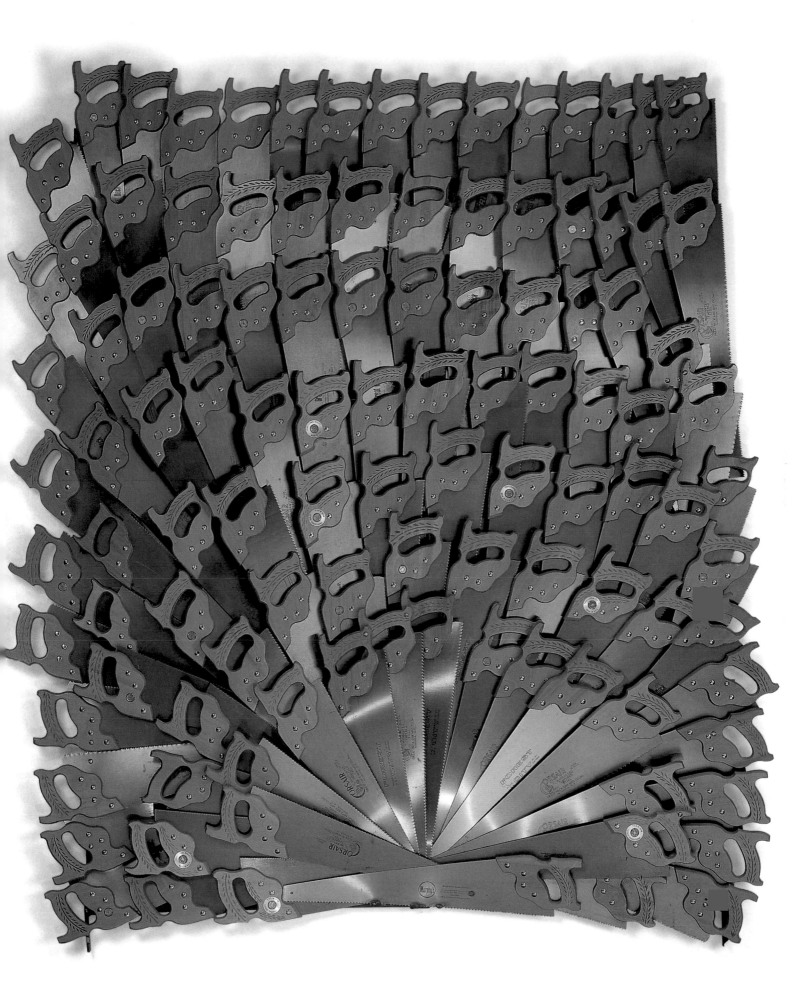

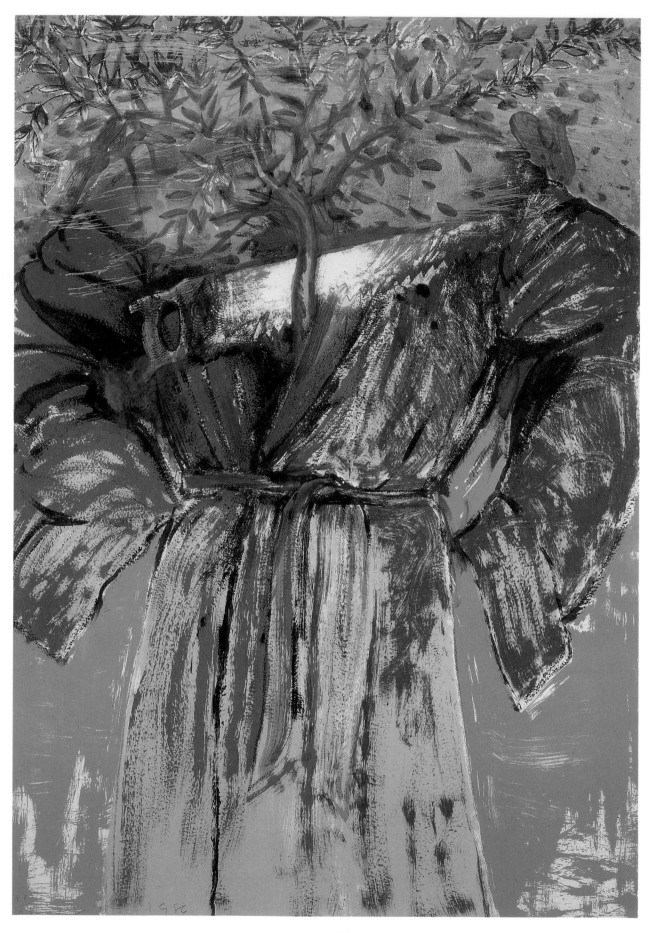

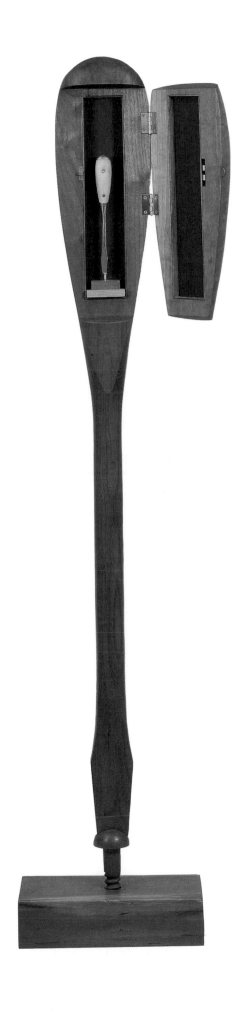

Opposite:

Jim Dine
• *Atheism* • *1986.*
Hand-colored lithograph,
68 x 47"

Right:

F. L. Wall
• *Screwdriver* • *1979.*
Ash, cherry, mahogany,
and walnut,
22 x 10 x 66"

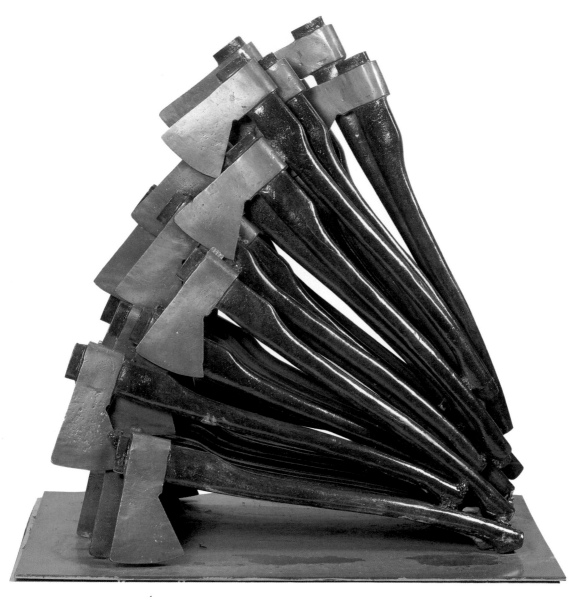

Arman • *Avalanche* • *1979. Cast bronze, 33 x 29 x 19"*

Opposite: **Jean Tinguely** • *Tools 85* • *1985. Motor-driven construction of hardware and tools, 36 x 24"*

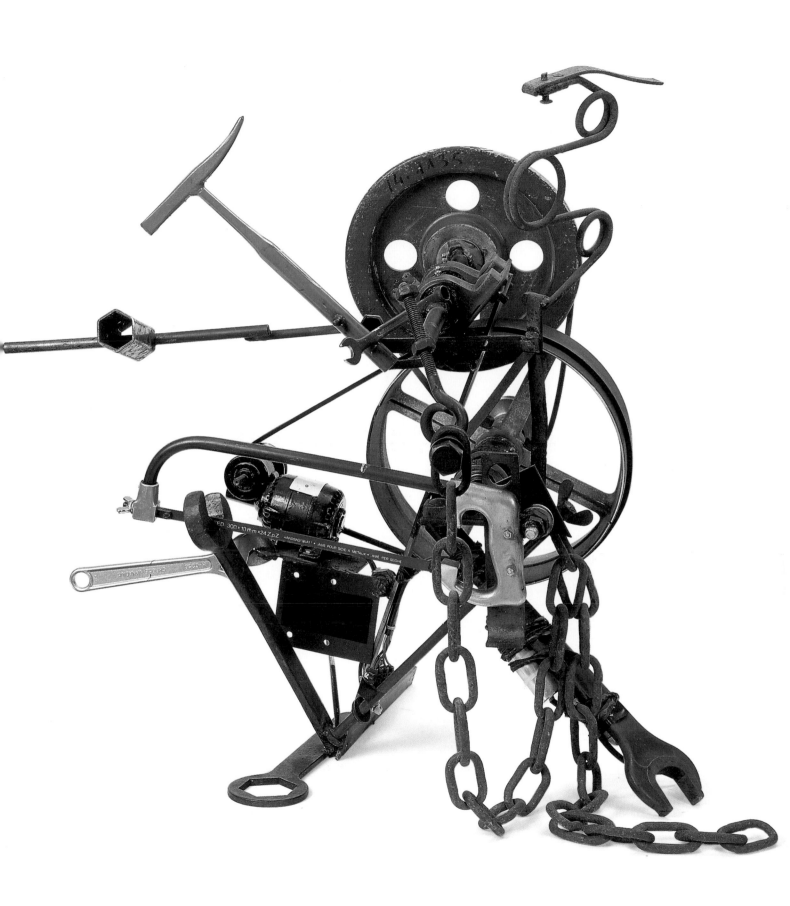

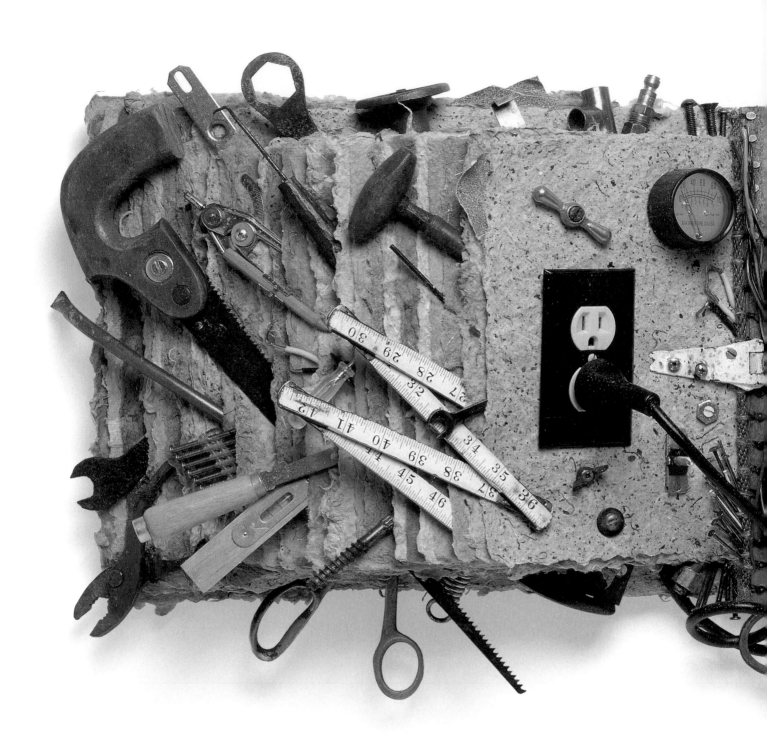

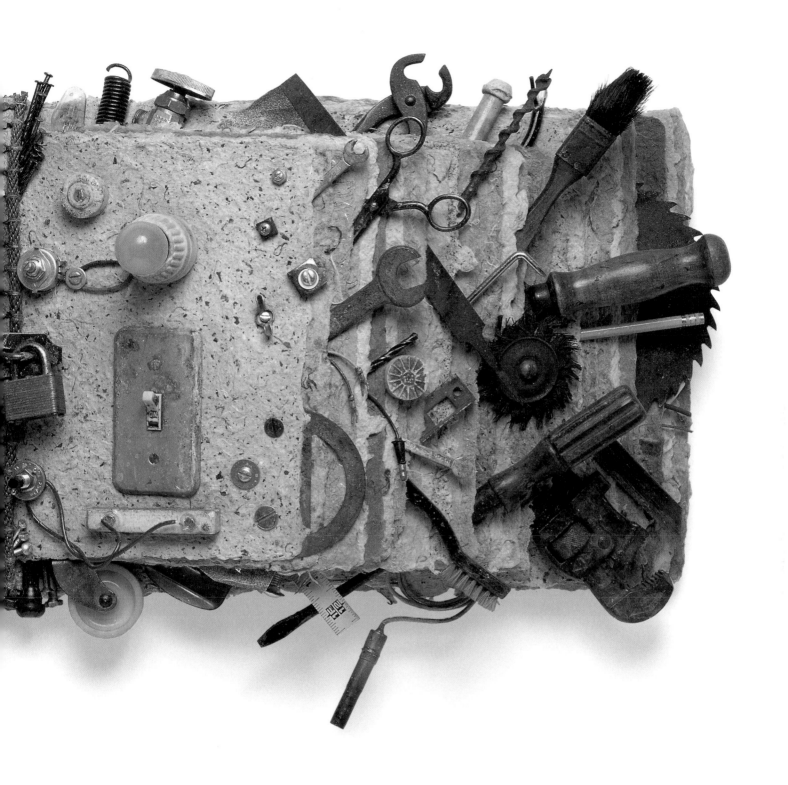

Colleen Barry-Wilson • *Tool Dictionary* • *1987. Handmade paper and hardware, 17 x 32 x 3"*

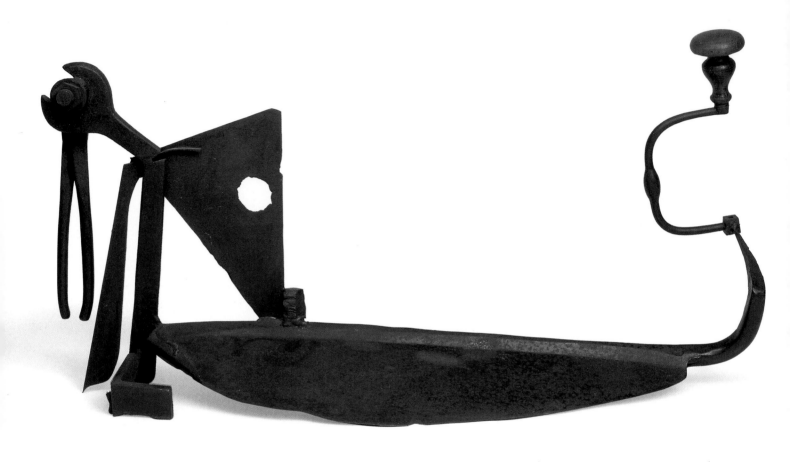

Anthony Caro • *Writing Piece "Spick"* • *1978. Wood and steel, 19 x 37 x 9 ½"*

Opposite: Oleg Kudryashov • *Two-Hand Saw* • *1979. Drypoint construction, 72 x 24"*

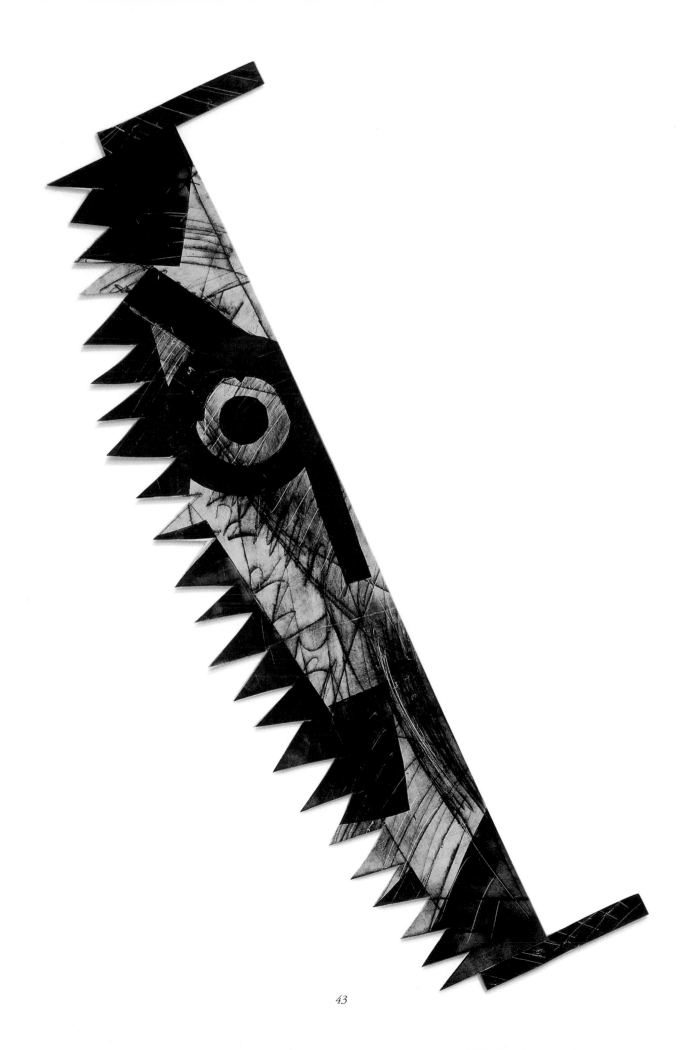

43

Hans Namuth

Right • Jack Plane • 1975.
Gelatin silver print, 12 x 17"

Below • Drill • 1975.
Gelatin silver print, 17 x 12"

Opposite top • Bow Saw • 1975.
Gelatin silver print, 12 x 17"

Opposite bottom • Cooper's Windlass •
1975. Gelatin silver print, 17 x 12"

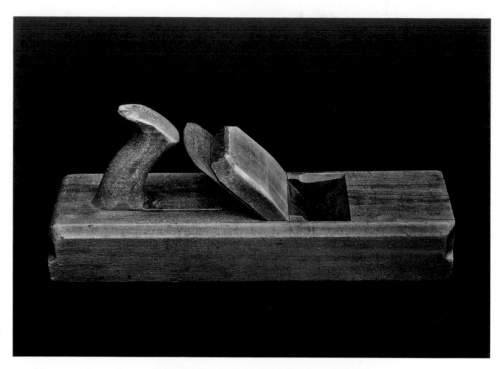

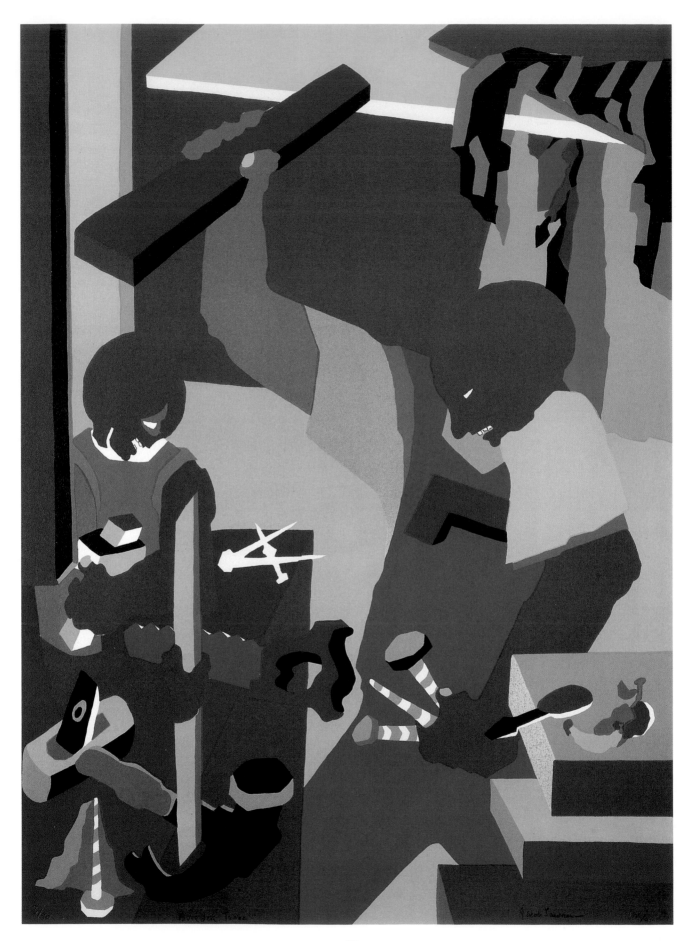

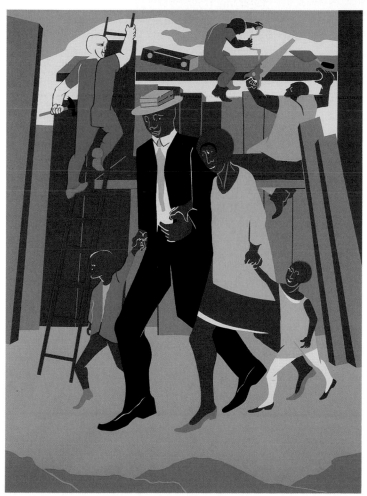

Jacob Lawrence

Opposite:
• *Builders Three* •
1991. Lithograph, 30 x 22"

Above:
• *Carpenters* •
1977. Lithograph, 18 x 22"

Left:
• *The Builders* •
1974. Lithograph, 34 x 25 ¹⁄₄"

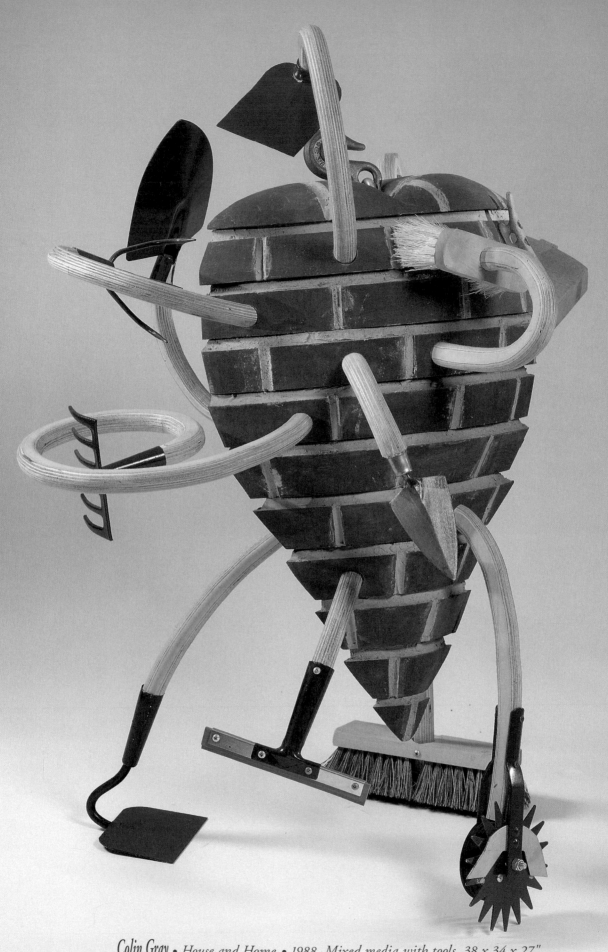

Colin Gray • *House and Home* • *1988. Mixed media with tools, 38 x 34 x 27"*

Opposite: Daniel Mack • *Chair Maker's Chair* • *1989. Mixed media including sugar maple and tools, 54 x 21 x 14"*

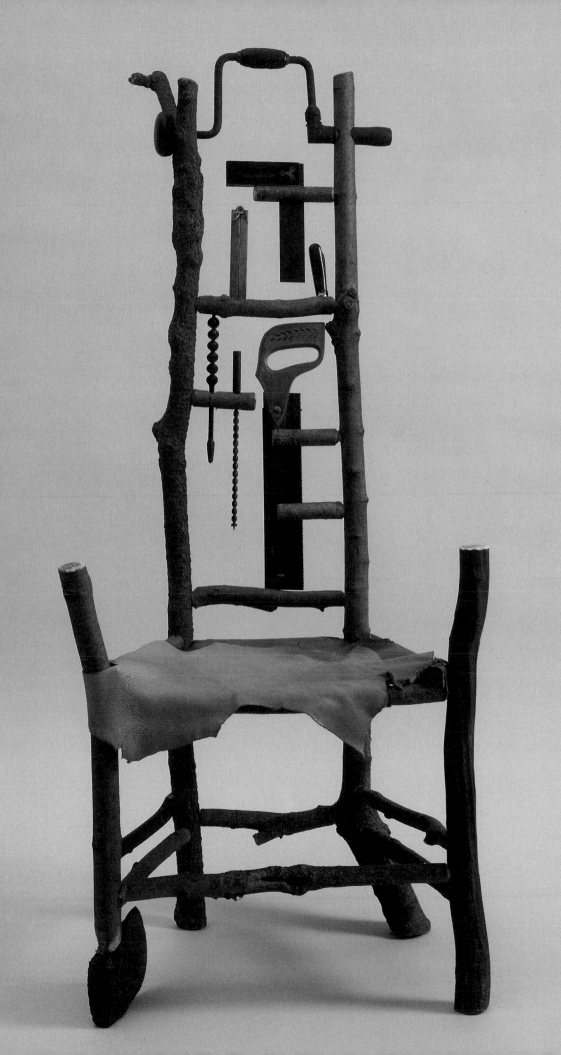

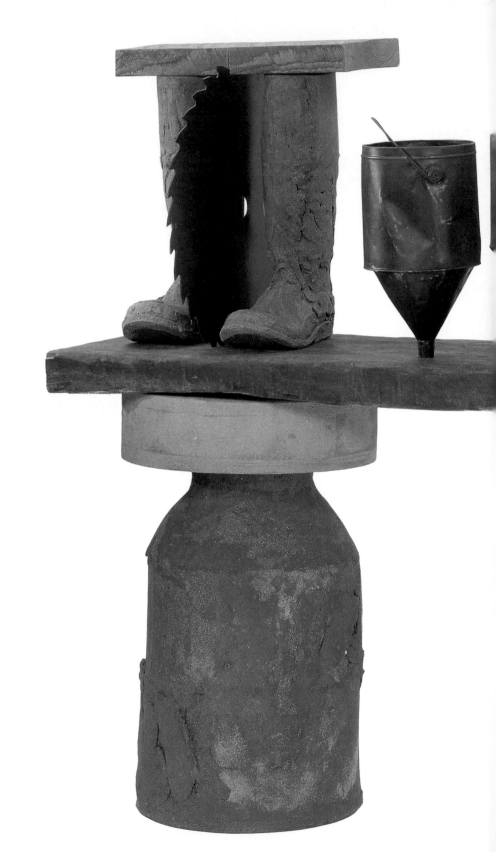

Tony Hepburn • *Work Bench* •
1988. Clay, wood, metal, and
circular saw blade, 58 x 84 x 20"

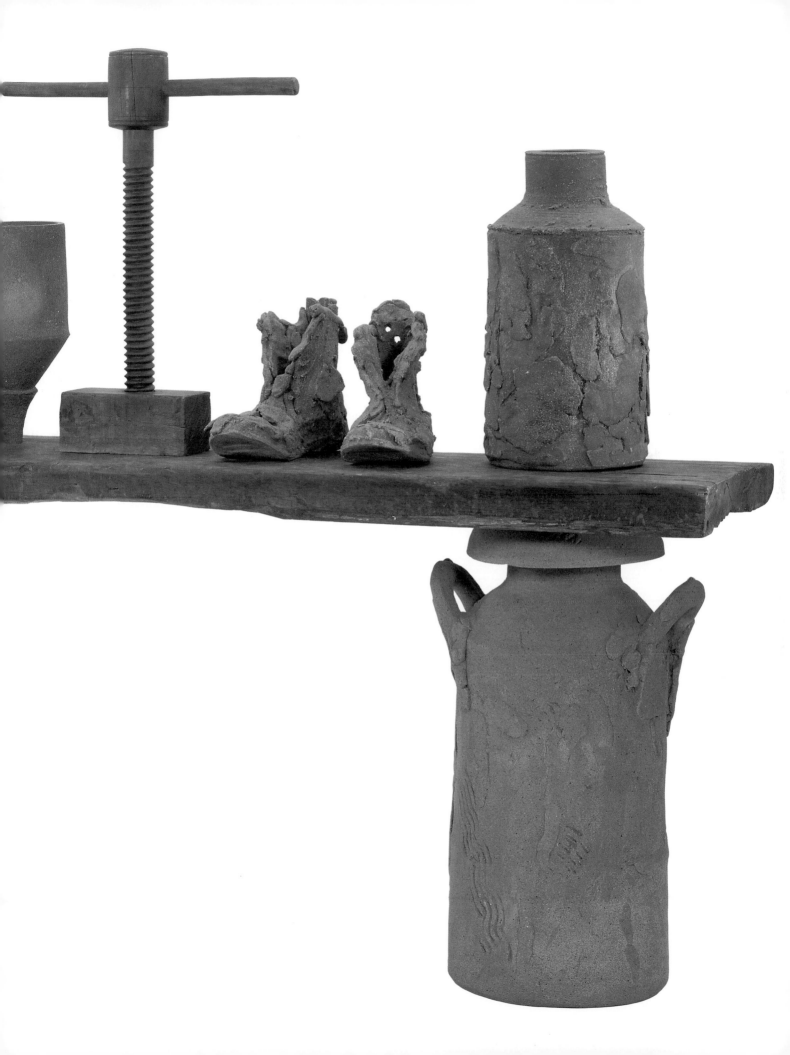

James Surls • *Rebuilding* • *1991. Carved and burned magnolia wood, 36 x 29 x 29"*

Opposite: Graham Crowley • *The Clampdown* • *1983. Oil on canvas, 60 x 48"*

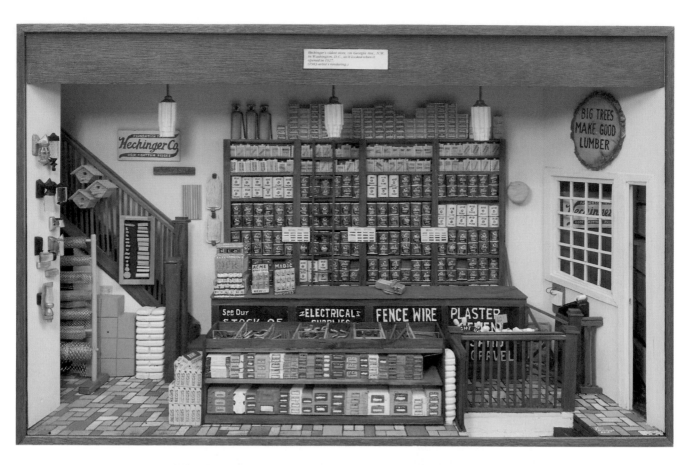

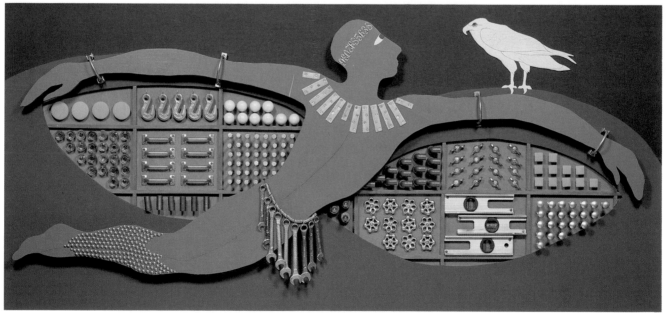

Top: **Jim McCullough** • *Hechinger Georgia Avenue Store in 1927* • *1983. Mixed media, 31 x 20 x 6"*

Above: **Maria Josephy** • *Prometheus* • *1980. Mixed media including hardware, 79 x 36"*

Opposite: **Roy Superior** • *Mr. Goody Two Shoes' Tool Shed* • *1989.*
Mixed media construction including wood, bone, and brass, 32 x 18 x 13 ¹/₂"

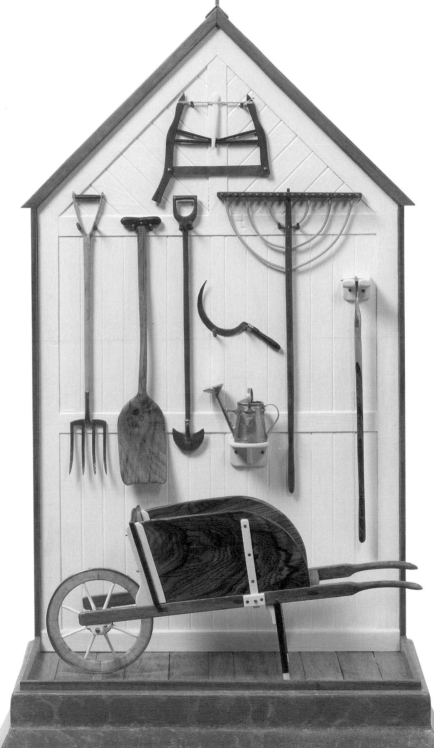

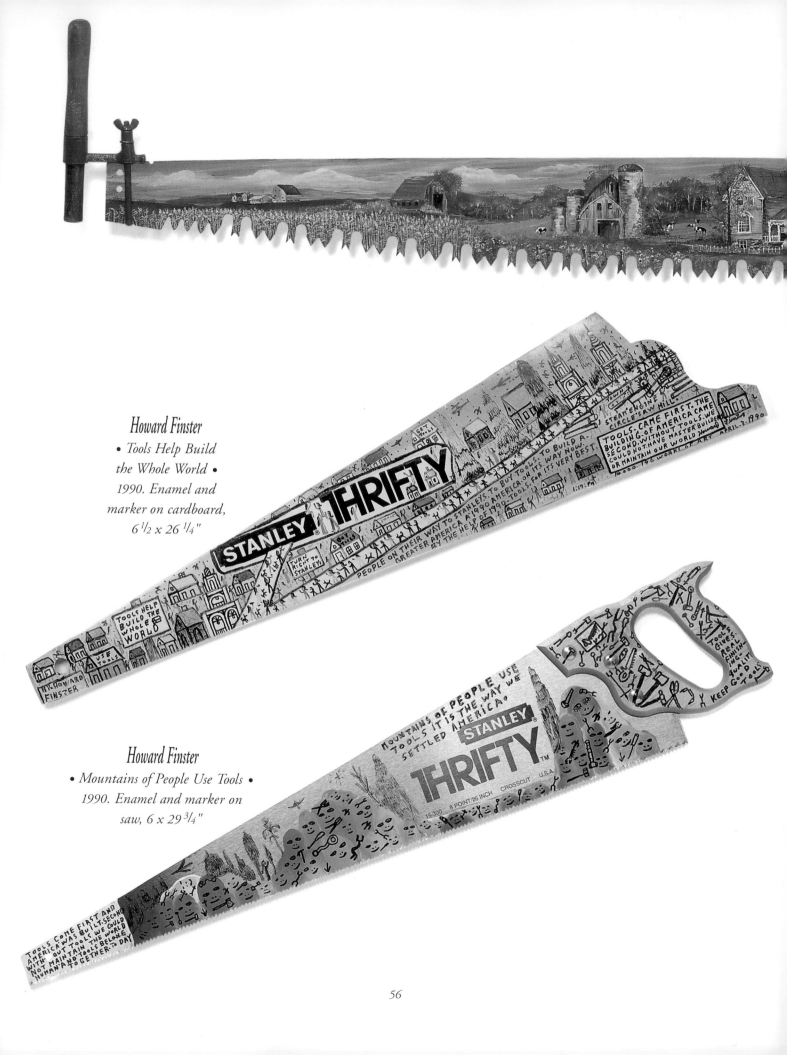

Howard Finster
• *Tools Help Build the Whole World* •
1990. Enamel and marker on cardboard,
6 ¹/₂ x 26 ¹/₄"

Howard Finster
• *Mountains of People Use Tools* •
1990. Enamel and marker on saw, 6 x 29 ³/₄"

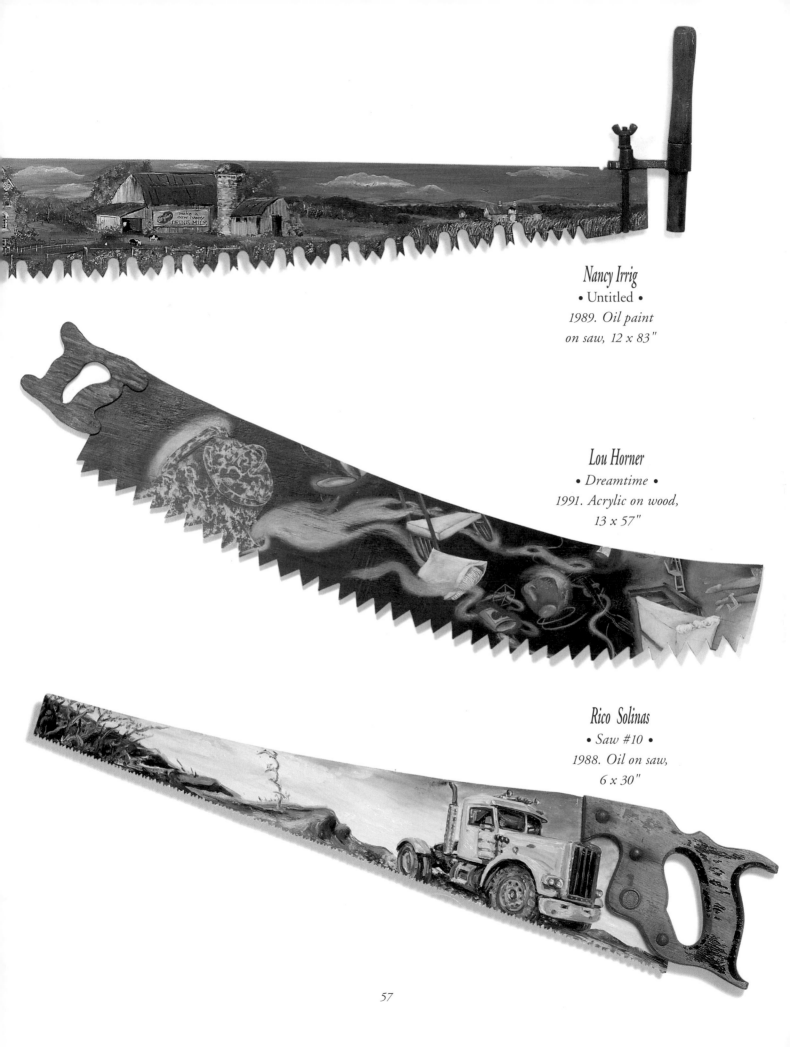

Nancy Irrig
• Untitled •
*1989. Oil paint
on saw, 12 x 83"*

Lou Horner
• Dreamtime •
*1991. Acrylic on wood,
13 x 57"*

Rico Solinas
• Saw #10 •
*1988. Oil on saw,
6 x 30"*

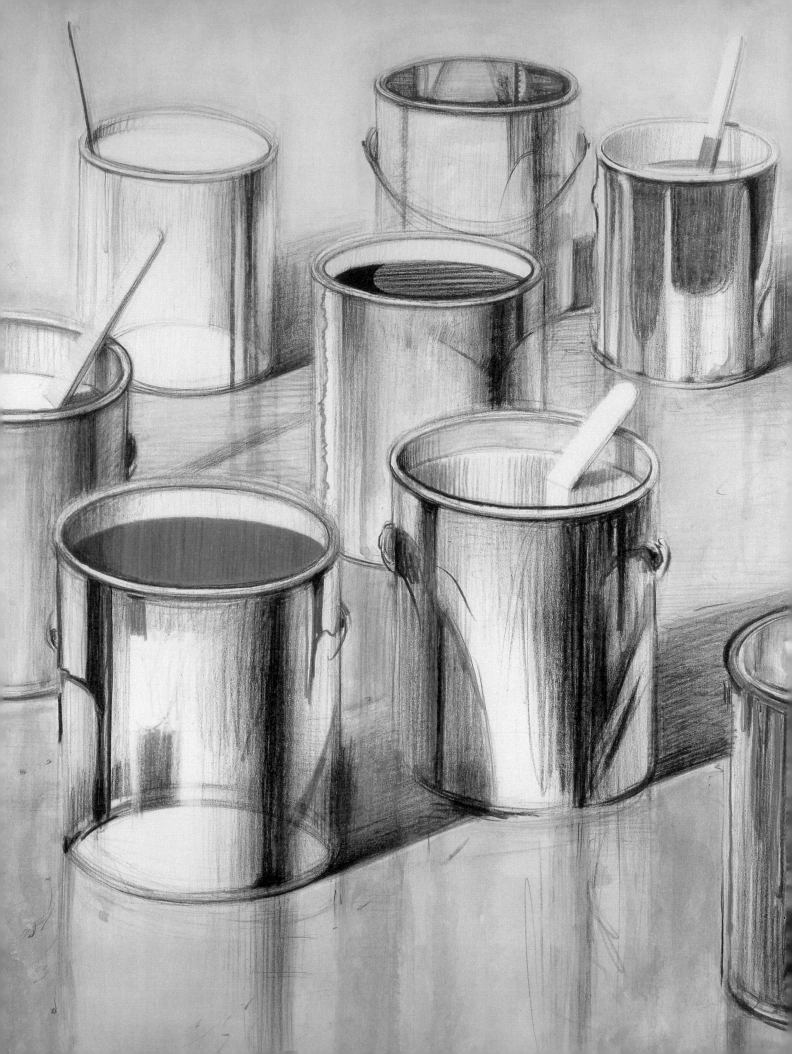

Charlie Brouwer
• *Now the Lord God Planted a Garden....* •
1992. Treated and stained wood, 72 x 50 x 6"

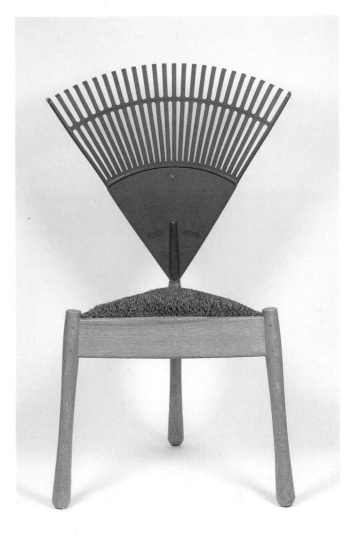

Lee A. Schuette
• *Rake Back Chair #2* •
1981. Oak, synthetic grass, and rake,
35 x 21 x 17"

Opposite: **Wayne Thiebaud** • *Paint Cans* • *1990. Lithograph, 39 x 29"*

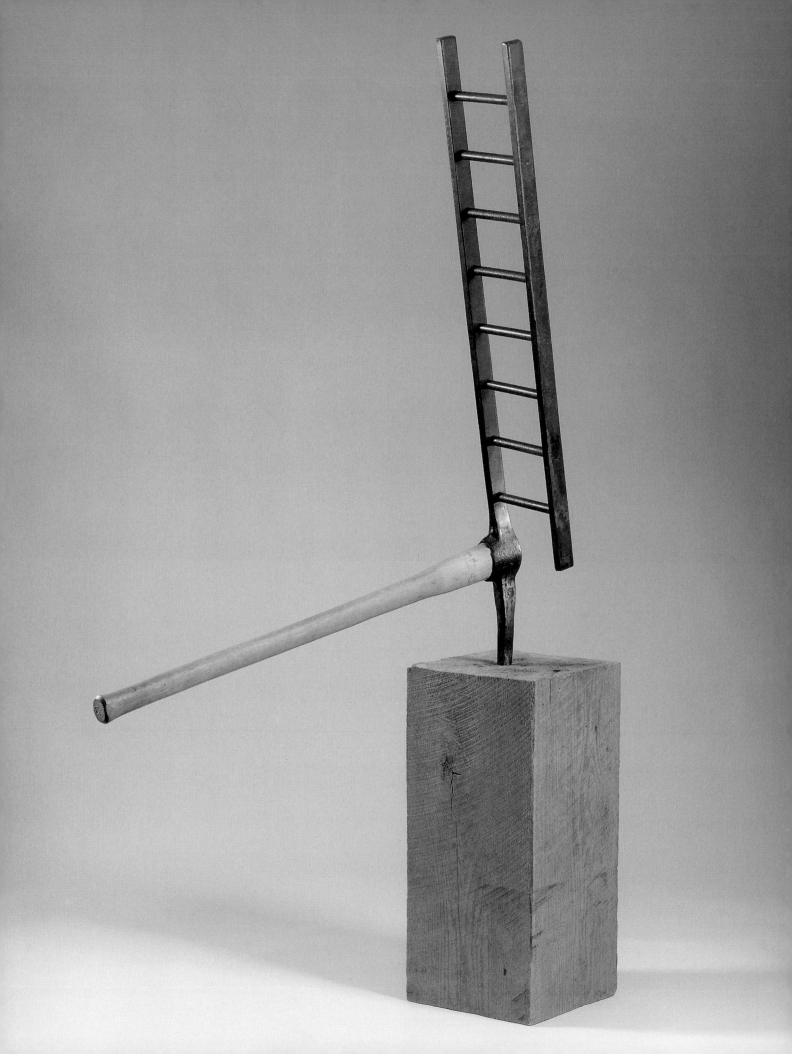

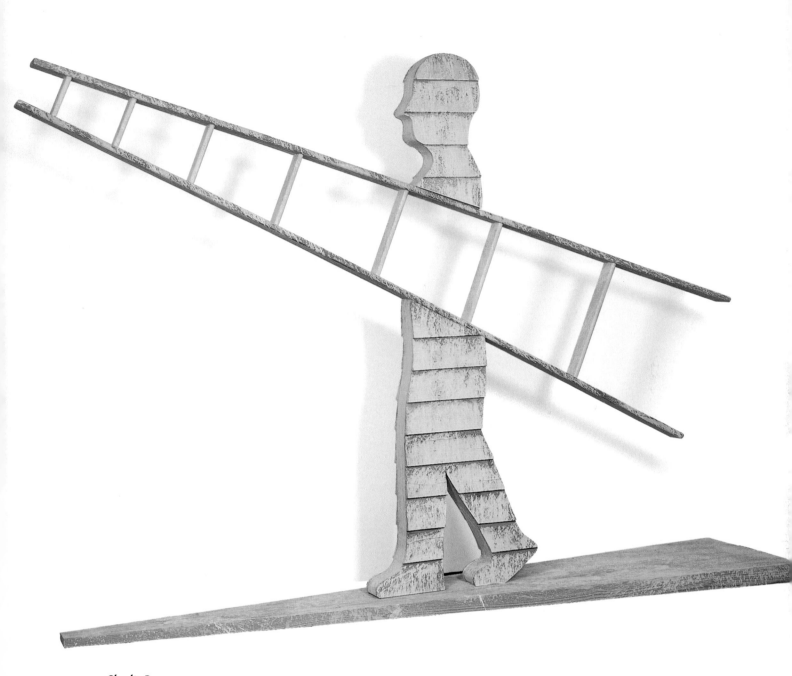

Charlie Brouwer • He Always Carried His Own Ladder to the Job • 1989. Painted wood, 96 x 120 x 48"

Opposite: *Gary Kuehn • Ladder Piece • 1986. Steel and wood, 70 x 40 x 14"*

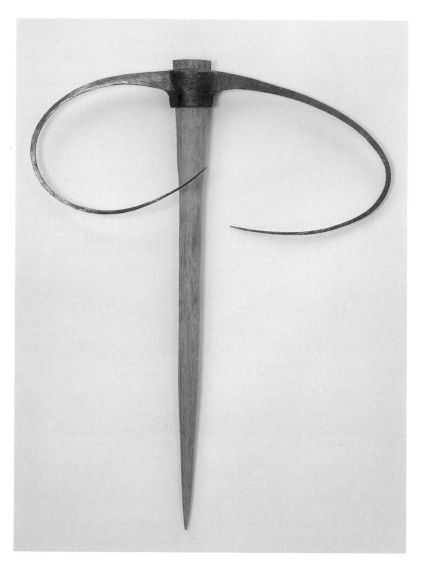

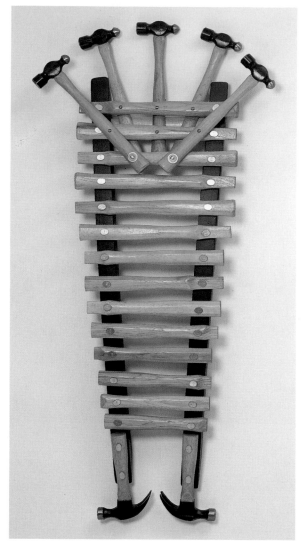

Above left: **Robert Wideman** • *Toothpick* • *1986. Steel and wood, 34 x 28"*

Above right: **Linda Thern-Smith** • *Phoenix* • *1987. Hammers and chair rockers, 44 x 21 x 6"*

Opposite: **Hugh R. Butt** • *The Long Road to Usefulness* • *1989. Painted steel and hardware, 57 x 31 x 8 ¹/₄"*

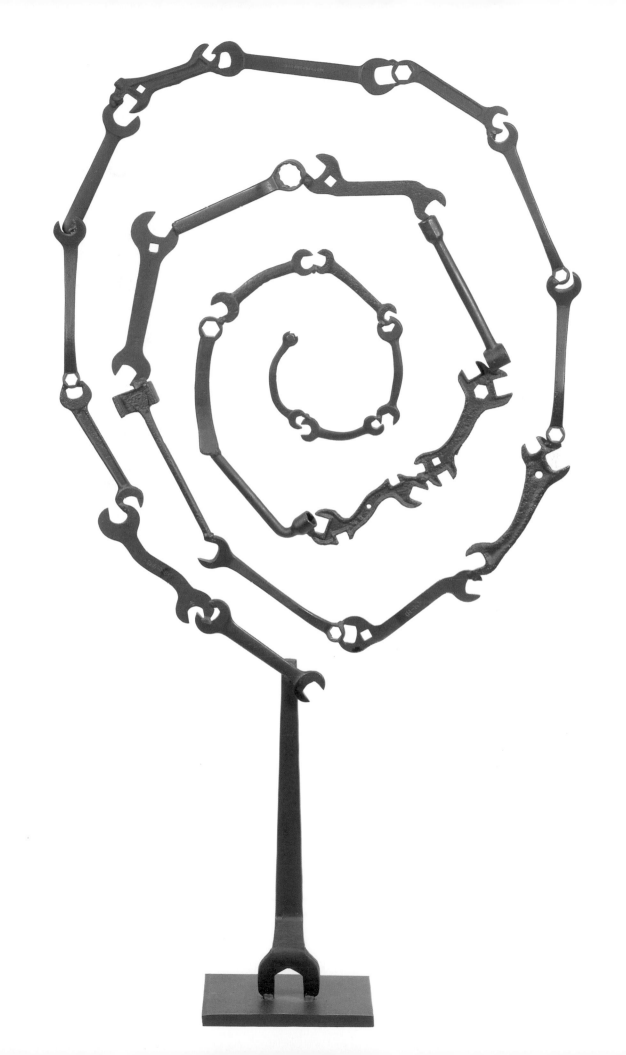

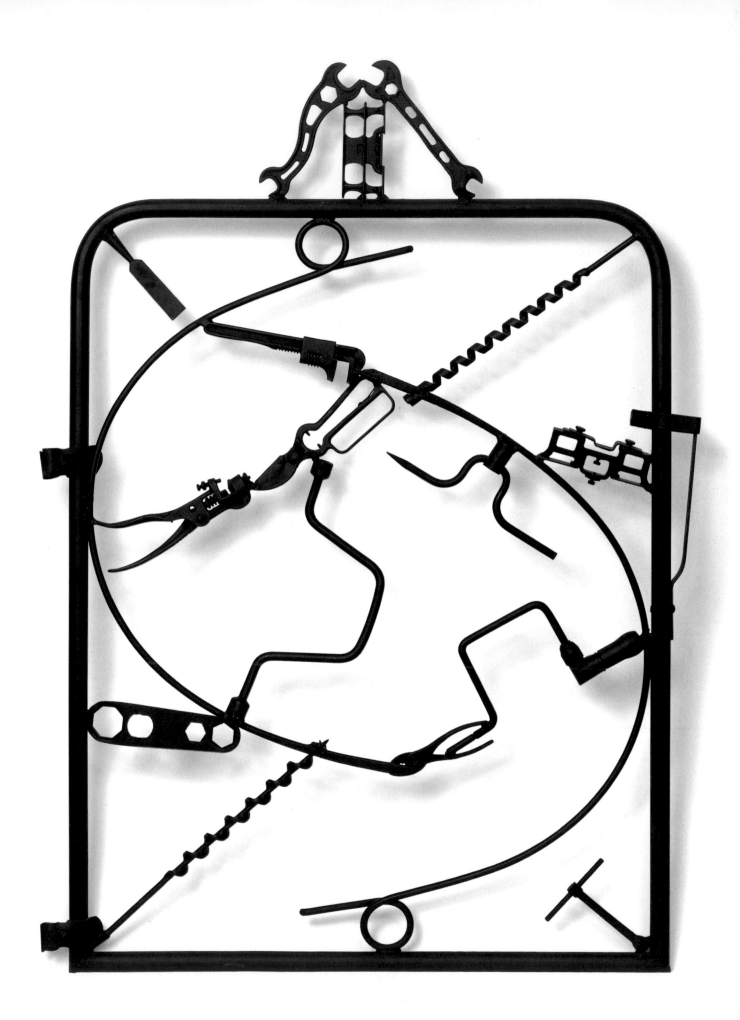

Hollis Sigler • *The Perfect Heart Is Only a Dream* • *1990. Oil pastel on paper, carved and painted frame, 33 x 39"*

Opposite: **Rod Rosebrook** • Gate • *1982. Wrought iron and hardware, 36 x 50"*

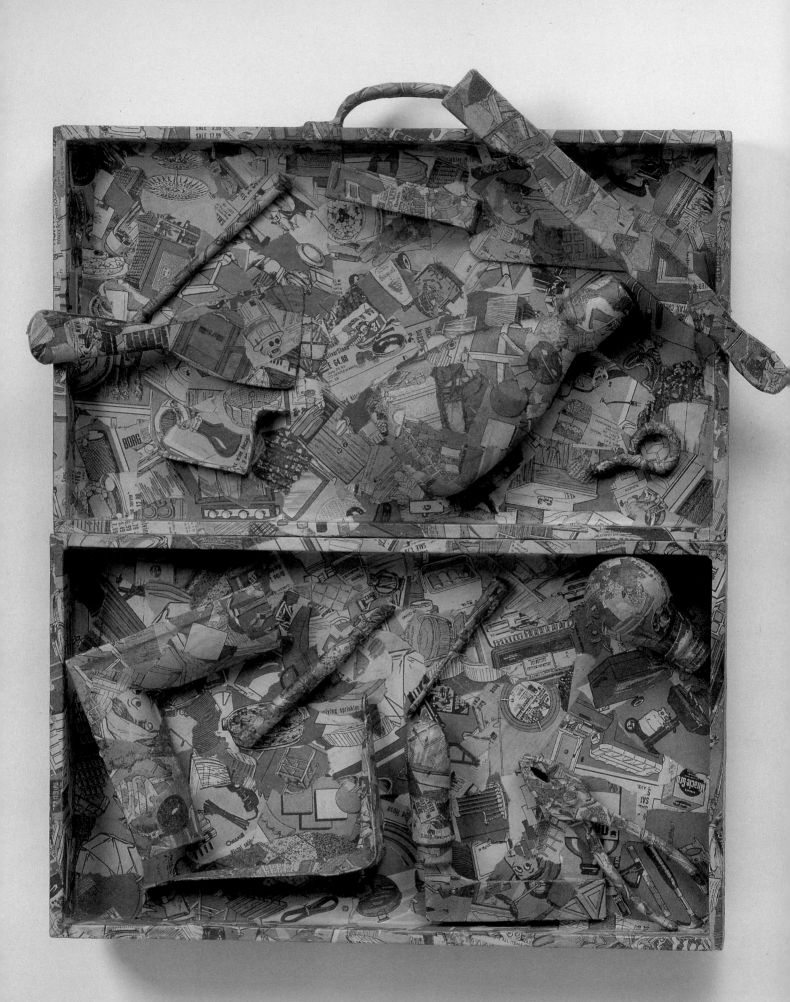

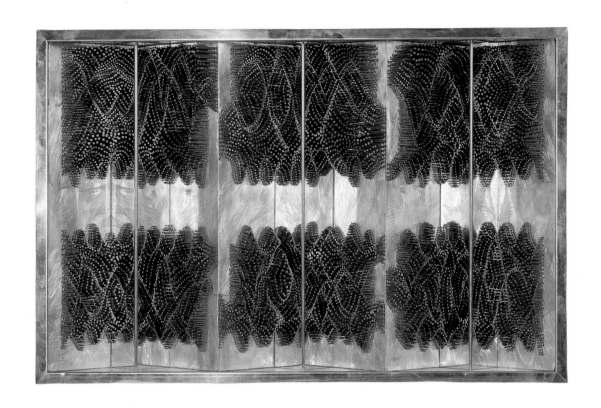

David Partridge • *Tri-Reflex* • 1983. Polished aluminum and nails, 17 x 25 ½ x 3 ½"

Opposite: Barton Lidicé Beneš • *Tools in Print* • 1983. Objects wrapped in newsprint, 20 x 24 x 4"

Pierre Flandreau • *Homage to Chester Arnold* • 1987. Painted bronze, 9 ½ x 14"

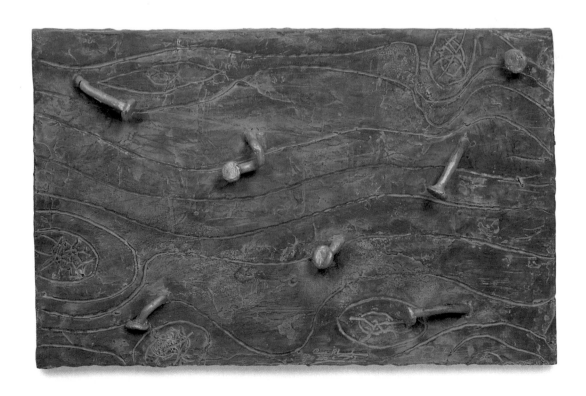

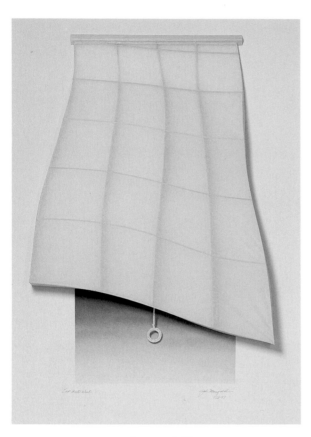

John Mansfield
• *East Meets West* •
*1987. Acrylic on paper
with rice paper and balsa wood,
46 x 34 x 6"*

Fred Nagelbach
• *Untitled, from "Turm" series* •
*1987. Corrugated galvanized tin and paint-
ed cedar shakes,
93 x 15"*

John Mansfield
• *Zen Saw II* •
1986. Rock, rice paper,
and balsa wood,
25 x 19 x 14"

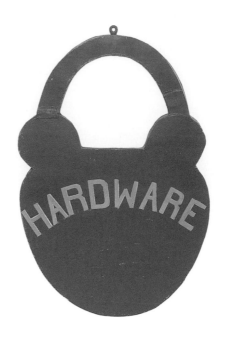

Artist unknown • Trade Sign •
c. 1880. Painted tin, 30 x 14 x 4"

Man Sui Au • Rust Series #13 • 1990.
Watercolor on paper, 11 x 15"

Jacqueline Conderacci

• *Locked Up and In and Out #16* •
1986. Type C print, 24 x 18"

• *Locked Up and In and Out #13* •
1986. Type C print, 24 x 18"

• *Locked Up and In and Out #24* •
1986. Type C print, 24 x 18"

James Drake • *Tool Room* •
1980. Welded steel,
96 x 144 x 96"

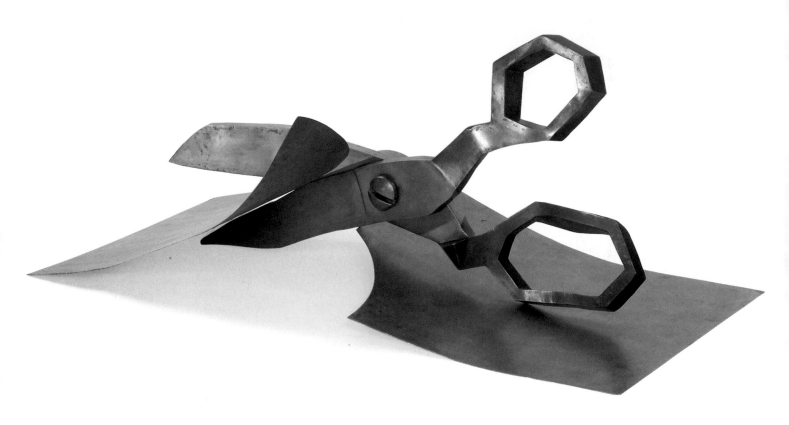

Christopher Plowman • Cut • *1986. Polished steel, 25 x 48 x 21"*

Opposite: **Leonard Koscianski** • *Needlenose Pliers* • *1979. Oil pastel on paper, 45 ¹/₂ x 34"*

Graham Ashton • *Instruments of Penetration—Tools of the Trade* • *1984. Watercolor on paper, 48 x 60"*

Opposite: **Bayat Keerl** • *Fatal Metal Mark #1* • *1979. Oil on photograph, 80 x 48"*

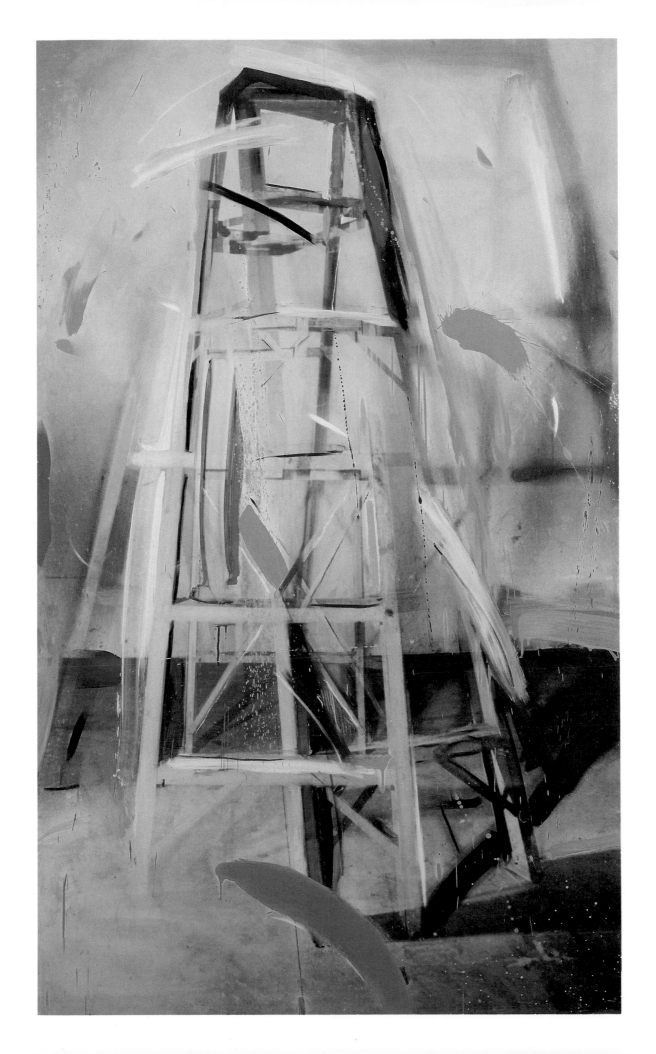

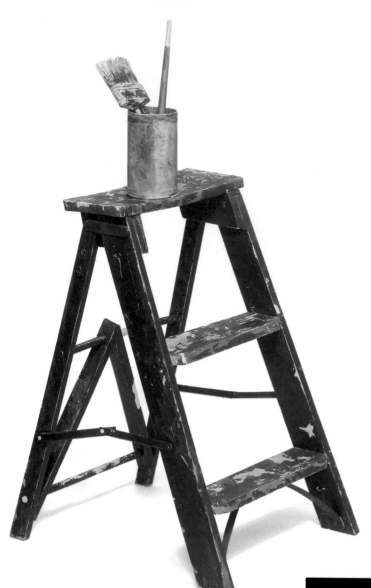

Pier Gustafson
• *Step Ladder with Can and Brushes* •
1982. Paper construction
with pen and ink,
38 x 20 x 18"

Hans Godo Frabel
• *Faucet (In the Middle of the Night)* •
1979. Glass,
10 ¹/₂ x 8 x 3"

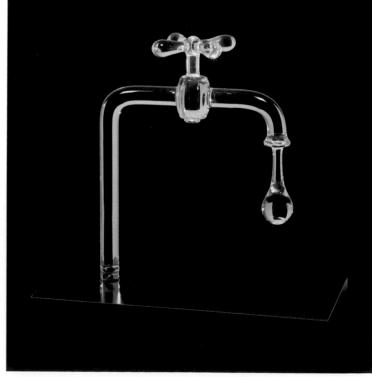

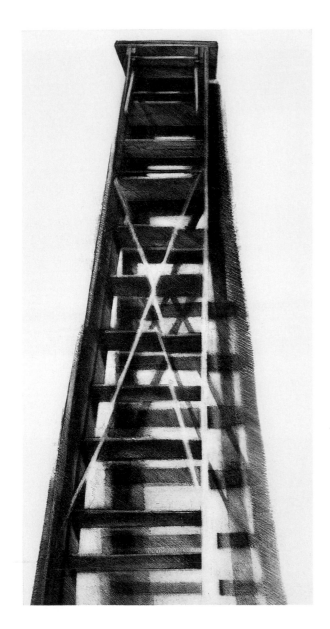

Michael Mazur
• *Ladder* •
*1974. Engraving
and aquatint,
41 x 24"*

Hans Godo Frabel
• *Light Bulb* •
*1979. Glass,
11 x 4¹/₂"*

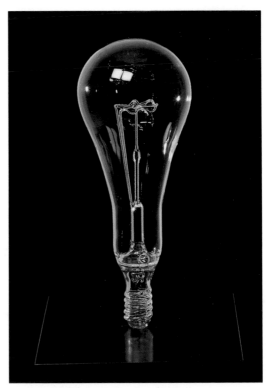

79

Bill Arnold • *Pickaxe* • *1984. Photogram, 20 x 40"*

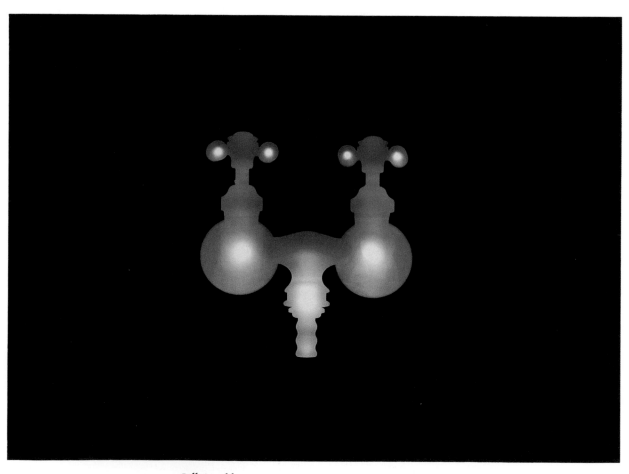

Bill Arnold • *Faucet* • *1984. Photogram, 19 x 23"*

Susan Firestone • *Smooth Cut* • *1987.*
Screenprint with intaglio, 12 ¹/₂ x 12 ¹/₂"

John Schlesinger • *Untitled (Hand/Eye)* • *1992.*
Gelatin silver print on circular saw, 19" diameter.

Barton Lidicé Beneš
• Hammer •
1982. Ceramic and paper,
20 x 14"

Jamie Davis
• Ginger Jar Vase •
1982. Ceramic,
16 ¹/₂ x 10"

Opposite:
Wim Delvoye
• Leontine •
1990. Enamel on
circular saw,
ceramic base,
18 x 15 x 6"

James Rosenquist
• *Trash Can in the Grass—Calix Krater* •
1978. Screenprint, 20 1/2 x 14"

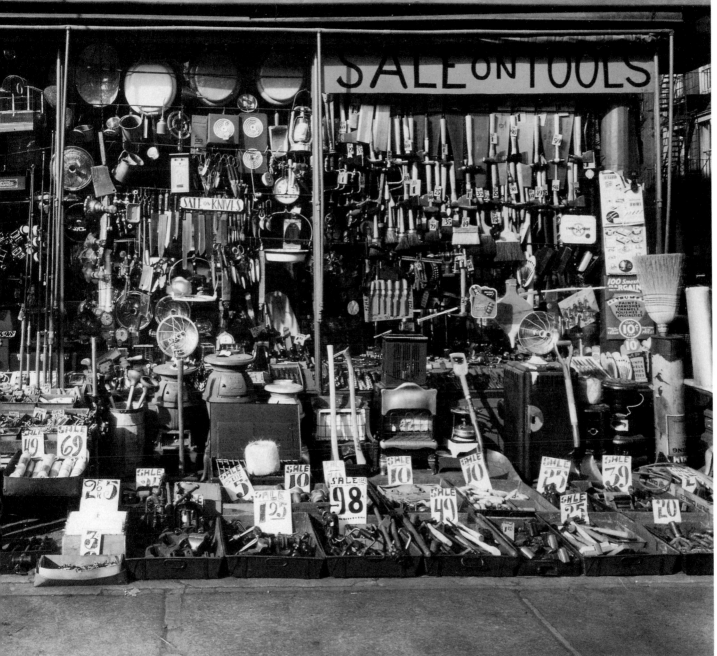

Berenice Abbott
• *Hardware Store* •
1938. Gelatin silver print, 10 ¹/₂ x 13 ¹/₂"

Berenice Abbott
• *Spinning Wrench* •
*c. 1958. Gelatin silver print,
4 1/2 x 19 1/2 "*

Walker Evans
• *Wrench (from "Beauties
of the Common Tool,"
Fortune, July 1955)* •
*1955. Gelatin silver print,
10 x 8 "*

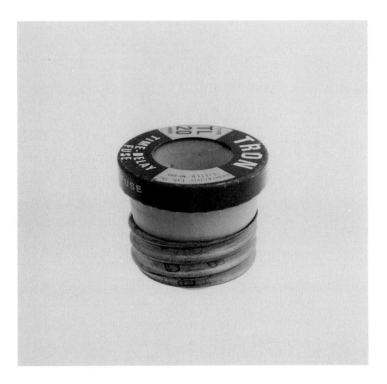

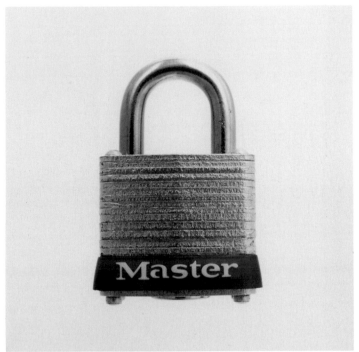

John McIntosh

• *Fuse* •
1989. Fujicolor HR print,
15 x 15"

• *Master Padlock* •
1989. Fujicolor HR print,
15 x 15"

• *Paint Brush* •
1989. Fujicolor HR print,
20 x 16"

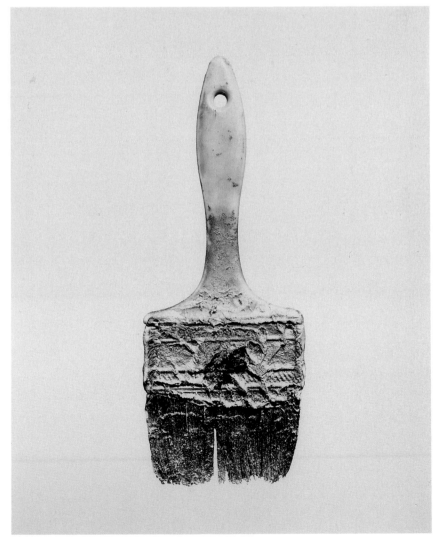

William Eggleston • *Near the River at Greenville, Mississippi* • *1986. Type C print, 16 x 20"*

Debbie Fleming Caffery • *Homer* • *1986. Gelatin silver print, 24 x 20"*

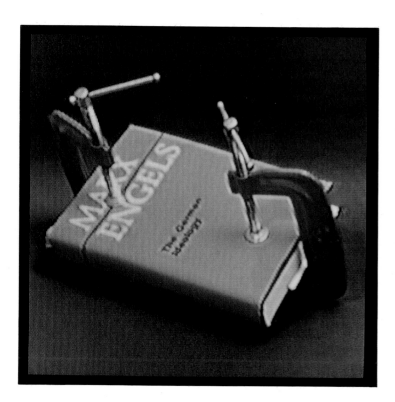

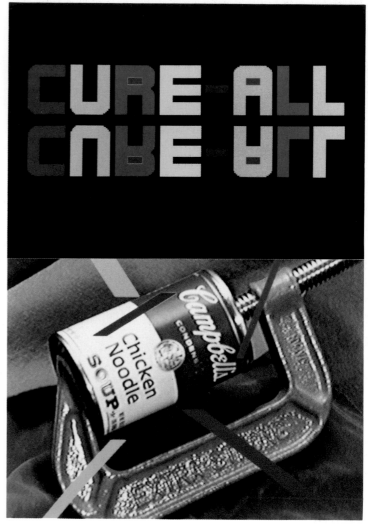

MANUAL • *Marx/Engels (German Ideology) from "Videology Series"* • 1984. Type C print, 18 x 18"

MANUAL • *Cure All* • 1987. Ektacolor print, 13 ½ x 9 ¼"

Opposite: Tom Barrow • *Heartbeat of America* • 1988. ER Polacolor print, 24 x 20"

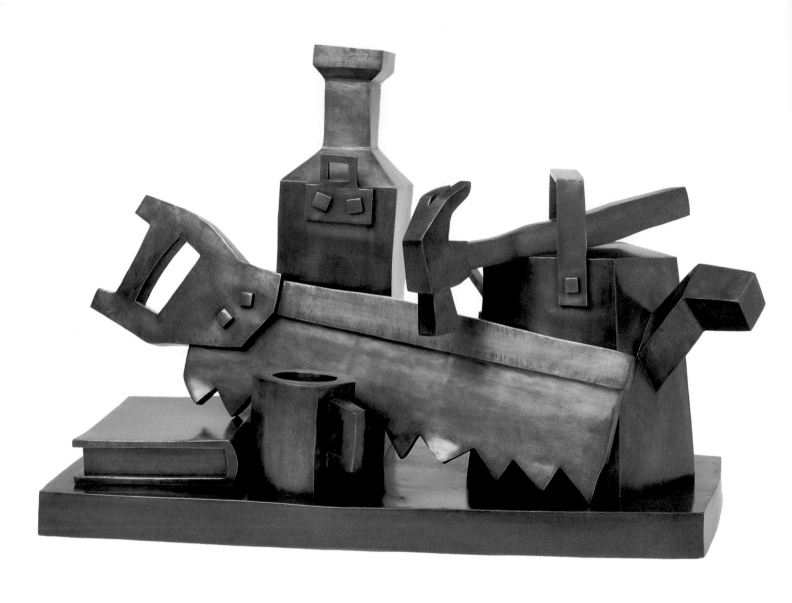

Christopher Plowman • *Still Life with Tenon Saw* • *1985. Varnished steel, 24 x 30 x 24"*

Opposite: **Fred Gutzeit** • *Glove Box* • *1982. Asphalt siding, spectral mylar, and work gloves, 41 x 32 x 4"*

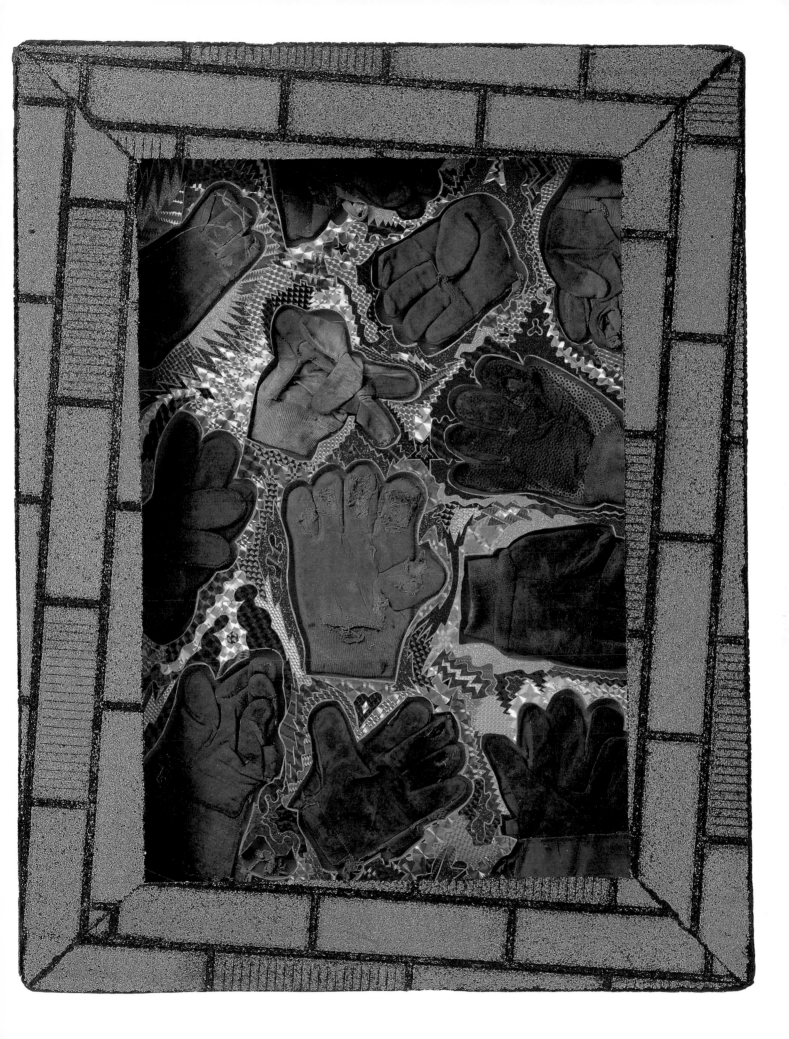

Dies de Jonge
• *Brush and Tub* •
1982. Wood,
14 x 6"

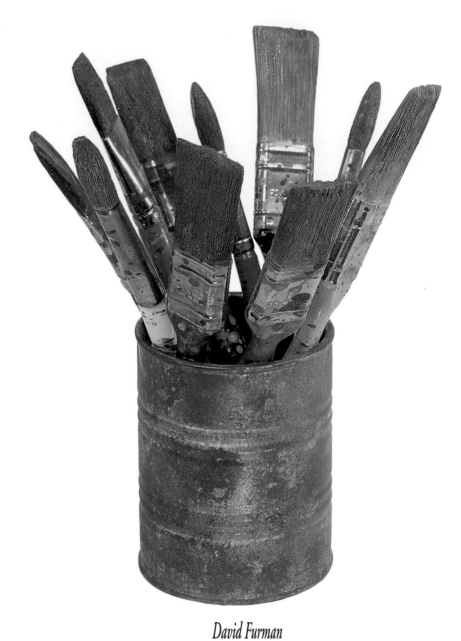

David Furman
• *Paint Brush Bouquet* •
1989. Glazed and enameled ceramic,
8 ½ x 7"

Opposite: **Phyllis Yes**
• *Paint Can with Brush* •
1981. Mixed media with paint
can and brush, 9 x 11"

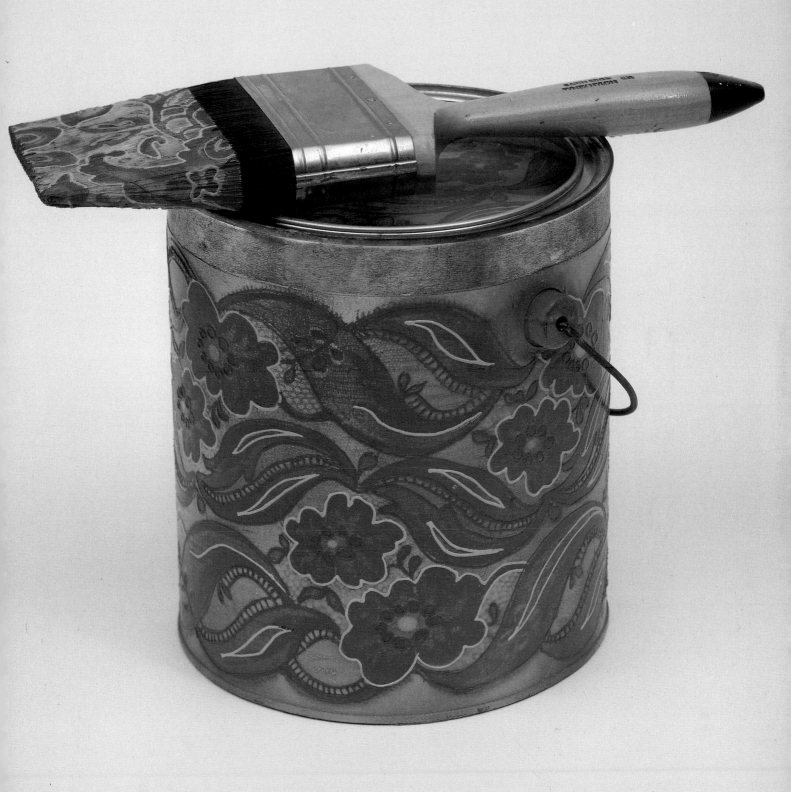

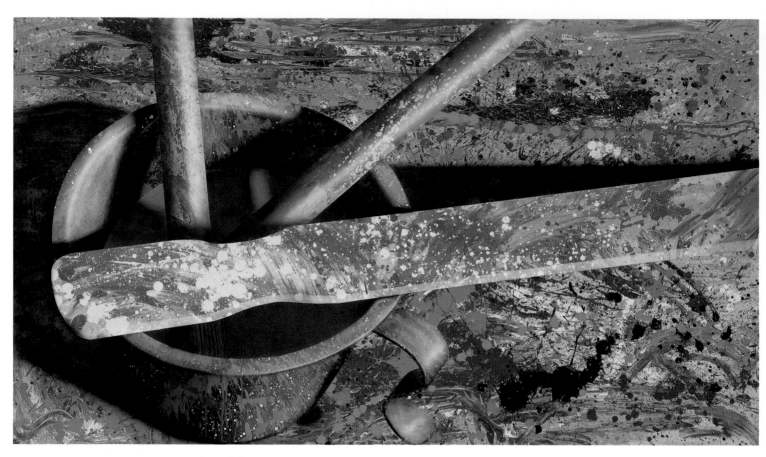

Oscar Lakeman • Containers #222 • 1987. Acrylic on canvas, 41 x 72"

Arman • *Still Hungry* • *1979. Bronze-plated wrenches, 15 x 17 x 8"*

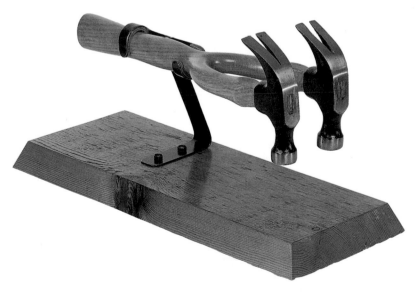

Vladimir Salamun • *Siamese Hammer Joined at the Handle* • *1982. Red oak and claw hammer heads, 6 x 14 x 6"*

Bill Wilson
• *Pliers and Nail* •
1987. Painted wood, 35 x 10"

Maria Porges
• *Homonymous* •
*Mixed media with
hatchet handle, 17 x 8"*

Opposite:
H. C. Westermann
• *The Slob* •
*1965. Hammer, nails,
and aluminum,
22 x 4 1/2 x 4 1/2"*
*© 1995 Estate of
H. C. Westerman/Licensed
by VAGA, New York*

Mr. Imagination • *Paintbrush Portraits* • *1991. Mixed media with paintbrushes, 9 x 4" to 12 x 5"*

Marilyn Keating and Debra Sachs • *Two Carpenters* • *1989. Painted wood, 13 x 26 x 3"*

Silas West • Advertising Sign • *c. 1895. Painted tin, 76 x 44"*

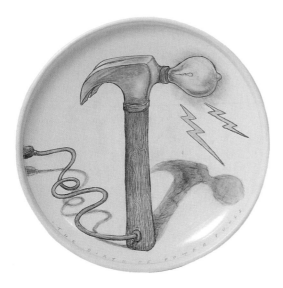

Maria Porges • *The Birth of Power Tools* •
1984. Painted ceramic, 13 1/2" diameter

Maria Porges • *Table Saw* •
1983. Painted ceramic, 16" diameter

Ed McGowin • *Workers Waving Goodbye* • *1991. Oil on canvas, carved and painted frame, 52 x 52"*

Henryk Fantazos • *Women in Labor* • *1986. Oil on canvas, 40 x 51"*

Pier Gustafson • *Drill Press* • *1982. Paper construction with pen and ink, 78 x 30 x 18"*

Opposite: **Arman** • *Blue, Red, Brown* • *1988. Acrylic with paintbrushes on canvas, 54 x 42 1/2"*

Greg Drasler • *Jack* • *1987. Oil on canvas, 70 x 50"*

Kaisa Puustak • Saw & Axe • 1987. Aquatint, 14 x 20"

Christopher Plowman • Hand Tools • 1982. Etching, 24 ³/₄ x 36"

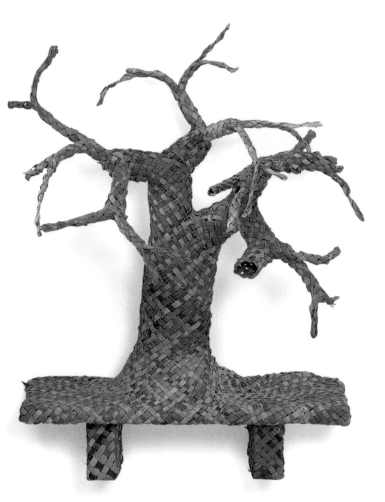

John McQueen
• *Just Past Dead Center* •
1991. Plaited elm bark,
27 x 21 x 13"

Peter Gryzybowski
• *Untitled (Oak)* •
1990. Oil on canvas,
50 x 36"

Opposite left: Constance Bergfors
• *Hard Rock Twist* •
1989. Walnut,
95 x 12 x 7"

Opposite right: Steven Geiger
• *Mechanized Icon* •
Wood with mixed media,
100 x 25 x 25"

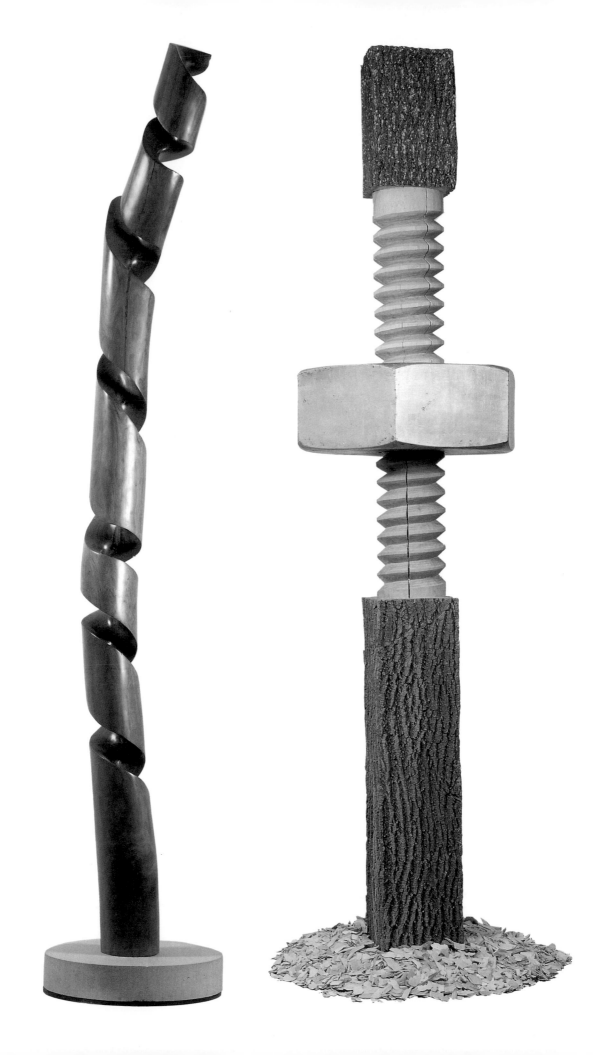

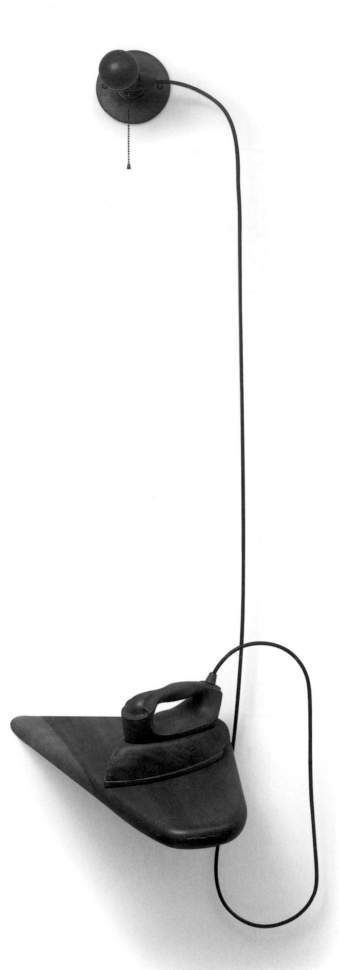

F. L. Wall
• *One Room Efficiency* •
1983. Cherry and steel,
60 x 14"

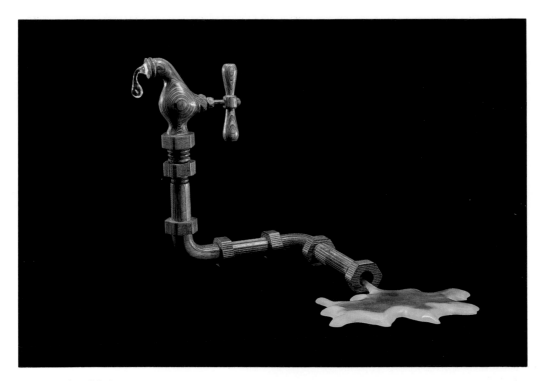

Amy Musia • Ohio River Faucet • 1981. Birch and acrylic resin, 14 x 16 x 23"

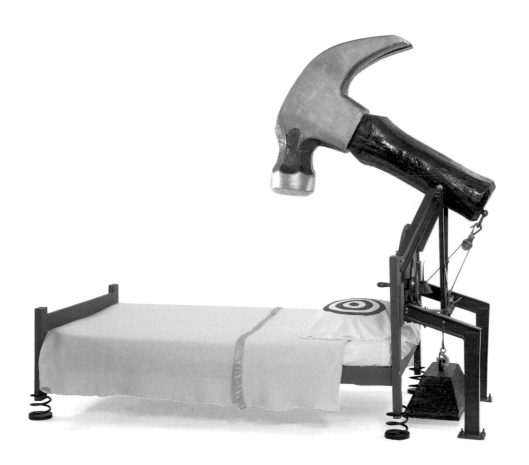

Scott Lesiak • Insomniac Bed • 1990. Mixed media, 60 x 48 x 72"

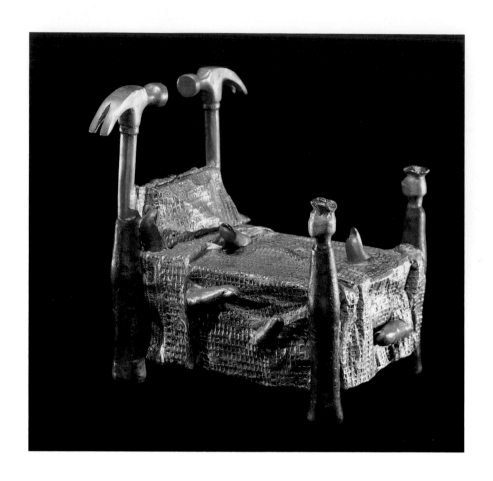

Leah Poller
• *Bed of Nails* •
1993. Cast bronze,
10 x 9 x 7"

Altina
• *Emperor on a Skate* •
1981. Painted fiberglass,
metals, and wood,
59 x 55 x 17"

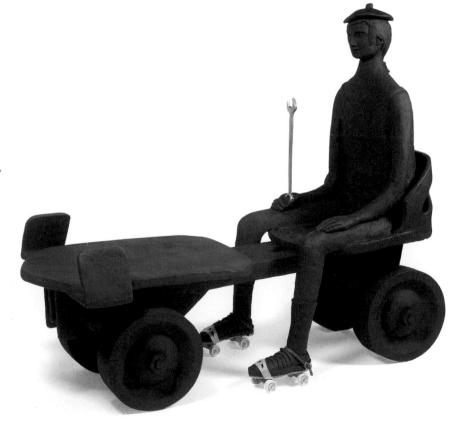

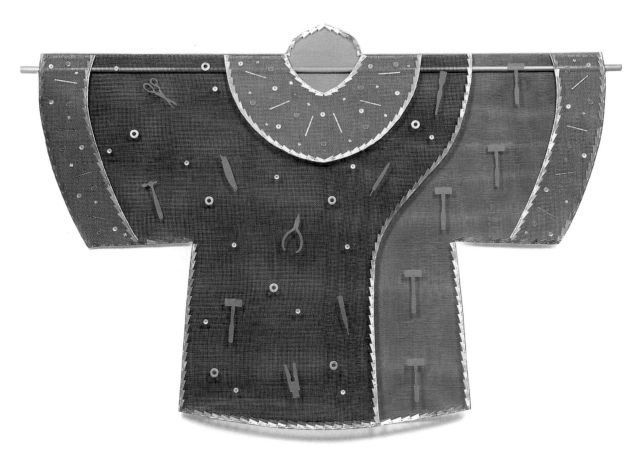

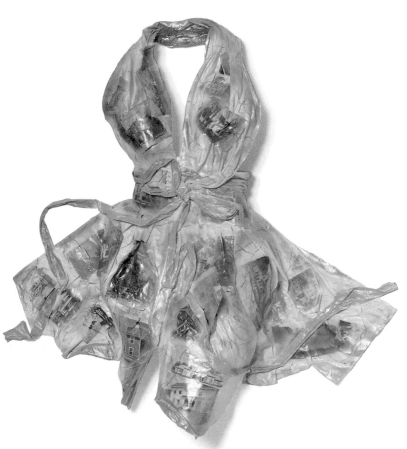

Above: **Debra Chase**
• *Hand-Tooled Jacket II* •
*Wire mesh, aluminum,
and acrylic resin,
46 x 35 x 2"*

Left: **Shelley Laffal**
• *House Coat* •
*1988. Mixed media
with collage,
38 x 51 x 7"*

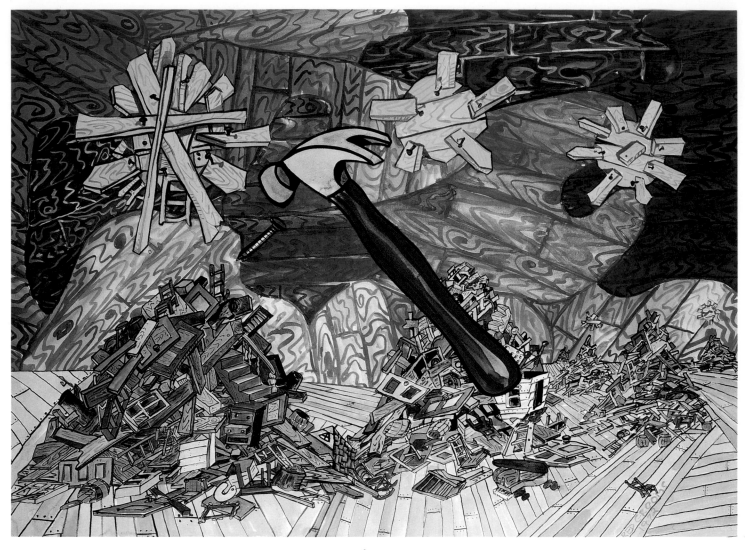

Red Grooms
• *I Nailed Wooden*
Suns to Wooden Skies
(in conjunction with the film
Hippodrome Hardware *1972–73)* •
1972. Polymer and collage
on paper, 21 ¹/₂ x 31"

Opposite top:
Andy Yoder
• Untitled •
1988. Watercolor
on paper, 22 x 30"

Opposite bottom:
Barton Lidicé Beneš
• *Reliquary/Pier 48 Hudson River* •
1982. Mixed media
on paper, 30 x 22"

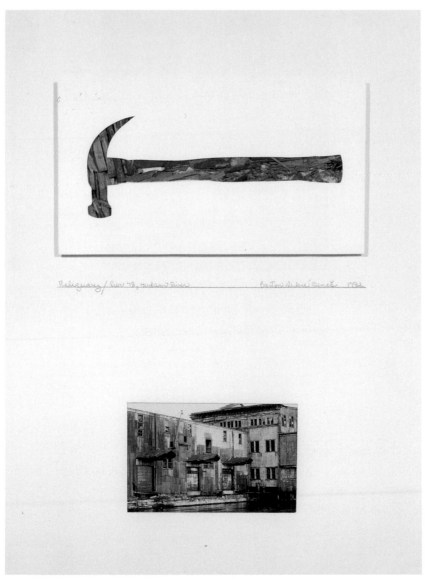

Reliquary / Pier 48, Hudson River Barton Lidicé Beneš 1982

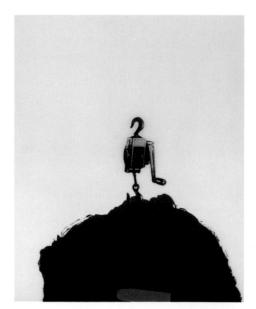

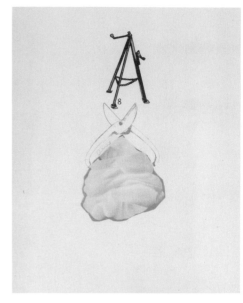

William T. Wiley • *Eerie Grotto Okini* • *1982. Woodblock print, 22 x 30"*

Opposite top: **Claes Oldenburg** • *Screw Arch Bridge* • *1980. Etching and aquatint, 34 x 60"*

Opposite bottom: **Claes Oldenburg** • *Knifeship* • *1986. Silkscreen, 30 1/2 x 36 1/4"*

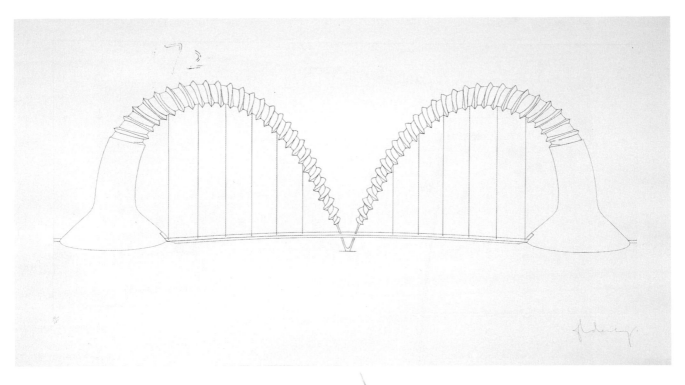

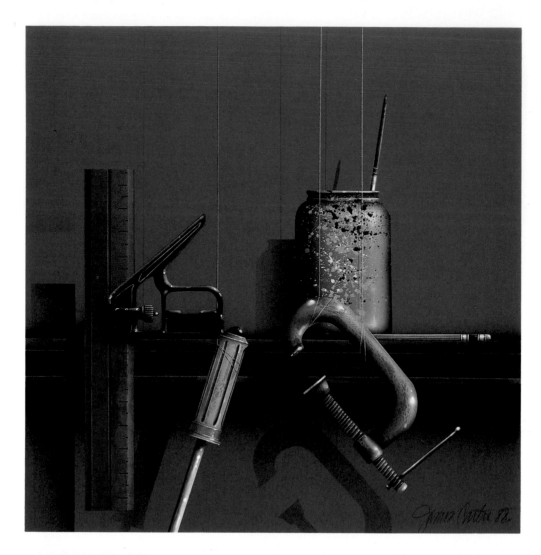

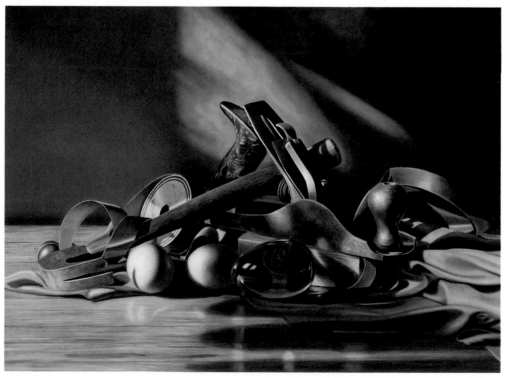

120

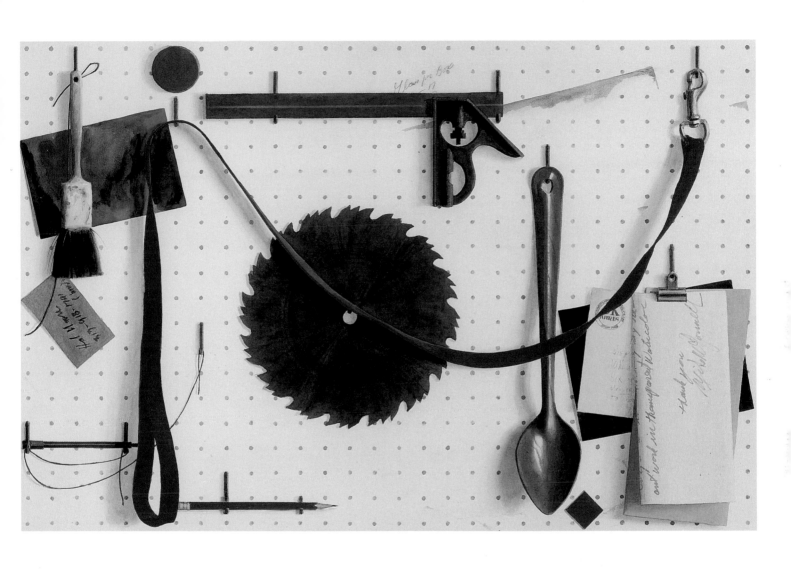

Mike McDonnell • Table Saw Blade • *1987. Watercolor on paper, 30 x 40"*

Opposite top: **James Carter** • Paint Can & Tools • *1988. Acrylic on canvas, 21 x 21 ¹/₂"*

Opposite bottom: **Steven Jones** • Nesting • *1992. Tempera and oil on panel, 24 x 32"*

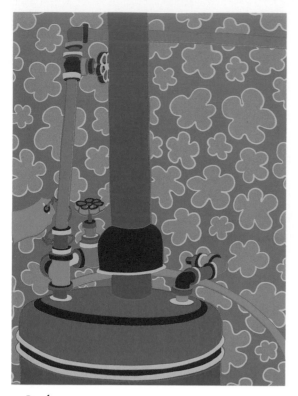

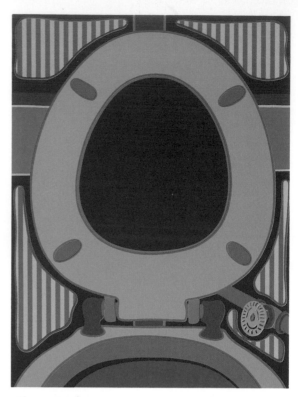

Clayton Pond • *Hot Water Heater* • *1981. Silkscreen, 24 x 18"* Clayton Pond • *Toilet Seat* • *1981. Silkscreen, 24 x 18"*

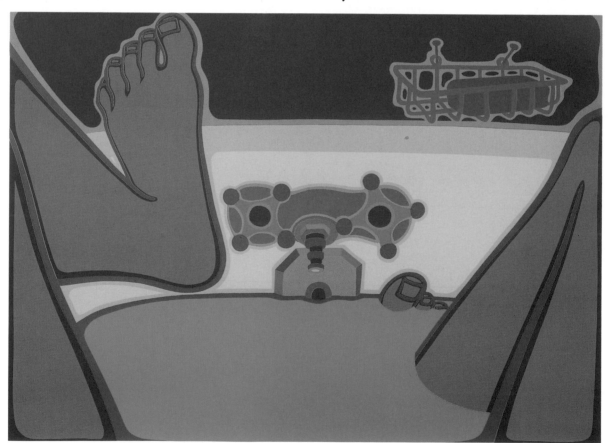

Clayton Pond • *Self-Portrait in the Bathtub* • *1981. Silkscreen, 19 x 24"*

Opposite: Michael Rocco Pinciotti • *The Nest* • *1989. Mixed media including twigs, neon, and feathers, 22 x 15 x 12"*

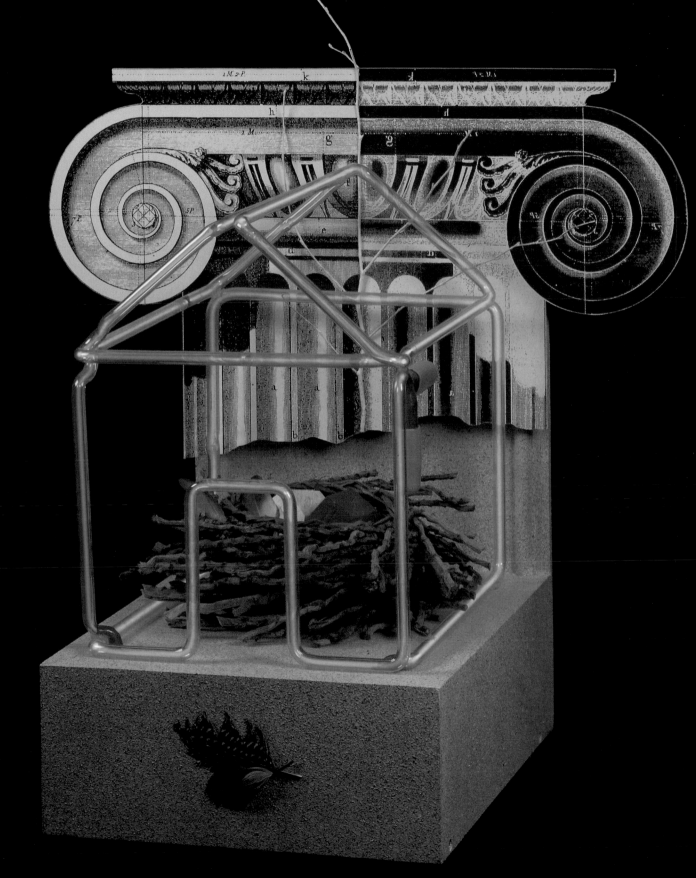

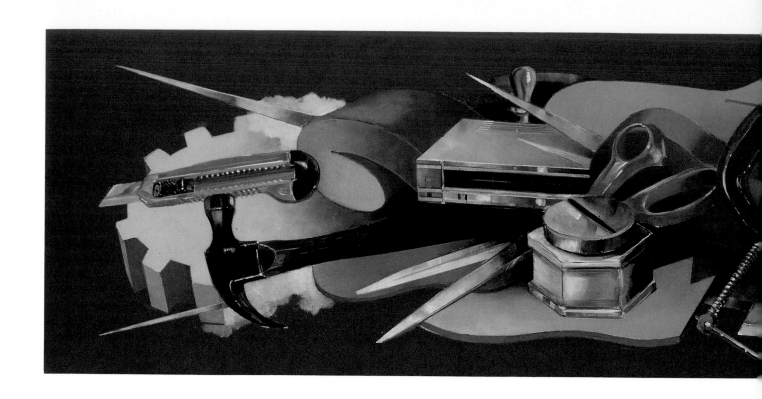

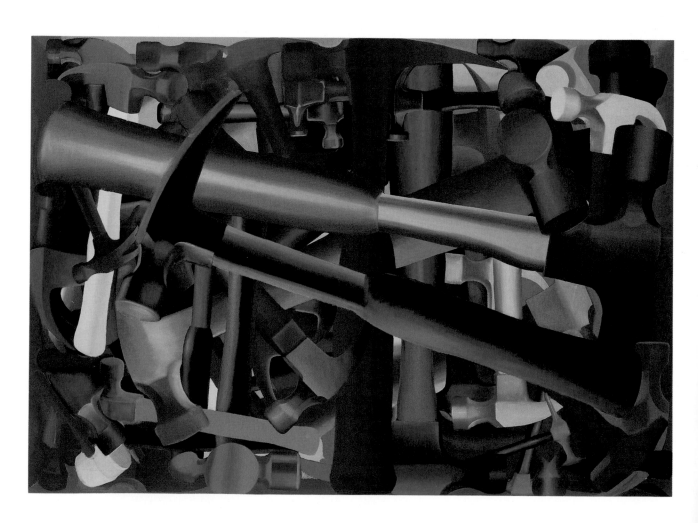

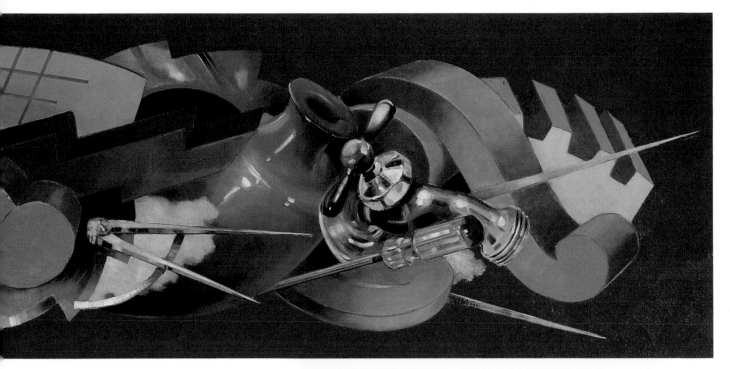

Above:
Joseph Maresca
• *Modern Painting #7* •
1986. Oil on linen,
14 x 60"

Opposite:
Patrick Kirwin
• *Hammers Inside* •
1991. Oil on canvas,
60 x 80"

Right:
Ron English
• *The Reconstruction* •
1992. Oil on canvas,
48 x 34"
© 1995 Ron English/
Licensed by VAGA,
New York

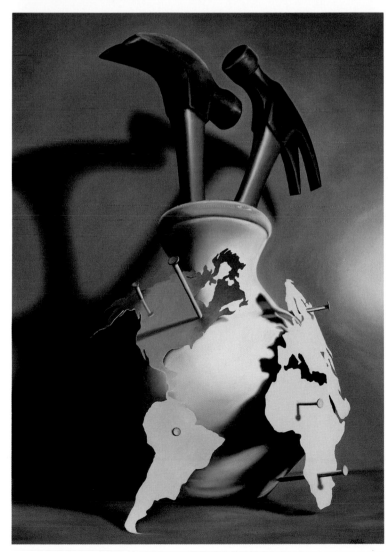

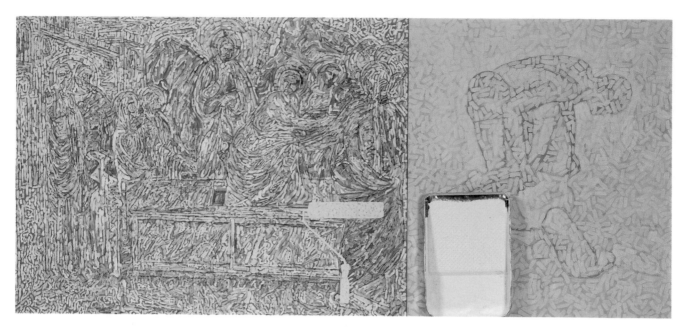

Dale Alward • *Resurrection* • *1989. Acrylic and charcoal on canvas with paint tray, 38 x 84"*

Jim Smith • *Esmeralda* • *1984. Acrylic on wood and hardware, 48 x 72 x 4"*

Opposite: *Stan Dann* • *Hand Tools* • *1988. Mixed media on carved wood, 69 x 47 x 6"*

Mark Kostabi
• *Power Tool Baby* •
1989. Oil on canvas,
54 x 48"

Right:
Roger Shimomura
• *Rinse Cycle* •
1988. Acrylic on canvas,
60 x 24"

Opposite:
Jonathan Borofsky
• *Hammering Man* •
1990. Cast-paper collage,
144 x 69 x 3"

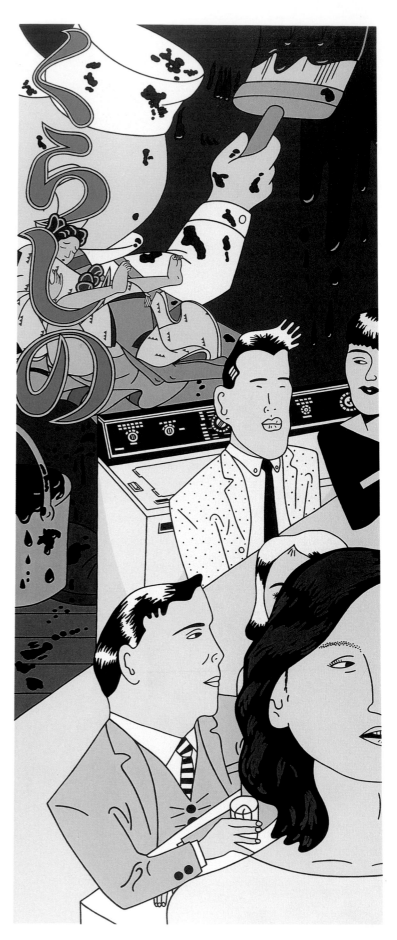

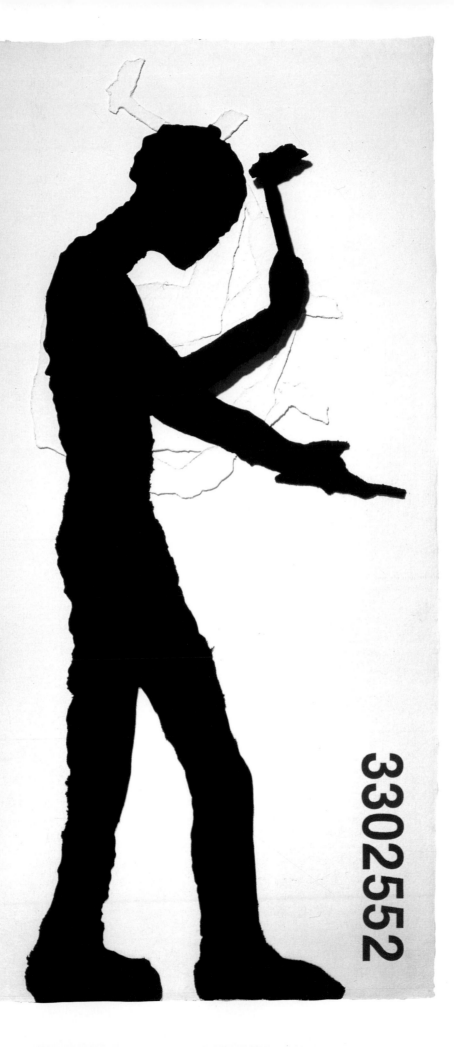

3302552

Susan Firestone • Hard Choices, Dreams Out of Context • 1987. Screenprint, 30 x 24"

Michael Malpass • *Big Mike* • *1985. Steel and hardware, 30" diameter*

Ivan Chermayeff • Untitled • *1978. Kodalith print, 36 x 36"*

Opposite: **Arman** • *Revealed Secrets* • *1993. Electric drills in Plexiglas, 40 x 32 x 3"*

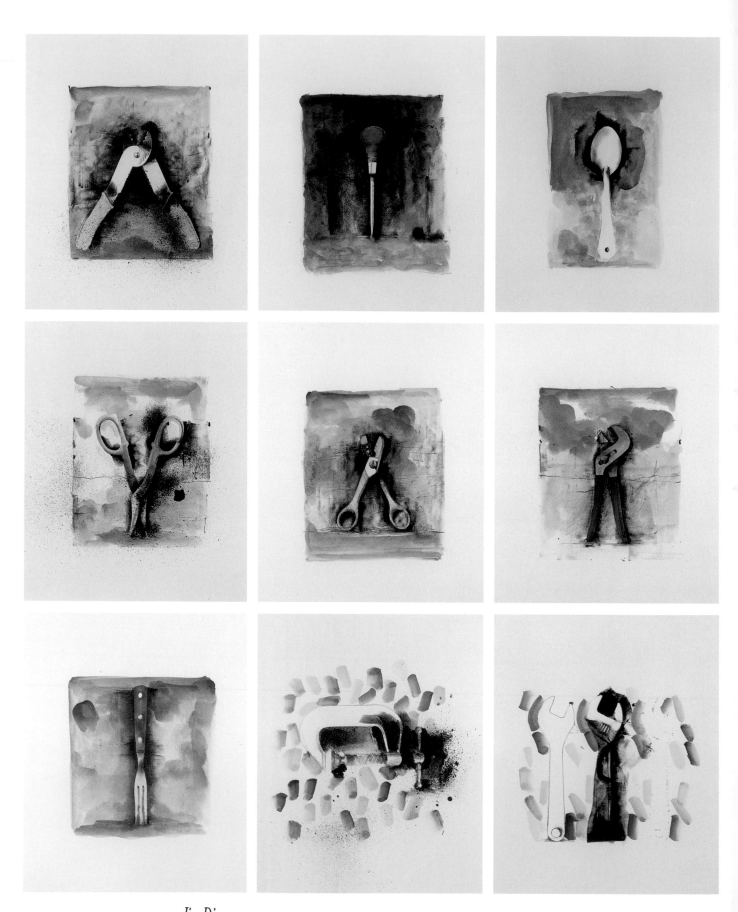

This page and opposite: **Jim Dine** • *Ten Winter Tools II* • *1973–89. Hand-colored lithographs, 26 x 20" and 20 x 26"*

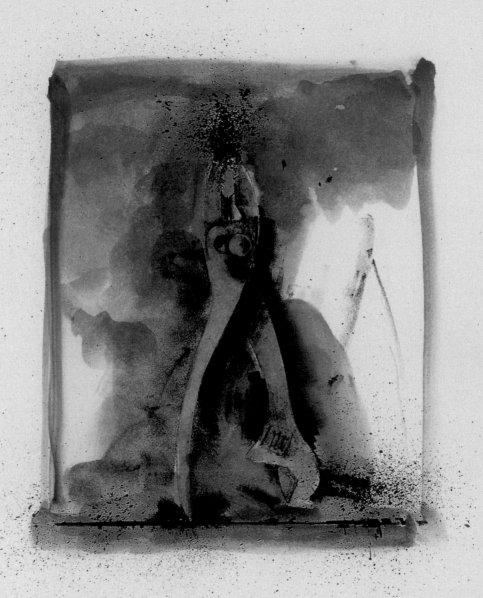

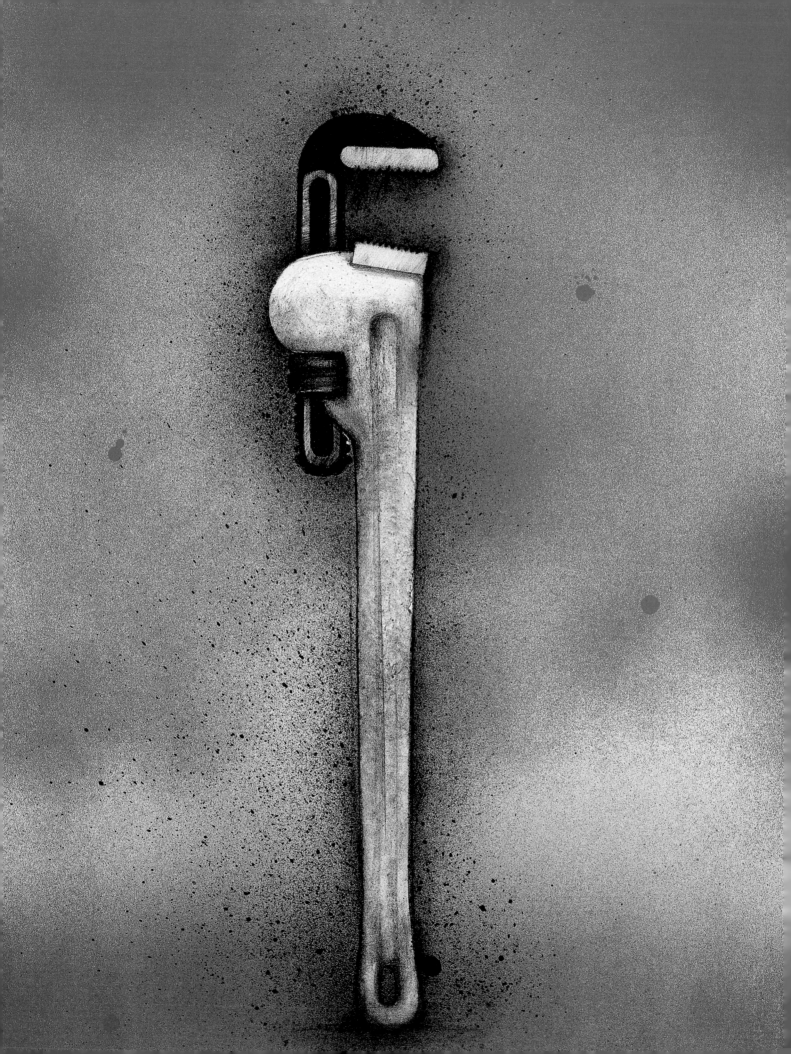

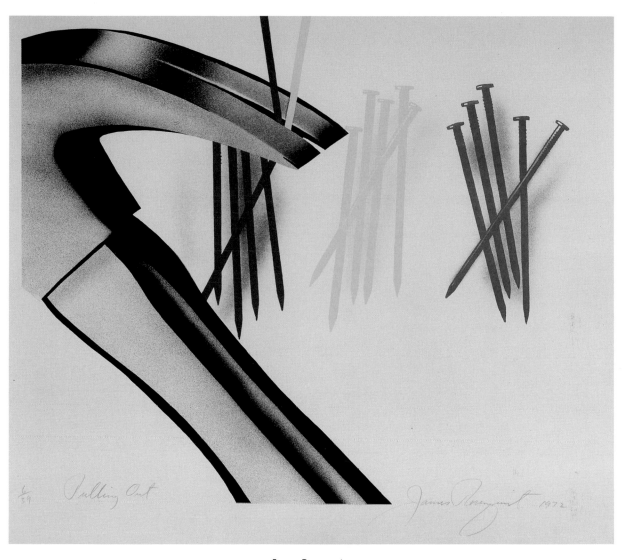

James Rosenquist

• *Pulling Out* •

1972. Color lithograph, 25 ¹/₂ x 30 ¹/₄"

© 1995 James Rosenquist/

Licensed by VAGA, New York

Opposite:

Jim Dine

• *Big Red Wrench in a Landscape* •

1973. Color lithograph, 30 x 22"

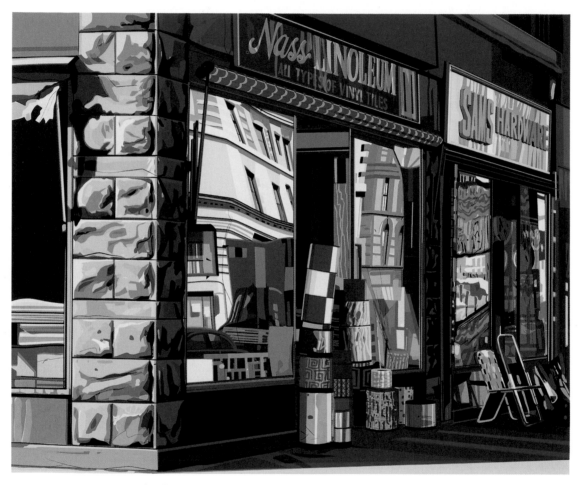

Richard Estes • *Nass Linoleum* • *1972. Screenprint, 14 x 17"*
© *1995 Richard Estes/Licensed by VAGA, New York*

Opposite: **Fernand Léger** • *Les Constructeurs* • *1951. Lithograph, 17 ¹/₂ x 23"*

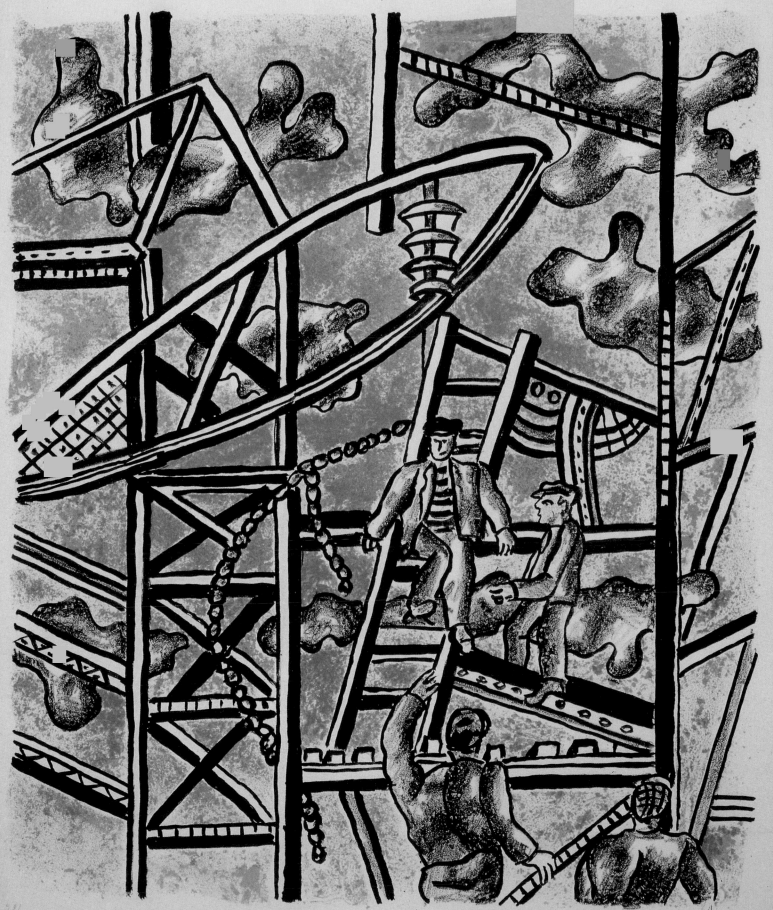

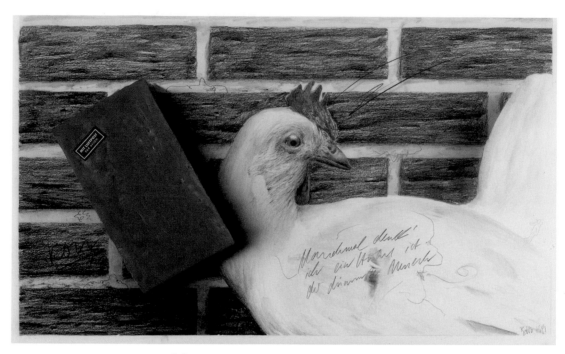

Woschek • *Hen & Brick* • *1981. Pastel and gouache
with collage, 14 ½ x 23 ½"*

Georgia Deal • *Collector's Chair III* •
1985. Linocut on handmade paper, 29 x 22 ½"

Tom Hebert • *Untitled #4* •
1985. Mixed media on canvas, 46 x 34"

Ben Nicholson • Spanners Two • 1974. Mixed media on paper, 19 x 16"
© 1995 Mrs. Angela Verren-Taunt/Licensed by VAGA, New York

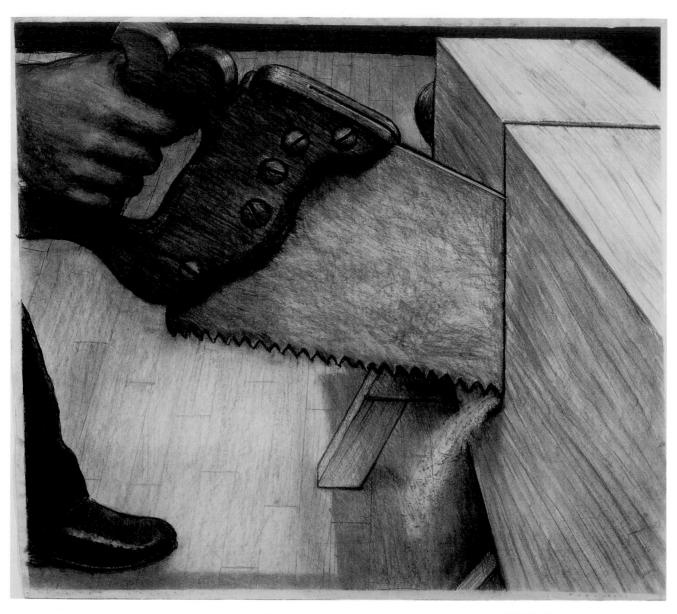

Chester Arnold
• *Sawn Asunder* •
1988. Charcoal on paper,
42 x 46"

Madelaine Shellaby
• *Bathtub* •
1981. Charcoal and
pastel on paper,
22 x 30"

John Grazier
• *Passing Windows in Fall* •
1983. Graphite on paper,
28 x 38"

Fran Larsen
• *Light and Shadows, Taos* •
1986. Watercolor on paper
with painted frame,
38 x 32"

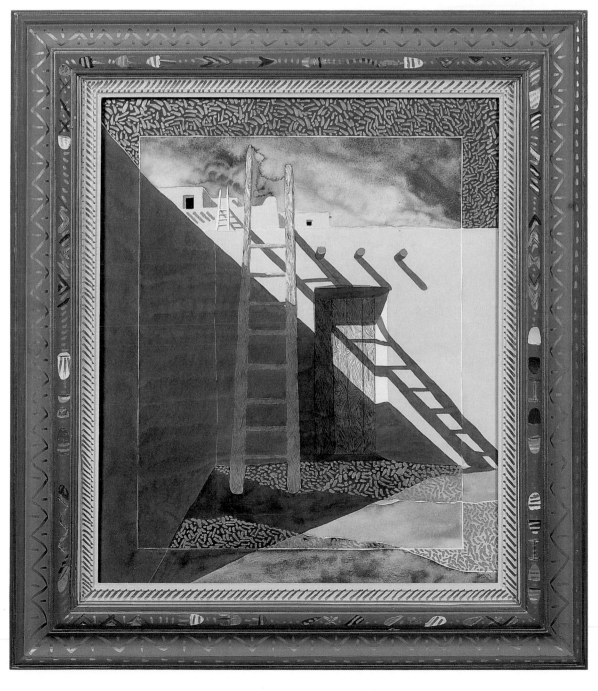

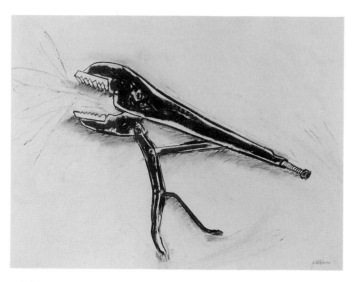

Judith Cowan • *Wrench* • *1984. Oil stick on paper, 22 1/2 x 30"*

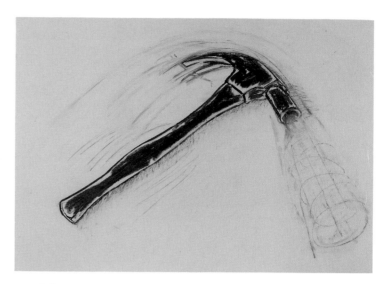

Judith Cowan • *Hammer* • *1984. Oil stick on paper, 22 1/2 x 30"*

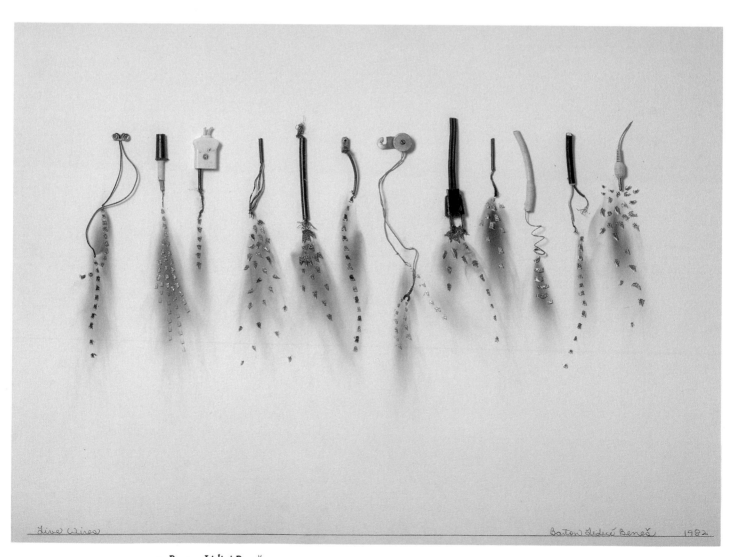

Barton Lidicé Beneš • *Live Wires* • *1982. Mixed media on paper, 22 x 30"*

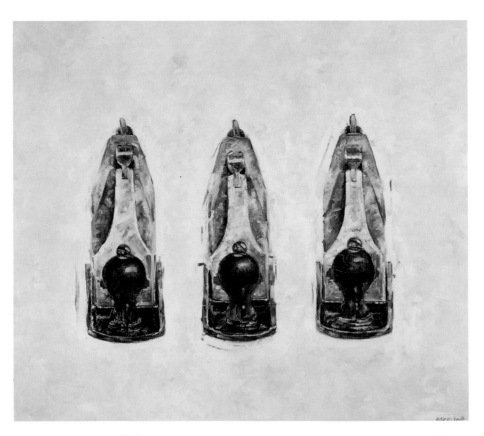

Werner Hoeflich • *Three Planes* • *1986. Oil on linen, 35 x 40 1/2"*

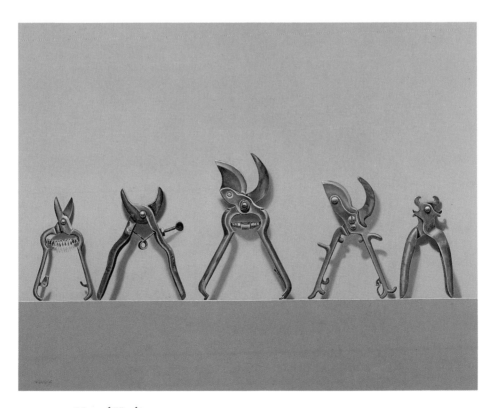

Manuel Hughes • *Work Dance I* • *1988. Oil on canvas, 24 x 30"*

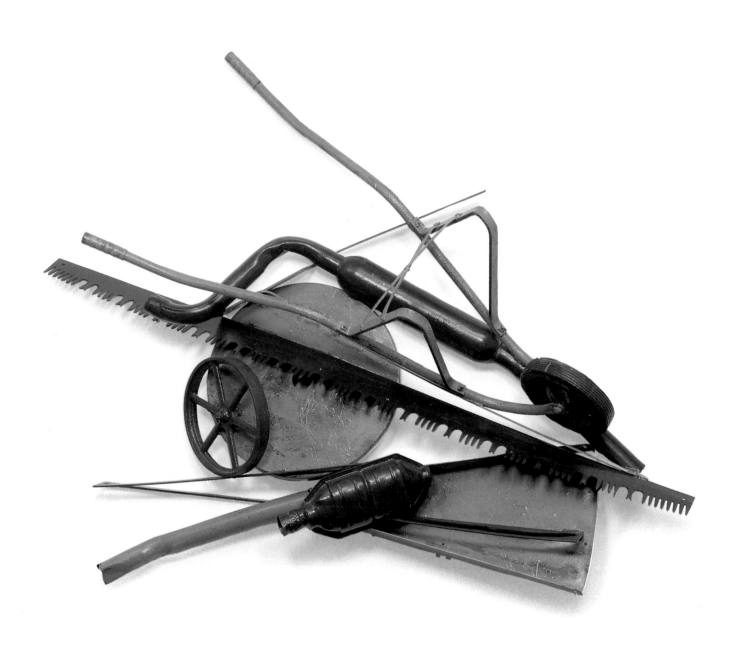

Dina Wind • *Wheelbarrow* • *Painted steel and hardware, 55 x 72 x 20"*

Marte Newcombe • *The Metropolitan* • *1989. Pastel on paper, 24 x 22"*

Judith McKellar • *Brickyard* •
1975. Mezzotint, 11 1/2 x 8"

Charles Hobson • *Six Hammers #4* •
1988. Monotype with pastel, 21 x 16"

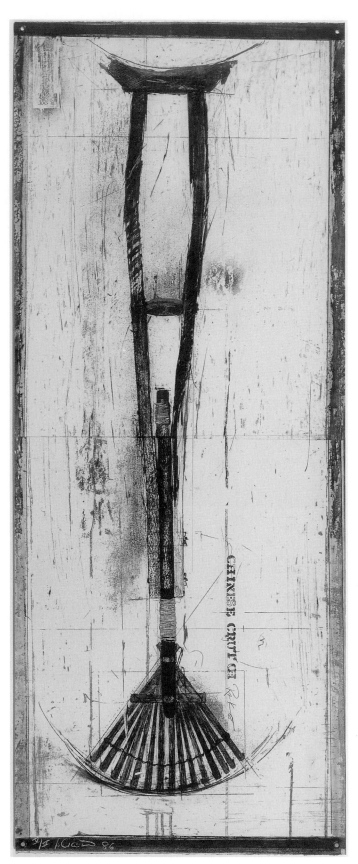

Patrick LoCicero • *Window on a Pedestal* •
1986. Hand-worked color lithograph, 62 x 26"

Patrick LoCicero • *Chinese Crutch Rake* •
1986. Hand-worked color lithograph, 62 x 26"

Robert Herhusky • *H.O.M.E.* • *1987. Wood, lead, and glass, 32 x 60"*

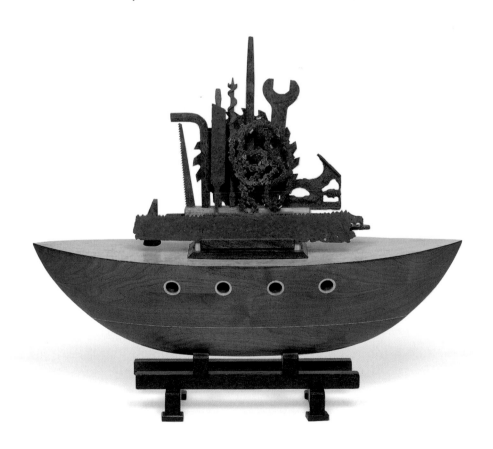

Richard Bronk • *Ship of Tools* • *1992. Wood and tools, 22 x 25 x 8"*

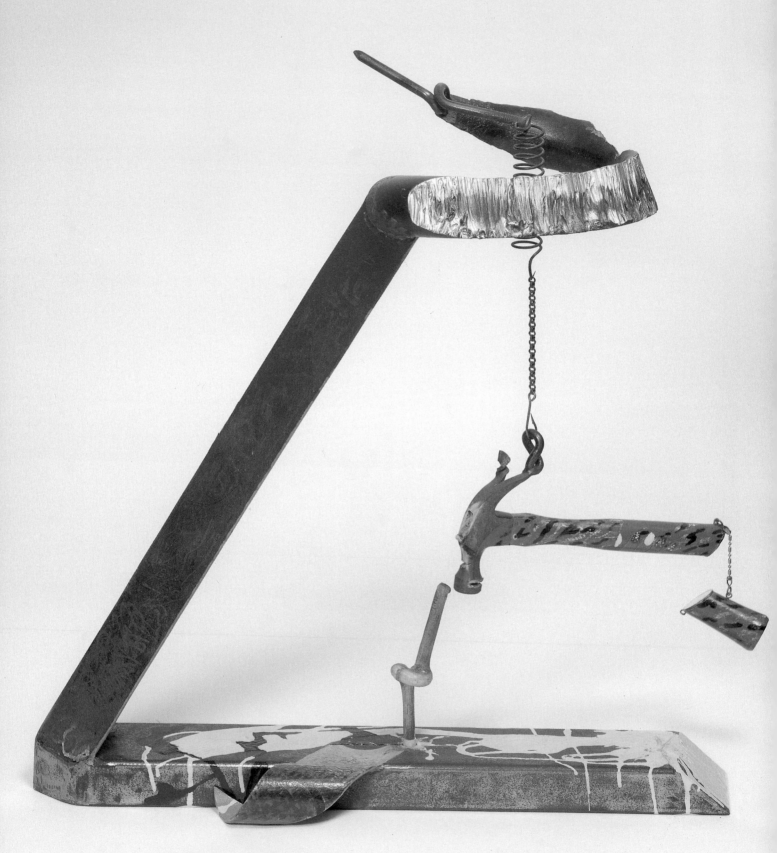

Thai Bui • *Hanging Hammer* • *1986. Painted steel with mixed media, 29 x 27 x 10"*

Jeffery Chapline • *Tools* • *1986. Cast glass, 37 x 37 x 20"*

Mark Blumenstein
• *Barney Wiggle* •
1991. Metal and hardware,
52 x 64 x 23"

Robert Harmon, Jr.
• *Looking for Spirits* •
1986. Wood and metal,
32 x 38 x 6"

Dusan Otasevic
• *Saw* •
1983. Canvas and wood,
39 x 50"

Werner Hoeflich
• *Flying Clamps* •
1986. Oil on linen,
37 x 50"

Walter Garde
• *Extension Cord #5* •
Acrylic on wood,
38 3/4 x 48 1/4"

Joe Schubert
• *Yellow Links* •
1990. Watercolor on paper,
30 x 32"

Linda Hanson
• *Warm October Light* •
1989. Oil on canvas,
40 x 61"

Carlos Raul Perez
• *The Carpenter* •
1988. Oil on canvas,
48 x 64"

155

Dale Loy • Flash L.T.G • 1978. Oil on canvas with collage, 48 x 48"

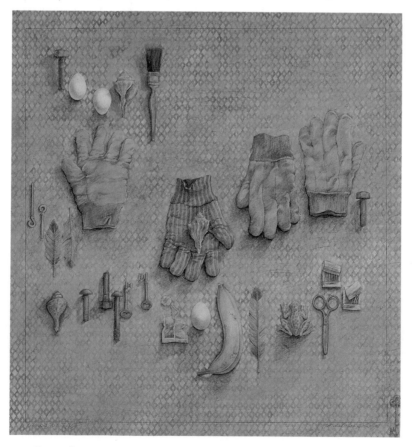

Patricia Bellan-Gillen • Still Life III • 1981. Pen drawing with graphite, 36 x 33 ¹/₂"

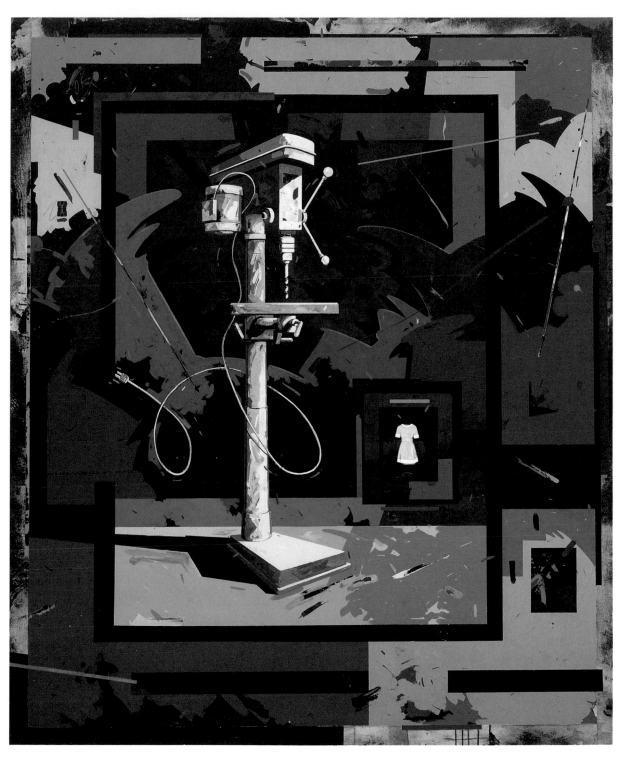

Mark McDowell • *Homage to the American Industrial Revolution #2—Drill Press* • *1986. Acrylic on canvas, 72 x 60"*

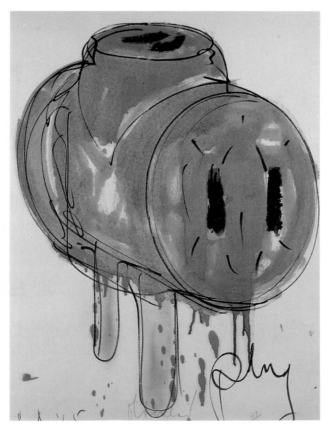

Franz Bader
• Bark •
1988. Cibachrome print,
16 x 20"

Claes Oldenburg
• Three Way Plug •
1965. Offset lithograph
with airbrush,
32 x 24 $^{1}/_{2}$"

Yuri Avvakumov • *Stair Ladder Barricade* • *1989–93. Screenprint, 22 x 30"*

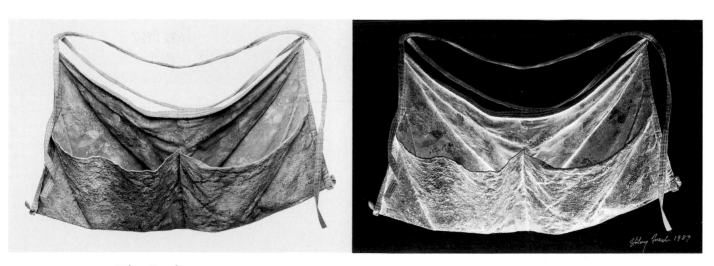

Hilary French • *Positive/Negative Apron* • *1990. Gelatin silver prints, 12 1/2 x 18 1/2" each.*

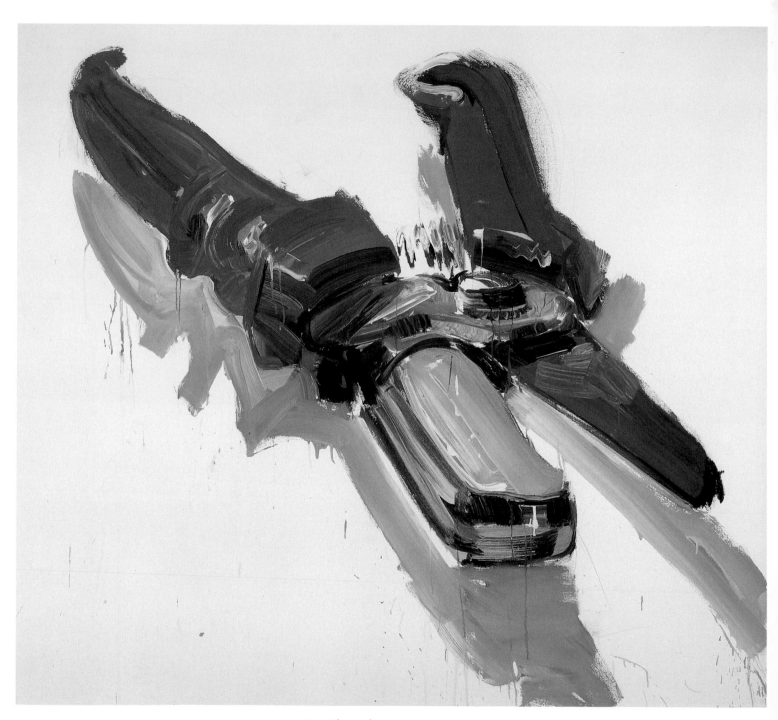

Tom Christopher • *Wire Cutters* •
Acrylic on canvas, 60 x 60"

Jeff Spaulding
• *Hammer Head III* •
1983. Graphite on paper,
39 x 29 $^{1}/_{2}$"

Bill Wilson
• *Staple Gun* • *1989.*
Hand-colored lithograph, 17 x 14"

Guy Goodwin
• *Untitled (Pickaxe/Shovel/Flowers)* •
1985. Charcoal on paper, 30 x 37"

Evan David Summer • Nocturne II • 1980. Etching, engraving, and drypoint, 17 x 23 1/2"

James Butler • At the Head of the Stairs • 1972. Lithograph, 21 1/2 x 14 1/2"

Opposite: Mel Rosas • Construction II • 1979. Charcoal on paper, 41 1/2 x 29 1/2"

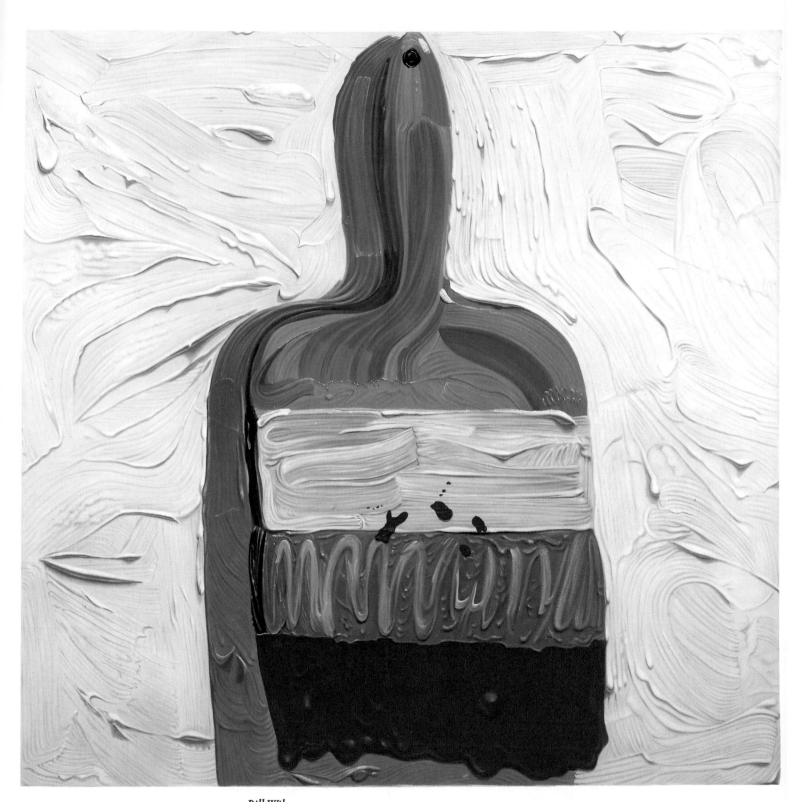

Bill Wilson • *Paintbrush* • *1978. Oil on canvas, 60 x 60"*

Right:
Arman
• *Untitled* •
1979. Acrylic on Plexiglas acrylic sheet,
11 3/4 x 11 3/4 x 2"

Below:
Philip Hazard
• *Blue Wiggle* •
1987. Acrylic on wood with neon, 53 x 8 x 4"

Below right:
Stephen Hansen
• *Painter* • *1989. Cast and painted polyethylene, 77 1/2 x 28"*

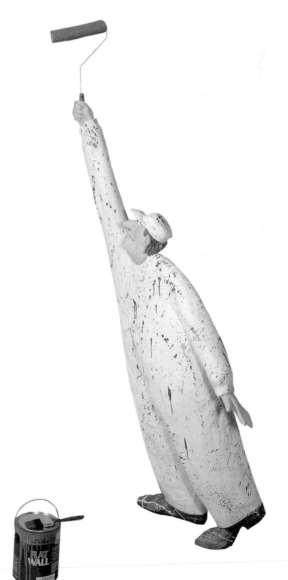

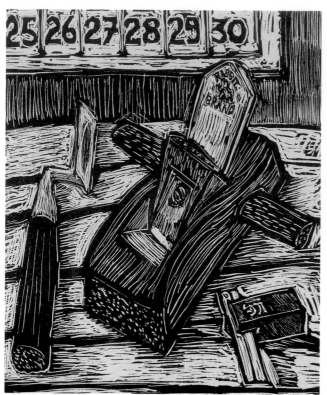

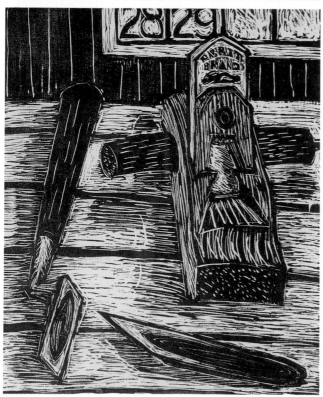

Harlan Mathieu

Above left:
• *Tsuki-Kanna I* •
1989. Woodcut,
14 1/2 x 12"

Above:
• *Tsuki-Kanna II* •
1989. Woodcut,
14 1/2 x 12"

Left:
• *Tsuki-Kanna III* •
1989. Woodcut,
14 1/2 x 12"

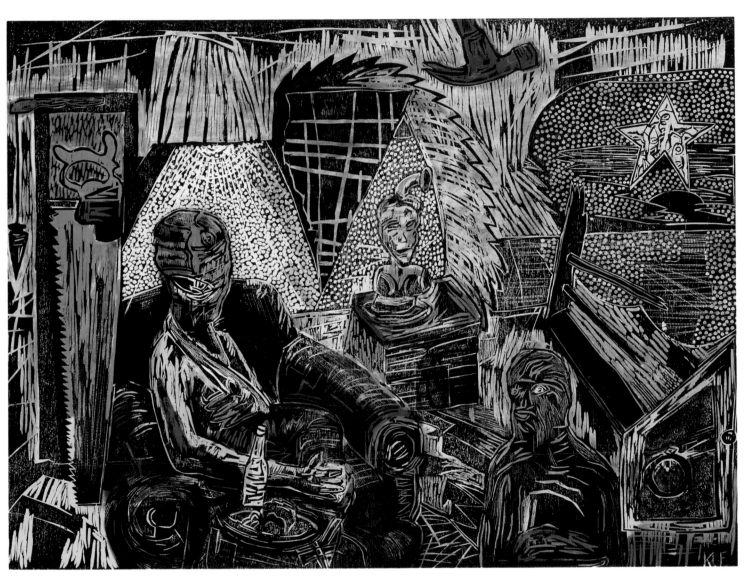

Ke Francis • *Tornado* • *1991. Woodcut on handmade pigmented paper, 30 x 40"*

Ke Francis • *Reconstruction Vision* • *1988. Acrylic on canvas construction with wood and wire elements, 102 x 190"*

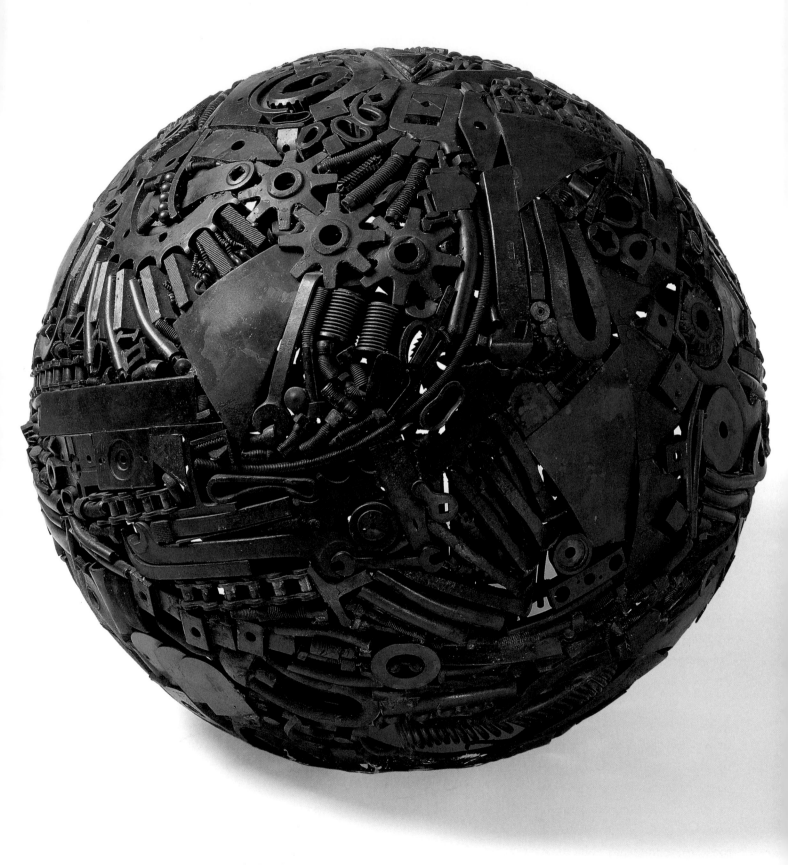

Michael Malpass • Globe • 1981. Steel and hardware, 32" diameter

Afterword: Artists and Tools

Upon hearing of an art collection based on the unlikely subject of tools and hardware, most people, regardless of how much or how little they know about art, can recall but one or two artists who have addressed the topic. The extraordinary range of artists whose work is found in the Hechinger Collection, as seen in the following brief biographies, will convince anyone that what at first appears to be a theme of rather narrow focus, is, to the contrary, one that provides a vibrant and rich path for artistic exploration. Rather than limiting the possibilities, the theme provides occasion for collecting powerful works by a wide range of artists, and gives unity and cohesion to an incredibly diverse range of expression and intent.

Works that address the subject of tools have a broad appeal that is unusual in contemporary art. Tools are tied to notions of who we are and who we think we are. They are at once objects of nostalgia and instruments of change. They are emblematic of the can-do spirit that is part of the American persona, and they speak to our unalterable belief that we can make things over; that we can get it right. Tools are the agents in our acts of creation and destruction and in our domination of the environment; they are extensions of ourselves.

In the twentieth-century, the familiar objects of everyday life have become the stuff of art. In the world of art based on the found object, low becomes high and tools become art. Drawing inspiration from the surrounding world, the artists represented in the Hechinger Collection have lifted tools, these nuts and bolts of ordinary existence, out of the realm of the mundane. They have construct-

ed from them works of beauty and of revelation, for it is not simply tools that fascinate the artist, but the human response to them. In the larger sense, it is the relationship between man and tools that is the artist's subject.

Artists salvage discarded tools to create wholly original works, such as the dissonant motorized sculpture of Jean Tinguely (page 39), the formal welded spheres of Michael Malpass (pages 27, 132, and 170), and the brute constructions of John Van Alstine (page 15). They are alert to the human and animal-like shapes of tools and make visual puns, as seen in H. C. Westermann's poignant hammer studded with bent nails (page 98) and Arman's lively school of silvery fish cum visegrips (pages 32–33). In their studios, a spirit of playfulness reigns: rakes become chairs, hammers are glass.

As artists have focused on the object, they have been drawn to the beauty inherent in utilitarian designs. Photographer Walker Evans wrote in the foreword to "Beauties of the Common Tool," a series of photographs he did for *Fortune* magazine in 1955, "Among low-priced, factory-produced goods none is so appealing to the senses as the ordinary hand tool." His photograph *Wrench* (page 86) exemplifies this approach of utter concentration on the object and deliberate avoidance of context. Other artists have used formal design qualities as the starting point for commentaries on art and culture. For example, Jim Dine's *Big Red Wrench in a Landscape* (page 136) presents a wrench in much the same formal manner as Evans, but adds a fading landscape as background in this wry observation on the changed conventions of art. Consider as well

Claes Oldenburg's *Screw Arch Bridge* (page 119), a humorous drawing of a bridge composed of two screws, in which form and function meet at the point of the absurd.

Artists of narrative and allegorical works mine the rich conventional symbology of tools—ladders are symbols of spiritual redemption in the work of Charlie Brouwer and Yuri Avvakumov. Susan Firestone and Phyllis Yes exploit the cultural associations of tools to explore issues of sexuality and gender. Tools become powerful emblems of the will to triumph over nature in Ke Francis's *Reconstruction Vision* (pages 168–69) and James Surls's *Rebuilding* (page 52). In the art of Colleen Barry-Wilson (pages 34–35), tools are conjoined with books to represent the dual aspects of culture: the intellectual and the material.

The variety of responses and approaches to tools extend beyond the traditional boundaries of fine art into the realm of folk art. This is an art that has traditionally exhibited a marked impetus to find new decorative uses for objects that have often lost their original utility. As such, it has given rise to an entire genre built upon discarded tools: painting on saws, of which Jacob Kass's *Winter Scene on Hand Saw* (page 16) is a typical example. Artists working close to the folk and naive traditions voice the feeling that incorporating tools into their art is a way of giving valued objects new life. Mr. Imagination, a self-taught artist who works outside of the mainstream, speaks of his figures made from used paintbrushes (page 100) as a means of bringing cherished tools back to life. Daniel Mack, maker of rustic furniture, views his series of chairs composed of antique tools (page 49) in much the same spirit.

Employed in the works of the most sophisticated of art makers and the most naive of artisans who might never think to characterize what they do as making art, tools seem to engender a democratization of art. They offer a means of expression open to all, for tools and mankind are inseparably bound. It is this intimate relationship that informs each piece in the Hechinger Collection and affords an accessibility and an immediacy of response of viewer to work not often found in art today.

—Carolyn Laray
Curator

Artists' Biographies

BERENICE ABBOTT

Berenice Abbott was born in Springfield, Ohio, in 1898. She died in 1991 in Monson, Maine, at the age of ninety-three. After studying at Ohio State University, she went to New York in 1918 intending to become a journalist but studied sculpture instead. She moved to Paris in 1921 to continue her sculpture studies and spent time in the studio of Constantin Brancusi. When Man Ray hired her to be his darkroom assistant in 1923, she began making her own photographs. From 1926 to 1929 she had her own studio in Paris and made photographic portraits, primarily of the avant-garde intelligentsia, including James Joyce, André Gide, and Jean Cocteau. She also met the French photographer Eugène Atget, who was to greatly influence her work. She acquired his entire collection of photographs upon his death. (The collection is now at the Museum of Modern Art in New York.) In 1929 she returned to New York and began photographing the city and its inhabitants. In 1935 Abbott received a grant from the Federal Arts Project's "Changing New York" program to continue this project, and from 1935 to 1939 she produced extensive photographic documentation of the city, culminating in the book *Changing New York* (1939). During the 1940s and 1950s she developed her own photographic equipment and techniques to illustrate scientific principles such as gravitational pull and the properties of objects in motion. In the mid-1960s she moved to Maine, where she lived and worked until her death. Abbott thought of the camera as an instrument of truth, and her photographs attempt an objective description of the external world. By communicating a wealth of detail about the subjects she documented, Abbott sought to establish the verity of her images.

HARDWARE STORE. 1938. PAGES 84–85
SPINNING WRENCH. C. 1958. PAGE 86

ALLEN ADAMS

Allen Adams was born in Arizona in 1952. He earned his B.A. from California State College, Stanislaus, in 1975 and an M.F.A. from the University of California at Davis in 1978. His work has been exhibited at the Fine Arts Museum of San Francisco, the Taft Museum, Cincinnati, and the Baltimore Art Institute. Adams's works are highly detailed, illusionistic wood sculptures of objects traditionally manufactured from other materials. To remind the viewer that his works are sculptures, not merely replicas of utilitarian objects, he leaves them unpainted and unstained. His pieces are characterized by fine detail and a virtuosic range of scale.

LATHE. 1979. PAGE 20

ALTINA

Born in New York City in 1916, Altina Carey studied art in Europe and in the United States with George Grosz and Rico Le Brun, among others. Her early work was in industrial design. She assisted Salvador Dalí in dressing windows on New York's Fifth Avenue in the 1940s and designed eyewear for Harlequin, for which she received a National Design Award. Upon moving to California, she created *Interregnum*, a film based on drawings by George Grosz; it won the first prize at the Venice Biennale film festival and received an Academy Award nomination in 1961. During this period she also received several mural commissions, including one for the Los Angeles County Department of Mental Health. In the late 1960s Altina began making fantasy furniture called "Chairacters"—sculpted figurative works that function as benches and chairs. She drew inspiration for these pieces from Henri Cartier-Bresson's photographs of empty chairs, which seemed to evoke their departed sitters. Her first solo exhibition, at the McKenzie Gallery, Los Angeles, in 1967, featured her chairs. The artist also developed a series of "portrait chairs" with faces cast from life masks of her sitters. She continued to make fantasy furniture after moving to Washington, D.C., in 1974. Produced in multiples, mainly in fiberglass, her pieces are often finished to simulate other materials such as terra-cotta or stone. They recall the more intimate aspects of certain periods of ancient Greek and Roman art.

EMPEROR ON A SKATE. 1981. PAGE 112

DALE ALWARD

Born in 1962, Dale Alward earned his B.F.A. in sculpture, video, and film production from the Rhode Island School of Design, Providence, in 1984. While working on his degree at R.I.S.D., Alward also studied semiotics at Brown University, and glass techniques at Ohio State University. Alward's work has been exhibited at several art centers, including the Washington Project for the Arts, Washington, D.C., the Montpelier Cultural Arts Center, Maryland, and Strathmore Hall Arts Center, Rockville, Maryland. In his work Alward sets up visual comparisons between completed images and preparatory sketches, between finished areas of painting and raw materials. Through these juxtapositions, he asks the viewer to participate in the manipulation of the subject matter and to meditate on the process of image-making.

RESURRECTION. 1989. PAGE 126

ARMAN

Born the son of an antiques and secondhand furniture dealer in Nice, France, in 1928, Armand Fernandez gave up his surname in youthful emulation of Van Gogh, and in 1957 he became Arman when a typesetter dropped the "d" from his name. A founding member of New Realism with artists Yves Klein and Jean Tinguely and theorist Pierre Restany, Arman continues to be one of the most innovative and provocative artists of our time. His formal training included studies at the National School of Decorative Arts in Nice and the Louvre School in Paris. Arman is also a student of archaeology and Asian art, as well as an amateur cellist, a judo expert, and a skilled chess player. After a brief military service in Indochina, he turned his attention to abstract painting and embarked on a series of "happenings" and events with Yves Klein. From 1947 to 1953 he became involved with Zen Buddhism, the Rosicrucians, Gurdjieff, and astrology. Around 1960 he began creating his now world-famous "destructions" *(poubelles)*, and "accumulations." His "accumulations," or constructions, have incorporated such ordinary objects as pliers, shoe trees, and wrenches, as well as scrapped industrial goods, broken bicycles, and discarded phonograph records, which he composes into broad, allover patterns. Other works have featured paint tubes embedded in Lucite or Plexiglas, with the paint partially squeezed out to form sculptural objects or self-referential paintings. His complementary series, "destructions," consists of musical instruments and other single objects that have been reduced to fragments. In 1961 he had his first New York show at the Cordier-Warren Gallery and was included in "The Art of Assemblage" at the Museum of Modern Art. He took up residence in New York in 1963, becoming friends with Andy

Warhol, Roy Lichtenstein, and Frank Stella. In 1964 he had his first solo museum show at the Walker Art Center in Minneapolis, followed by one at Amsterdam's Stedelijk Museum. In 1967 he began an "Art-Industry" collaboration with Renault, the French car manufacturer. He taught at U.C.L.A. in 1967–68. His work has been shown throughout the world, including the Venice Biennale and Documenta. Arman is notorious both for his large-scale installations and for his public "destructions," which have included dynamiting a sports car. In recent years, his works have become more introspective, as seen especially in his encrusted bronze castings of ordinary objects. But as in his earlier work, the deliberate, orgiastic redundancy of his mature style offers a critique, at times humorous, of the excesses and eccentricities of modern life. A touring retrospective of his work was held in 1991–92.

AVALANCHE. 1979. PAGE 38
BLUE, RED, BROWN. 1988. PAGE 104
JAWS. 1984. PAGE 35
REVEALED SECRETS. 1993. PAGE 133
SCHOOL OF FISHES. 1982. PAGES 32–33
STILL HUNGRY. 1979. PAGE 97
UNTITLED. 1979. PAGE 165

BILL ARNOLD

Bill Arnold was born in 1941 in Brooklyn, New York. He received his B.A. from San Francisco State University in 1965 and his M.F.A. from the San Francisco Art Institute in 1970. Arnold has explored a wide range of photographic mediums, including photograms. He has been awarded a National Endowment for the Arts grant, and his work has been exhibited at the Metropolitan Museum of Art, the San Francisco Museum of Art, and the Corcoran Gallery of Art, Washington, D.C. Although photograms are essentially a type of silhouette, Arnold achieves an astonishing degree of solidity with this technique, making his images appear almost full-bodied.

FAUCET. 1984. PAGE 80
PICKAXE. 1984. PAGE 80

CHESTER ARNOLD

Born in Santa Monica, California, in 1952, Chester Arnold studied at the College of Marin, Kentfield, California, from 1970 to 1974 and went on to earn his M.F.A. from the San Francisco Art Institute in 1987. Arnold has had regular solo exhibitions at galleries in California since 1979. He has taught classes in drawing and painting at San Francisco State University and the San Francisco Art Institute. Arnold's representational paintings explore different themes in various series. His work is filled with references to other art, including

figures or settings from historical paintings. In the late 1980s Arnold did a series of tool "portraits," structured similarly to Renaissance portraits, with the sitter in the foreground and a distant landscape in the background. Many of these paintings showed building frameworks, construction activities, or fires, suggesting continual cycles of creation and destruction.

CORRECTION. 1987. PAGE 24
SAWN ASUNDER. 1988. PAGE 142

GRAHAM ASHTON

Graham Ashton was born at Wirral, Cheshire, England, in 1948. He earned his B.A. in fine art from the Coventry School of Art in 1970. Ashton's work has been exhibited in galleries and art spaces in England, Ireland, Australia, and the United States. He lives in London and spends part of each year in the United States. Ashton works in a variety of media, including oils and watercolor. His treatment of oil paint and watercolor are similar: he lays down washes of thinned paint, building up layers that float across the canvas or paper. Among his influences are such postwar American painters as Helen Frankenthaler and Morris Louis, as well as mid-nineteenth-century practitioners of the English watercolor tradition.

INSTRUMENTS OF PENETRATION—TOOLS OF THE TRADE. 1984. PAGE 76

YURI AVVAKUMOV

Yuri Avvakumov was born in Tiraspol, Russia, in 1957. He graduated from the Moscow Architecture Institute in 1981. Avvakumov is a sculptor, a printmaker, and a practicing architect with his own firm, AGITARCH Studio, in Moscow. His work has been exhibited at the State Museum of Moscow, the Palazzo dell'Arte, Milan, and the Fondation pour l'Architecture, Brussels. He has been influenced by the Russian avant-garde artists of the 1920s such as Vladimir Mayakovsky, Ljubov Popova, and Konstantin Melnikov. Ladders and exposed stairwells are recurring themes in both his art and his architectural designs. For Avvakumov, ladders are carriers of meaning, becoming temporary monuments, symbols of construction and progress, or barricades.

STAIR LADDER BARRICADE. 1989–93. PAGE 159

FRANZ BADER

Franz Bader was born in Vienna, Austria, in 1903. He apprenticed as a bookseller but was forced to flee Austria in 1939 when Hitler's army invaded. He arrived in New York and then moved to Washington, D.C. Bader worked in and ultimately acquired a bookshop, where he showed art, primarily by local artists, in the back room. He was one of the few people

exhibiting modern art in Washington at the time and was among the first to show the work of Gene Davis, Jacob Kainen, and Peter Milton. Bader described his own photography as his "third life," which he took up late in his career. He focused on elements and objects often overlooked, seeking out their inherent aesthetic qualities. Bader's work has been exhibited at museums and galleries in Washington and elsewhere. He died in 1994.

BARK. 1988. PAGE 158

TOM BARROW

Tom Barrow was born in 1938 in Kansas City, Missouri. He received a B.F.A. in graphic design from the Kansas City Art Institute in 1963 and an M.S. in photography from the Institute of Design in 1967. He studied photography with Aaron Siskind. He has been awarded two National Endowment for the Arts Photographer's Fellowships. Barrow has had exhibitions at the Los Angeles County Museum of Art and the San Francisco Museum of Modern Art. His work has also been included in exhibitions at the Nelson-Atkins Museum of Art, Kansas City, the Museum of Fine Arts, Santa Fe, and the Houston Center for Photography. He is Assistant Curator of Research at the George Eastman House, Rochester, New York. Barrow has made many photographs on the theme of houses and homes and is known for a series of urban landscapes called the "Cancellation Series" because of the X marked across each of the images. Another of his series explores the subject of American icons and is composed of large-scale Polaroid images that have been pieced together.

HEARTBEAT OF AMERICA. 1988. PAGE 91

COLLEEN BARRY-WILSON

Colleen Barry-Wilson received a B.A. in weaving and sculpture from California State University at Chico in 1973 and an M.F.A. in weaving and textile design from Edinboro State University, Pennsylvania, in 1980. She has taught papermaking and fiber classes at California State University and in workshops throughout California. Barry-Wilson's work has been exhibited in museums and art centers throughout the United States, including the Fresno Art Center and Museum, California, the Palo Alto Cultural Arts Center, California, and Texas Christian University, Fort Worth. She has completed several large-scale public commissions, including installations for the Hall of Justice Building, Redwing, California, and the Municipal Court, Sacramento, California. The artist makes mixed-media pieces she describes as books, embedding found objects, such as rusted nails, zippers, broken pencils, and old buttons, within soft-hued, textured handmade paper. By

juxtaposing the organic and the industrial, Barry-Wilson comments on the relationship between urban society and the natural environment.

TOOL DICTIONARY. 1987. PAGES 40–41

PATRICIA BELLAN-GILLEN

Patricia Bellan-Gillen received her B.F.A. from Edinboro State University, Edinboro, Pennsylvania, in 1975, and an M.F.A. in printmaking from Carnegie-Mellon University, Pittsburgh, in 1979. She has been awarded two grants from the Pennsylvania Council on the Arts and one from Carnegie-Mellon. Her work has been exhibited in galleries in Pennsylvania and Washington, D.C. In her prints, which she often reworks with graphite or colored pencil, Bellan-Gillen combines un-related objects into still-life arrangements that encourage viewers to reexamine their perceptions.

STILL LIFE III. 1981. PAGE 156

BARTON LIDICÉ BENEŠ

Barton Lidicé Beneš was born in New Jersey in 1942. He studied painting at the Pratt Institute, New York, in 1960–61 and graphics at the Académie des Beaux-Arts, Avignon, France, in 1968. Beneš works in a variety of media, including sculpture, collage, and printmaking. His work has been widely exhibited at museums in the United States, including the Craft and Folk Art Museum, Los Angeles, the Virginia Museum of Fine Arts, Richmond, the Renwick Gallery, Washington, D.C., and the Alternative Museum, New York. His work is included in the collections of the National Museum of American Art, Washington, D.C., the Art Institute of Chicago, and the Bibliothèque Nationale in Paris. Beneš uses all sorts of found objects, as well as objects collect-ed in his travels around the world, to create his collages, sculptures, and assemblages. His works are humorous explo-rations of societal customs and assumptions. In 1983 Beneš made a series of collages and paper sculptures from six million dollars in shredded bills he was given by the Federal Reserve Board. In another series, "Letters to My Aunt Evelyn," Beneš incorporated portions of his correspondence with his aunt in his objects. His pieces often include visual puns and are often crafted to look as if they were made from other media. The artist extends his punning to the titles, whose meaning becomes central to the objects.

HAMMER. 1982. PAGE 82
LIVE WIRES. 1982. PAGE 144
RELIQUARY/PIER 48 HUDSON RIVER. 1982. PAGE 115
TOOLS IN PRINT. 1983. PAGE 66

CONSTANCE BERGFORS

Constance Bergfors was born in Quincy, Massachusetts, and was educated at Smith College, where she majored in zoology. While working as a medical illustrator she developed a love for drawing, which she pursued first at the Corcoran School of Art in Washington, D.C., and then at the Accademia di Bella Arte in Rome. The artist traveled and lived abroad in both Europe and Africa before returning to the United States in 1964. Her work has been shown in exhibitions at the Galeria Editalia, Rome, the Museo Nacional de Belas Artes, Rio de Janeiro, and various East Coast galleries and museums in the United States. Bergfors's initial flat canvases of floating color shapes gradually evolved into irregularly shaped relief paintings. Well after having become established as a painter, she took up carving, first in stone and then in wood. Despite the change in media, she continues to focus on abstract bio-morphic forms as the subject of her work. Bergfors's sculptural process consists of stripping logs of their outer bark and sap-wood, carving the wood with a chainsaw, and then sanding and polishing it to achieve a smooth finish.

HARD ROCK TWIST. 1989. PAGE 109

MARK BLUMENSTEIN

Mark Blumenstein was born in Philadelphia in 1943. After studying agriculture at Pennsylvania State University for a year, he left to work for a photography company. In his spare time he began to make carved wood sculptures. In the early 1970s he moved to a farm in West Virginia. He bought a set of welding torches so that he could dismantle the discarded trucks and machinery he found on the property, and he began to weld the objects together, first into furniture for his log cabin, then into sculptures. The whimsical sculptures of birds and animals he creates from farm machinery, old tools, and found objects are in art collections around the country. Blumenstein found in the old tools and machinery a history he felt should be acknowledged: "I just couldn't see discarding pieces of the past that so many hands had been involved with," he said.

BARNEY WIGGLE. 1991. PAGE 152
SAW BIRD. 1979. PAGE 18

JONATHAN BOROFSKY

Born in Boston, Massachusetts, in 1942, Jonathan Borofsky received a B.F.A. from Carnegie-Mellon University in Pittsburgh. After studying at the École de Fontainebleau in 1964, Borofsky earned his M.F.A. from the Yale University School of Art in 1966. He works in a wide range of media, including painting, sculpture, drawing, and printmaking, and

also creates site-specific installations. Borofsky had his first solo exhibition at Paula Cooper Gallery, New York, in 1975 and has since exhibited throughout the world, including solo exhibitions at the Nelson-Atkins Museum of Art, Kansas City, the Tokyo Metropolitan Art Museum, the Philadelphia Museum of Art, and the Whitney Museum of American Art, New York. Borofsky's work has also been included in three Whitney Biennials and in Documenta VII, Kassel, Germany. His work is included in many international museum collections. Borofsky's work has changed throughout his career, with his early conceptual work evolving into figurative and expressionistic modes. The artist has said that these stylistic shifts mirror the complexities of life. Among Borofsky's earliest pieces were pages across which he wrote numbers; he then stacked the pages and designated them sculptures. He continues to number his artworks. Because his work explores the duality between the rational and the emotive, much of his imagery is also drawn from dreams and the subconscious. Borofsky continually recycles images and ideas, reusing them in new contexts. Among the images he recycles are a series of archetypal figures—Molecule Man, Running Man, and Hammering Man—that represent different aspects of the individual and to which viewers are to bring their own ideas and associations.

HAMMERING MAN. 1990. PAGE 129

RICHARD BRONK

Richard Bronk received a B.S. at the University of Wisconsin at Stout. He has had solo exhibitions at the Wisconsin Academy of Sciences, Arts and Letters, Madison, and Mount Mary College, Milwaukee, and his work has been exhibited at the Milwaukee Art Museum (1987) and at the Charles A. Wustum Museum of Fine Arts, Racine, Wisconsin (1992). His work is included in the collection of the City of Milwaukee. Bronk's humorous hand-carved sculptures are often visual and verbal puns based on common expressions and phrases.

SHIP OF TOOLS. 1992. PAGE 149

CHARLIE BROUWER

Charlie Brouwer was born in Holland, Michigan, in 1946. He received an M.A. in painting in 1980 and an M.F.A. in sculpture in 1984, both from Western Michigan University, Kalamazoo. Brouwer has taught high school in Australia and in the United States and has taught art at Radford University, Radford, Virginia, since 1987. He has shown at galleries and art centers throughout the United States and in Hungary and Poland. His work has been included in exhibitions at the Art Museum of the Americas Organization of American States,

Washington, D.C., and the Charles A. Wustum Museum of Fine Arts, Racine, Wisconsin. His work is in the McDonald's Corporation Collection, the UpJohn Corporation Collection, the Notoro Collection of International Contemporary Art, Poland, and the International Outdoor Wood Sculpture Park, Nagyatad, Hungary. Brouwer employs a visual vocabulary of natural and artificial objects, including tools, as metaphors to express larger spiritual truths. With his use of tool imagery and his preference for raw lumber as a medium, Brouwer alludes to the perception that "in America, anyway, every man is a handyman." The simple, honest quality resulting from the simplicity of his medium, together with his rough-hewn, almost childlike style, lend his work an accessibility that gives way to deeper meanings.

HE ALWAYS CARRIED HIS OWN LADDER TO THE JOB. 1989. PAGE 61
NOW THE LORD GOD PLANTED A GARDEN.... 1992. PAGE 59

THAI BUI

Thai Bui, a native of Hanoi, Vietnam, studied at the City College of San Francisco and the San Francisco Art Institute. He was awarded the Skowhegan Scholarship from the School of Sculpture, Skowhegan, Maine. Bui works primarily in steel but also incorporates other materials in his pieces, including rocks, wood, copper, and tools. Often small-scale, his work is highly detailed and playful.

HANGING HAMMER. 1986. PAGE 150

JAMES BUTLER

Born in Fort Dodge, Iowa, in 1945, James Butler received a B.S. from the University of Nebraska at Omaha in 1967 and an M.F.A. from the University of Nebraska at Lincoln in 1970. He has taught printmaking at Southern Illinois University and Illinois State University. Butler's work has been included in exhibitions of prints and drawings at numerous galleries and at the Minneapolis Museum of Art, St. Paul, and the Walker Art Center, Minneapolis. Butler's drawings and prints focus on surreal portrayals of everyday scenes, in which common objects are often depicted in unusual settings.

AT THE HEAD OF THE STAIRS. 1972. PAGE 162

HUGH R. BUTT

Hugh R. Butt was born in Delhaven, North Carolina, in 1910. He earned his B.A. from the University of Minnesota and his M.D. from the University of Virginia in 1933. A doctor on staff at the Mayo Clinic in Rochester, Minnesota, Butt is also a self-taught artist who creates metal sculptures. In the 1980s he made a series of sculptures using antique tools he

had collected. The artist wrote that this group of sculptures "signifies my belief that it sometimes takes a long time before tools find their proper usefulness."

THE LONG ROAD TO USEFULNESS. 1989. PAGE 63

DEBBIE FLEMING CAFFERY

Debbie Fleming Caffery was born in New Iberia, Louisiana, in 1948. She received her B.F.A. from the San Francisco Art Institute in 1975. Caffery photographs workers in the local sugarcane fields and sugar mills. She works with a simple camera and prefers to use daylight to illuminate her subjects. The straightforward simplicity of her images aligns her with the documentary tradition of Berenice Abbott and Walker Evans. Caffery's work has been exhibited widely throughout the United States and Europe, including shows at the Contemporary Arts Center, New Orleans, and the National Museum of American History, Smithsonian Institution, Washington, D.C.

HOMER. 1986. PAGE 89

ANTHONY CARO

Anthony Caro was born in London in 1924. One of Britain's most distinguished sculptors, Caro was knighted in 1987. Over the years he has forged a new language out of simplified architectonic shapes that simultaneously evoke the subtle strength of metal and the warm roundness of clay. He received an M.A. in engineering from Christ College in Cambridge in 1944. After serving in the Fleet Air Arm of the Royal Navy during World War II, he studied sculpture at Regent Street Polytechnic in London and attended the Royal Academy Schools in London. From 1951 to 1953 he was assistant to Henry Moore. He taught at St. Martin's School of Art in London from 1953 to 1979 and continues to participate in workshops. In 1954 he began modeling figurative sculpture in clay and plaster. The following year he participated in his first group exhibition, at the Institute of Contemporary Arts in London. Inspired by a 1960 trip to Brittany, where he studied menhirs and dolmens—ancient human-made stone formations—he created his first abstract sculptures in steel, adding color a year later. He visited the United States for the first time in 1959, returning to teach at Bennington College in Vermont from 1963 to 1965. He began making table sculptures, which often incorporated a handle or sometimes a tool to ensure that they would not be mistaken for models of his large-scale works. In 1967 he was given his first retrospective, at the Rijksmuseum Kröller-Müller in Otterlo, and since then he has continued to be the subject of major exhibitions throughout the world. In 1970 he produced his first unpainted sculptures. He was commissioned to create a work for the 1978 inauguration of the East Wing of the National Gallery of Art in Washington, D.C. His first visits to Greece in the 1980s inspired a body of work that includes *After Olympia*, his most monumental work to date. Intensely physical, Caro's work suggests a kind of primal struggle between rigid geometry and organic forms. Other recurring themes include the play between void and solid, frame and infill, and concave and convex.

WRITING PIECE "SPICK". 1978. PAGE 42

JAMES CARTER

Born in Port Chester, New York, in 1948, James Carter studied at Silvermine College of Art in Connecticut and graduated with a B.F.A. from the Maryland Institute of Art. Carter's paintings and prints have been exhibited at the Zenith Gallery, Washington, D.C., the Horizon Gallery, New York, and the Bell Gallery, Greenwich, Connecticut. His still lifes display the influence of Surrealist painters of the 1930s such as René Magritte and Max Ernst. Like the Surrealists, Carter juxtaposes unexpected objects—teacups, whales, and blue skies, for example—which often sit uncomfortably within his pictorial space. But he has also been influenced by the late-nineteenth-century American trompe l'oeil painters William Harnett and John Peto, as demonstrated by the great detail and tactile presence of the objects in his work.

PAINT CAN & TOOLS. 1988. PAGE 120

JEFFREY CHAPLINE

After receiving his B.F.A. in ceramics from the University of Kansas at Lawrence in 1980, Jeffrey Chapline went on to study glassworking, receiving his M.F.A. from the University of California at Los Angeles in 1984. He has been awarded two grants from U.C.L.A. and a fellowship from the Creative Glass Center of America. His work has been exhibited at galleries and universities around the country. Chapline works in cast glass by arranging objects in a sand mold, making a casting, and filling the mold with molten glass; he then makes still-life arrangements from the objects.

TOOLS. 1986. PAGE 151

DEBRA CHASE

Debra Chase was born in Rochester, New York, in 1954. She received a B.S. in studio art in 1977 from Nazareth College, Rochester, and an M.F.A. from the School for American Craftsmen, Rochester Institute of Technology, in 1982. Her

sculpture has been exhibited at the American Craft Museum, New York, the Albright-Knox Art Gallery, Buffalo, and the Renwick Gallery, National Museum of American Art, Smithsonian Institution. Chase sees her wall-mounted "clothing" of wire mesh as visual metaphors for rites of passage, celebrations, and various social states. Beginning with kimono compositions that were two-dimensional and meant to be displayed on the wall, Chase moved to larger, more three-dimensional constructions, including a series of "Life Jackets" that refer to meaningful but fleeting experiences from daily life. The mesh screening allows the artist to work with light and transparency while it serves as the ground for decorative, rhythmic patterns of elements such as tools, leaves, flowers, and figures.

HAND-TOOLED JACKET II. PAGE 113

IVAN CHERMAYEFF

Ivan Chermayeff was born in London in 1932. He studied at Harvard University, the Institute of Design, Chicago, and Yale University's School of Art, where he received his degree in 1955. A graphic designer, painter, illustrator, and photographer, Chermayeff is a founding partner of the graphic design firm Chermayeff & Geismar, Inc., New York. He has received numerous awards, including the Industrial Art Medal from the American Institute of Architects and the Gold Medal of the American Institute of Graphic Artists. His paintings, collages, and illustrations have been exhibited throughout the world, including the Soviet Union, Europe, and Japan. His well-known design projects include the United States exhibit pavilions at Expo '67 and '70 and corporate logos for IBM, Mobil, Westinghouse, and the National Parks Service. He has served on the boards of the Museum of Modern Art and the Archives of American Art, National Museum of American Art. Chermayeff created a series of kodalithographs for the Hechinger Company, photographing tools, hardware, and lumber in the company warehouse, then enlarging and cropping the images, which he printed in high contrast. Removed from their usual context, the subjects become explorations of pattern, texture, light, and dark.

UNTITLED. 1978. PAGE 132

TOM CHRISTOPHER

Born in Los Angeles in 1952, Tom Christopher received his B.F.A. from the Art Center College, Pasadena, California. He moved to New York City in 1981 and worked for CBS-TV as a courtroom sketch artist. He has also done illustrations for the *Wall Street Journal* and the *New York Times*. Christopher

returned to California in 1993, but he maintains a studio in New York. His work is exhibited regularly at galleries in New York and California. Among his commissions have been works for Absolut Vodka and for Long Island City, New York. Christopher's work was influenced by the Bay Area figurative painters of the late 1950s and early 1960s. His brushstrokes are loose and gestural, and he uses intense, primary colors, creating canvases that are full of energy and motion. He has painted a series focusing on tools and more recently has begun a series of New York cityscapes.

WIRE CUTTERS. PAGE 160

CHRIS COLLICOTT

By using tools in a nontraditional way, designer Chris Collicott encourages viewers to look beyond the tool's mundane function and appreciate its inherent aesthetic quality.

WRENCH BOWL. 1986. PAGES 10–11

JACQUELINE CONDERACCI

Jacqueline Conderacci was born in Rochester, New York, in 1953. She attended the International Center of Photography, New York, in 1980, where she studied with Buzz Hartshorn, and she continued her photography courses in 1985 at New York University with Elaine Mayes and Mark Jenkinson. Her work has been shown at Sardi's and at OK Harris Gallery in New York. Her elegiac series "Locked Up and In and Out" focuses on door locks to discuss issues of confinement and bondage.

LOCKED UP AND IN AND OUT #13. 1986. PAGE 71
LOCKED UP AND IN AND OUT #16. 1986. PAGE 71
LOCKED UP AND IN AND OUT #24. 1986. PAGE 71

JUDITH COWAN

Judith Cowan was born in London in 1954. She attended Bristol Polytechnic in 1973–74, Sheffield Polytechnic in 1974–77, and the Chelsea School of Art in 1977–78. She is the recipient of a Gulbenkian Rome Scholarship as well as the Greater London Arts Association Award. Her drawings and sculptures have been shown extensively in England and are included in the collection of the Arts Council of Great Britain. Cowan's vocabulary ranges from antique vases and metalware to contemporary household implements. Her realist renderings of consumer products seem to propose truth as an empty vessel as they explore notions of containment, contrary meanings, and a hidden core.

HAMMER. 1984. PAGE 144
WRENCH. 1984. PAGE 144

GRAHAM CROWLEY

Born in Romford, England, in 1950, Graham Crowley attended the St. Martin's School of Art from 1968 to 1972 and the Royal College of Art, London, from 1972 to 1975. He was an artist-in-residence at Oxford University in 1982–83 and was a visiting tutor at the Royal College of Art. Crowley's work has been shown extensively in England and Europe, including exhibitions at the Venice and Paris biennials, at the Fitzwilliam Museum, Cambridge, and at the Walker Art Gallery, Liverpool, and is included in a number of public collections. He has also completed several large-scale public commissions. Crowley worked originally as an abstract painter but began to paint figuratively in the 1970s. He has been influenced by cartoons and comics, particularly the work of Walt Disney. His works—exaggerated images of ordinary objects—suggest a child's view of the world, in which household items are imbued with the potential to come alive. This perception is enhanced by the disproportionate scale of Crowley's objects and his often skewed perspective.

THE CLAMPDOWN. 1983. PAGE 52

STAN DANN

Stan Dann was born in Vancouver, British Columbia, in 1931. Dann studied at the Faulkner Smith Academy of Fine Art, Vancouver, and received a B.A. from the Art Center College, Los Angeles, in 1957; he has worked primarily in California. He has completed several public commissions in the United States, and his work is included in many corporate collections. The artist creates constructions composed of carved and painted wood elements in high relief against a flat background. He combines geometric and organic shapes based on ordinary objects such as tools and appliances in his dynamic compositions, which are further energized by the expressionistic brushwork he applies to the surfaces.

HAND TOOLS. 1988. PAGE 127

JAMIE DAVIS

Jamie Davis was born in Philadelphia in 1945. He earned a B.A. from Vanderbilt University, Nashville, in 1967, an M.A. from Exeter College, England, in 1971, and an M.F.A. from Clemson University, South Carolina, in 1973. Primarily a ceramicist, Davis also creates wall-mounted sculptures of metal, fabric, and paper. His work has been exhibited at the Renwick Gallery, Smithsonian Institution, Washington, D.C., and in several galleries. His body of work is quite varied in media and technique, but all of it is self-referential, expressing his personal experience. His work from the 1980s, during

which time he was building a house, features images of tools and construction.

GINGER JAR VASE. 1982. PAGE 82

GEORGIA DEAL

Georgia Deal was born in New York City in 1953. She completed a B.A. in fine arts in 1975 at the Virginia Polytechnic Institute in Blacksburg and an M.F.A. in printmaking at the University of Georgia in Athens in 1977. Known as a master printmaker and papermaker, Deal has also been a visiting artist and has taught at numerous universities on the East Coast and abroad. She has exhibited widely, and her work can be found in several collections, including the Philadelphia Museum of Art, the Munson-Williams Proctor Institute, Utica, New York, and the Philip Morris Collection. Her symbolic narratives, which often feature abstract, basketlike vessels or vortexes, mine the perennial themes of memory and anticipation, emptiness and fecundity. Her work abounds in humor and mystery, qualities that are complemented by the seductive surfaces of her handmade paper.

COLLECTOR'S CHAIR III. 1985. PAGE 140

DIES DE JONGE

Dies de Jonge was born in Brouwershaven, Holland, in 1948 and completed his studies at the Art Academy in Rotterdam in 1974. He specializes in etching, wood sculpture, and design. He has exhibited in Europe, the Far East, and the United States. His work is in several public collections, including the Municipal Museum in Amsterdam and the Museum Boymans-van Beuningen, Rotterdam, as well as many private collections in Europe and the United States. Labeled an Abstract Realist, De Jonge is fascinated by contemporary hand tools and sequential motion. He produces "portraits" that capture the tools' actions and shapes at near-life-size scale.

BRUSH AND TUB. 1982. PAGE 94

WIM DELVOYE

Wim Delvoye was born in Werwick, Belgium, in 1965. His sculptures have been included in the 1990 Venice Biennale, as well as in several exhibitions in Holland, Belgium, and New York. Delvoye's mixed-media sculptures reflect a witty blend of Dada and Surrealist sensibilities. By juxtaposing everyday, utilitarian objects with appropriated genre scenes from the past, Delvoye questions notions of identity, good taste, and functionality within a historic context.

LEONTINE. 1990. PAGE 83

JIM DINE

Jim Dine was born in Cincinnati, Ohio, in 1935. He served as a bridge between Pop Art and a new generation of figurative expressionism, and continues to refine his technical virtuosity in paintings, sculptures, drawings, and graphics. From 1953 to 1955 he studied at the University of Cincinnati and the Boston Museum School, and in 1957 he received his B.F.A. from the University of Ohio. After a year of graduate work, he moved to New York in 1958. He taught at various schools in the New York area through 1961. In 1959 he exhibited with Claes Oldenburg at the Judson Gallery, his first New York show. During the early years in New York, his work combined real and painted objects, evolving from the theater pieces he made for the Judson Gallery "happenings." These expressionist assemblages reinterpreted Action Painting by presenting objects not as symbols but as real, contingent presences. In 1964 Dine was included in the Venice Biennale. He began his "Robe" series in 1966, when he moved to London to distance himself from the Pop Art scene. In 1970 he moved to Vermont, and during the 1970s he taught at several New England institutions. In 1980 he was elected to the American Academy and Institute of Arts and Letters. The Whitney Museum of American Art, New York, gave him his first retrospective in 1970, when he was thirty-five, and the Museum of Modern Art, New York, held a print retrospective in 1978. A touring exhibition of his drawings began ten years later. Dine developed a love of tools at his family's hardware store, and they have remained a favorite subject throughout his career, along with hearts, palettes, and robes. In recent years he has added skulls, trees, gates, and the torso of Venus to his lexicon of images, and his work has been marked by a heightened sense of drama and sensual gestural surfaces.

ATHEISM. 1986. PAGE 36
BIG RED WRENCH IN A LANDSCAPE. 1973. PAGE 136
TEN WINTER TOOLS II. 1973–89. PAGES 134–35
TOOL BOX. 1966. PAGES 116–17

JAMES DRAKE

James Drake was born in Lubbock, Texas, in 1946 and lived in Guatemala from 1955 to 1959. He received a B.A. and an M.F.A. from the Art Center College of Design in Los Angeles. Drake has exhibited widely, including shows at the Corcoran Gallery of Art in Washington, D.C., the La Jolla Museum of Contemporary Art, California, and the Museum of Modern Art in Ljubljana, former Yugoslavia. In 1989 he received a Southeast Center for Contemporary Art Award in the Visual Arts and a National Endowment for the Arts Grant and Travel Fellowship. His work can be found in the collec-

tions of the Corcoran Gallery of Art in Washington, D.C., the Birmingham Museum of Fine Art, Alabama, the New Orleans Museum of Art, and the Museum of Fine Arts, Houston. Known primarily as a sculptor, Drake is also an accomplished painter, draftsman, and printmaker. In the late 1970s he began a series of monochromatic, theme-based room installations in cast metals, including *Tattoo Parlor* and *The Tool Room*, which play with the viewer's notion of reality. By the mid-1980s he had turned his attention to the conflicts and paradoxes of life along the Texas-Mexico border. Often confrontational and foreboding, his haunting images explore the dynamics of aggression in social exchange in the tradition of Goya, Géricault, and Rivera. Drake uses a wide array of symbols—including weapons, trophies, flowers, and snakes—to convey moral and spiritual struggle, mixing traditional artists' materials with industrial products and charred refuse to lend a sense of passion and physical force to his works.

TOOL ROOM. 1980. PAGES 72–73

GREG DRASLER

Greg Drasler received a B.F.A. in 1980 and an M.F.A. in 1983 from the University of Illinois in Champaign. His paintings have been shown in New York, San Francisco, Newark, New Jersey, and Chicago and are included in several private and public collections. Drasler's quasi-Surrealist work, which often places oversize utilitarian objects and figures engaged in mundane tasks in forbidding or elusive landscapes, probes the netherworld between memory and dream.

JACK. 1987. PAGE 106

HAROLD E. EDGERTON

Harold E. Edgerton was born in Fremont, Nebraska, in 1903, and he died in 1990. He received a B.S. from the University of Nebraska at Lincoln in 1925 and earned an M.S. in 1927 and a Ph.D. in 1931 from the Massachusetts Institute of Technology. He was a professor of electrical engineering at M.I.T. from 1928 until 1972. He was also a founding partner of Edgerton, Germeshausen and Grier, a technical products and services firm. His photographs have been exhibited internationally and are included in the collections of the International Museum of Photography, George Eastman House, Rochester, New York, the Centre Pompidou, Paris, and the Moderna Museet, Stockholm. As an electrical engineer, he approached the medium as a means of scientific research and was a pioneer in stop-action photography. In 1931 he invented the stroboscopic flash, which gives off brilliant light for a microsecond, freezing action while rendering precise detail. Edgerton's work had a profound influence

on the course of twentieth-century photography. His photographs changed the way we see the world, often transcending the limits of scientific documentation and passing into the realm of visual icon.

HAMMER BREAKS GLASS PLATE. 1933. PAGE 6

WILLIAM EGGLESTON

William Eggleston was born in Memphis, Tennessee, in 1939. He attended Vanderbilt University in Nashville, Delta State College in Cleveland, Mississippi, and the University of Mississippi in Oxford. Considered a master of color realism, Eggleston established his reputation as a photographer with his first one-man show at the Museum of Modern Art, New York, in 1976 at the age of thirty-seven. Since then he has exhibited internationally and has been widely published, including a portfolio of Graceland, the home of Elvis Presley, and a book, *The Democratic Forest*, a chronicle of the Western world from the Tennessee hills to the Berlin Wall. He is the recipient of numerous awards, including a Guggenheim Fellowship in 1974 and a National Endowment for the Arts Fellowship the following year. In addition to his work in photography, Eggleston is an accomplished draftsman and painter. His work can be found in the collections of the Museum of Fine Arts in Houston, the Museum of Modern Art and the Whitney Museum of American Art in New York, and the National Gallery of Art in Washington, D.C. A "street" photographer in the tradition of Henri Lartigue, Walker Evans, Lee Friedlander, and Garry Winogrand, Eggleston seeks to capture the elusive moment, often with a lurid, unsettling twist. His largely unpopulated images focus on seemingly insignificant everyday scenes realized in vivid, saturated colors.

NEAR THE RIVER AT GREENVILLE, MISSISSIPPI. 1986. PAGE 88

RON ENGLISH

Ron English was born in Illinois in 1959 and received his B.A. from the University of Texas in 1986. He began his artistic career making large-scale surrealistic photographs. After finishing graduate school he moved to New York, where he worked as one of many painters at Kostabi World, where thousands of paintings were produced and marketed under Mark Kostabi's signature. English is among the young generation of artists working in the tradition of the Pop artists of the 1960s such as Andy Warhol, Roy Lichtenstein, and Jasper Johns. His paintings are often humorous, even cynical, social commentaries, and symbols of money and power are important parts of his imagery.

THE RECONSTRUCTION. 1992. PAGE 125

RICHARD ESTES

Richard Estes was born in Kewanee, Illinois, in 1932, and raised in Evanston, Illinois. He studied at the Art Institute of Chicago and began his career as a commercial artist, working in publishing and advertising. In 1959 he moved to New York. He spent a year living and painting in Spain in 1962. Estes quickly rose to prominence as a seminal Photorealist. He had his first solo show in 1968 at the Allan Stone Gallery, New York, and has since participated in numerous national and international exhibitions. Known primarily as a painter, Estes is also an accomplished printmaker. His work can be found in the collections of the Art Institute of Chicago, the Solomon R. Guggenheim Museum in New York, the Hirshhorn Museum and Sculpture Garden in Washington, D.C., and the Teheran Museum of Contemporary Art, Iran. Estes's art, virtually synonymous with the urban streetscape, makes contemporary icons out of storefronts, parked vehicles, street furniture, and signage. Using photographs that he takes himself, Estes painstakingly reorders structural relationships until he achieves an idealized order devoid of decay and, for the most part, of human presence and emotion. A timeless, frozen quality transforms his scenes, mirroring the crisp edges and glittering surfaces of his highly finished canvases. Like Edward Hopper and Jan Vermeer—two of his heroes—light is central to his vision of the world. Estes's work is also marked by an allover focus that rewards extended viewing.

NASS LINOLEUM. 1972. PAGE 138

WALKER EVANS

Walker Evans was born in St. Louis, Missouri, in 1903 and was raised in Kenilworth, Illinois. After attending Williams College, he lived in Paris and took courses at the Sorbonne. He settled in New York in 1927 and started taking photographs the following year. His first photographs, of early Victorian houses in New England and New York, were exhibited at the Museum of Modern Art in New York in 1933. In 1935 he spent time in Mississippi and Alabama photographing tenant farmers and sharecroppers; these photographs were published in a collaborative book with the writer James Agee titled *Let Us Now Praise Famous Men* (1941). In 1945 Evans became a staff photographer and then an associate editor for *Fortune* magazine, where he worked until 1965. There he published many photographic portfolios, including "Beauties of the Common Tool" (July 1955), which he introduced by writing that "almost all basic small tools stand, aesthetically speaking, for elegance, candor and purity." After leaving the magazine, he became a professor of graphic design at Yale University, where he remained until his death in 1975. He

received many awards, including a Guggenheim Foundation Fellowship in 1940. His work has been exhibited internationally and is included in most major museum collections of photography. Along with Berenice Abbott and Dorothea Lange, Evans established the tradition of documentary photography. He was profoundly affected by the social problems of his time and felt a sense of responsibility to point up the plight of the less fortunate. By striving to make his images as detached and unemotional as he could, by removing sentiment and beauty, Evans endowed these social commentaries with profound impact.

WRENCH (FROM "BEAUTIES OF THE COMMON TOOL," *FORTUNE*, JULY 1955). 1955. PAGE 86

HENRYK FANTAZOS

Henryk Fantazos was born in Kamionka Strumilowa, near Lvov in former Poland, in 1944. He attended the Lyceum of Fine Arts in Katowice, Poland, from 1957 to 1963 and completed an M.F.A. in painting at the Academy of Fine Arts in Cracow, Poland, in 1967. In 1975 he emigrated to the United States. He has exhibited in Poland, Germany, and America. His work is included in several public and private collections both in Europe and the United States. Drawing on the traditions of the Neue Sachlichkeit Viennese School and the Cracow Circle of Metaphorical Art, Fantazos creates haunting still lifes and poetic commentaries on contemporary urban existence.

WOMEN IN LABOR. 1986. PAGE 103

HOWARD FINSTER

Howard Finster was born in Valley Head, Alabama, in 1916, and has lived on his three-acre home, called Paradise Garden, in Pennville, Georgia, since the mid-1960s. He experienced visions from the age of three and was a revivalist Baptist preacher for forty years in Georgia, Alabama, and Tennessee. He received his calling to paint "sacred art" in 1976, when he was retouching a bicycle and a splash of white paint on his finger transformed into a vision. Since then he has created thousands of evangelically patriotic, religious, and heroic paintings and sculptures. Today he is the best-known living folk artist. His work has been exhibited widely, including shows at the High Museum of Art in Atlanta, Georgia, the National Museum of American Art in Washington, D.C., the Museum of American Folk Art and the Paine-Webber Gallery in New York, and the Los Angeles County Museum of Art. In 1984 he was included in the United States exhibition at the Venice Biennale. His riotous images, which combine every kind of graphic medium, include "primitive" portraits of such American icons as Elvis Presley, George Washington, and John Kennedy, as well as biblical quotations and texts from his own fiery wisdom. Tools hold a particular fascination for Finster, who considers them the hallmark of civilization and the key to winning the American West.

MOUNTAINS OF PEOPLE USE TOOLS. 1990. PAGE 56
TOOLS HELP BUILD THE WHOLE WORLD. 1990. PAGE 56

SUSAN FIRESTONE

Susan Firestone was born in Madison, Wisconsin, in 1946. She holds a B.A. from Mary Baldwin College in Staunton, Virginia, and studied at the Pennsylvania Academy of Fine Arts in Philadelphia. She continued her studies at the Skowhegan School of Painting and Sculpture in Maine. In 1973 she completed her M.F.A. in painting at the American University, Washington, D.C., and she attended the Corcoran School of Art, Washington, D.C., in 1977. She has exhibited widely and has studios in New York and Washington, D.C. She works in painting, drawing, sculpture, and printmaking, and her materials—from transformers and auto parts to saw blades and tarot cards—hint at her idiosyncratic blend of Eastern mysticism and Western materialism. Firestone sees the artist as a craftsperson in contemporary society and tools as the artifacts of today. Her dreamy images often incorporate pictographs and electronically timed sequences of word variations. The goddess as muse and augur is a common motif, and since 1991 she has been making plaster and bronze casts of the human form. Her work, which includes Pop Art elements and pays homage to Man Ray and Marcel Duchamp, is also marked by a distinctly poetic approach.

HARD CHOICES, DREAMS OUT OF CONTEXT. 1987. PAGE 131
SMOOTH CUT. 1987. PAGE 81

PIERRE FLANDREAU

Pierre Flandreau was born in Panama in 1948. He received a B.A. from the College of Marin, Kentfield, California, and also studied at the California College of Arts and Crafts. Flandreau is primarily a painter, but he began to work with bronze in the mid-1980s. Many of the materials in his sculptures are found objects—natural materials or artificial items—which he juxtaposes in his explorations of the relationship of man to his environment.

HOMAGE TO CHESTER ARNOLD. 1987. PAGE 67

HANS GODO FRABEL

Hans Godo Frabel was born in Jena, Germany, in 1941. He studied scientific glassblowing at Jena Glaswerke and took art

classes at the Mainzer Kunstschule in Mainz, Germany. In 1965 he moved to Atlanta, Georgia, where he attended the Georgia Institute of Technology. In 1968 he established the Frabel Studio in Atlanta. Today he is recognized as one of the world's leading glass artists. He has done commissions for Absolut Vodka, the Carter Center, the Corning Museum of Glass, and the Smithsonian Institution, among others. Frabel's delicate and innovative sculptural compositions begin with heated borosilicate rods that are shaped with a hot lamp or by hand. His subjects, often rendered at life-size scale, encompass the human figure, tools, birds, flowers, and water droplets.

Faucet (In the Middle of the Night). 1979. Page 78

Hammer and Nails. 1980. Page 24

Light Bulb. 1979. Page 79

Ke Francis

Born in Memphis, Tennessee, in 1945, Ke Francis studied at the Memphis Academy of Arts from 1964 to 1967 and earned his B.F.A. from the Cleveland Institute of Art in 1969. Francis works in a variety of media, including painting, sculpture, printmaking (particularly woodcuts), and photography, and often combines several media in a single installation. He has been awarded a National Endowment for the Arts Individual Artist's Grant and a Rockefeller Foundation Grant. His work has been exhibited at the Southeastern Center for Contemporary Art, Winston-Salem, North Carolina, and the National Museum of American Art, Washington, D.C. His profoundly narrative works seem to translate the Southern oral tradition into visual terms. In 1980 Francis began working on the "Reconstruction" series, which depicts the destruction wrought by tornadoes and the rebuilding that goes on afterward. His idiosyncratic style—part Cubist, part "primitive"—and his particular vocabulary of images, including the circular saw, combine to create quirky yet heroic paeans to the human spirit.

Reconstruction Vision. 1988. Pages 168–69

Reconstruction Vision. 1991. Page 26

Tornado. 1991. Page 167

Hilary French

Hilary French was born in Boston, Massachusetts, in 1958. She received her B.F.A. from the University of Wisconsin at Madison in 1980 and her M.F.A. in photography from the Rhode Island School of Design, Providence, in 1989. She has exhibited her photographs in galleries in Boston and elsewhere. Through her work, which includes photograms and photography combined with other media such as relief casts,

French explores the boundary between the actual object and its image.

Positive/Negative Apron. 1990. Page 159

David Furman

David Furman, a ceramic artist, was born in Seattle, Washington, in 1945. He received his B.A. from the University of Oregon in 1969 and his M.F.A. from the University of Washington in 1972. Furman is director of the Studio Arts program at Pitzer College in Claremont, California, as well as a professor of art at Claremont Graduate School. His work has been exhibited nationally in numerous gallery and museum shows. He has been awarded two Fulbright Senior Artist Fellowships and a National Endowment for the Arts Interdisciplinary Fellowship. Furman creates trompe l'oeil ceramic sculptures of ordinary objects, such as bulletin boards and paintbrushes, which form part of an ongoing series.

Paint Brush Bouquet. 1989. Page 94

Walter Garde

Born in 1952 in Newark, New Jersey, Walter Garde received his B.F.A. from Virginia Commonwealth University, Richmond. His paintings and drawings have been exhibited at the University of Richmond and the Virginia Museum of Fine Arts, Richmond, as well as the Southeastern Center for Contemporary Art, Winston-Salem, North Carolina. He has received a fellowship from the Virginia Museum of Fine Arts and an award from the National Endowment for the Arts. The artist began a series of tool paintings in the early 1980s.

Extension Cord #5. Page 154

Steven Geiger

Steven Geiger was born in Quakerstown, Pennsylvania, in 1956. He studied at Bucks County Community College in 1986–88 and the School of Visual Arts, New York, in 1988–90. The sculptor's work was first exhibited at OK Harris Gallery in New York in 1991. Using found objects and natural materials, Geiger explores the transformation of materials into objects.

Mechanized Icon. Page 109

Guy Goodwin

Born in Birmingham, Alabama, in 1940, Guy Goodwin received a B.F.A. from Auburn University, Alabama, and an M.F.A. from the University of Illinois at Champaign-Urbana.

Goodwin's paintings have been exhibited in Europe and the United States, in shows at the Whitney Museum of American Art, New York, the Indianapolis Museum of Art, and the Pratt Institute, New York, among other museums. He creates watercolor and charcoal drawings to explore compositions and colors for his paintings. The format of his paintings derives from traditional still-life and landscape compositions with elements bluntly pared down and pieced back together in interlocking patterns. Tools and household objects are recurring themes in Goodwin's work, providing the vehicle for his investigation of space, form, texture, and color.

UNTITLED (PICKAXE/SHOVEL/FLOWERS). 1985. PAGE 161

COLIN GRAY

Colin Gray was born in 1952 and grew up in Devonshire, England. In the 1970s he moved to the United States. His sculptures have been exhibited at galleries in California, including a one-man show at the Riverside Art Museum. Gray began using tools in his sculpture in the early 1970s, not only because of their visually pleasing forms but also because they seem to be imbued with a physical presence. With their curved and twisted forms, Gray's sculptures are humorous and energetic.

HOUSE AND HOME. 1988. PAGE 48

JOHN GRAZIER

Born in 1946 in Long Beach, New York, John Grazier studied at the Corcoran School of Art, Washington, D.C., in 1968 and the Maryland Institute College of Art in 1970–71. His work was first exhibited at the Baltimore Museum of Art in 1974 and has since been exhibited at the Corcoran Gallery of Art, the Southeastern Center for Contemporary Art, North Carolina, and the Tampa Museum. Grazier completed a large commission of multiple works for the celebrated Greyhound Bus Terminal in Washington, D.C. His work is included in the collections of the National Museum of American Art and the Library of Congress. A draftsman and a painter, Grazier executes his images meticulously in black and white with airbrush. He paints empty office buildings, houses, lunch counters, and buses; uninhabited, enigmatic scenes that are permeated by a sense of loneliness. A slightly skewed perspective emphasizes the images' abstract designs and monochromatic patterns.

PASSING WINDOWS IN FALL. 1983. PAGE 143

RED GROOMS

Red Grooms was born Charles Rogers Grooms in Nashville, Tennessee, in 1937. An innovative painter, printmaker, filmmaker, and pioneer of "happenings," Grooms uses fantasy, wit, and satire as ways to comment on modern life in America, especially the city and its inhabitants. He began drawing as a child, absorbing various influences that would later inform his art—Hollywood movies, the circus, and the Tennessee State Fair. In 1955 he enrolled at the School of the Art Institute of Chicago, but he quit after a semester. The following year he moved to New York and attended the New School for Social Research, where he studied under the social realist painter Gregorio Prestopino. He continued his formal training at the George Peabody College for Teachers in Nashville, finishing at the Hans Hofmann School of Fine Arts in Provincetown, Massachusetts, in 1957. While working as a dishwasher in Provincetown that summer, the artist was nicknamed "Red" by a co-worker. In September 1957 he settled in New York and began to participate in "happenings" with Allan Kaprow and others. His early paintings were mostly figure studies and portraits painted with inexpensive hardware-store enamels and tinting colors. In 1958 he had his first exhibition, at the Sun Gallery in Provincetown, and a show at the City Gallery in New York later that year. Within a few years he was increasingly involved in making sculpture and collage. In 1962 he created his first film, *Shoot the Moon*, which was followed by several others, including the well-known *Ruckus Manhattan* (1975–76), a "sculpto-pictorama" of New York City, and *Hippodrome Hardware* (1972–73). Done as a circus-style show and based on a live performance of the same name, *Hippodrome Hardware* pays homage to the tools used to build his grandmother's house and the tools of the trade employed in the Hippodrome, Manhattan's biggest theater. In the 1960s and early 1970s Grooms developed an exaggerated, cartoonlike style, which was heightened with the use of bright, high-keyed colors, bold compositions, and everyday subjects. This approach was also evident in his multimedia environments, in which he filled entire rooms with cutout figures and objects. In the late 1970s he turned his attention to diverse topics ranging from sex, football, and hardware to cowboy imagery. Today he continues to explore themes related to popular culture, striking an edgy balance between documentation and acerbic commentary. His work has been the subject of numerous exhibitions, including a retrospective at Rutgers University Art Gallery in New Brunswick, New Jersey, in 1973 and the Pennsylvania Academy of Fine Arts in Philadelphia in 1985, both of which subsequently traveled

around the country. Grooms is represented in leading public collections worldwide.

I Nailed Wooden Suns to Wooden Skies (in conjunction with the film *Hippodrome Hardware*, 1972–73). 1972. Page 114

Peter Gryzybowski

Peter Gryzybowski was born in Poland and received his artistic training at the Cracow Academy of Fine Arts from 1977 to 1982. He moved to the United States soon after completing his degree. A painter as well as a performance artist, Gryzybowski has exhibited work in Poland, France, Germany, and the United States. His trompe l'oeil images—including an ongoing series of paintings resembling wood panels—are difficult to distinguish from the actual objects.

Untitled (Oak). 1990. Page 108

Pier Gustafson

Pier Gustafson was born in Minneapolis, Minnesota, in 1956. He received a B.S. from Gustavus Adolphus College, St. Peter, Minnesota, in 1978, and an M.F.A. in painting from the University of Wisconsin at Madison in 1982. He then moved to Boston. Gustafson makes painstakingly folded paper constructions and then covers the surface with pen and ink, creating, in effect, three-dimensional drawings. He has received a National Endowment for the Arts Fellowship and two Massachusetts Artist Fellowships. His work has been exhibited at the Museum of Fine Arts, Boston, the Institute of Contemporary Art, Boston, and the Minnesota Museum of Art, St. Paul. He began making sculpture-drawings of individual objects such as paint tubes and hammers, and then went on to create whole environments, including a crowded garage and a storeroom filled with forgotten objects.

Drill Press. 1982. Page 105

Step Ladder with Can and Brushes. 1982. Page 78

Fred Gutzeit

Fred Gutzeit was born in Cleveland, Ohio, in 1940. He attended the Cleveland Institute of Art from 1959 to 1962 and Hunter College, New York, from 1977 to 1979. He has exhibited widely and is represented in several private collections. In the tradition of Claude Monet, he created a series of paintings in 1977 that chronicled a close-up section of sidewalk at different times of day and under various weather conditions. Another body of work features mixed-media assemblages and installations created from discarded work gloves (which he collects himself and sometimes paints over in

bright colors), mirrors, and neon, among other materials. These idiosyncratic ensembles not only trace the artist's creative process but also reflect the accumulated social experience of the anonymous workers who wore the gloves.

Glove Box. 1982. Page 93

Stephen Hansen

Stephen Hansen was born in Tacoma, Washington, in 1950 and is a self-taught artist. His prints and papier-mâché sculptures have been exhibited internationally through the United States Information Agency and in the United States at museums and galleries, including the Lakeview Museum, Peoria, Illinois, the Byer Museum of the Arts, Evanston, Illinois, the Smith-Andersen Gallery, Palo Alto, California, and the Zenith Gallery, Washington, D.C. His work is included in numerous corporate collections, including that of Herman Miller, Inc., and private collections. Hansen's humorous, gently satirical sculptures of "Everyman" show the figure engaged in all sorts of routine activities—working around the house, talking on the telephone, leaning against a ledge. His often life-size figures seem to conspire with the viewer in good-humored, prankish jokes.

Man on a Limb. 1985. Page 21

Painter. 1989. Page 165

Linda Hanson

Born in Portland, Oregon, in 1941, Linda Hanson earned her B.A. from California State University in 1983 and her M.F.A. from the San Francisco Art Institute in 1986. Although primarily a painter, Hanson has also done illustration and graphic design. Her work has been exhibited at galleries and art centers in California and Washington, D.C. Hanson paints detailed images of familiar locales—the garage, the backyard, the kitchen—working in a traditional manner, with emphasis on fine rendering and light-filled space.

Warm October Light. 1989. Page 155

Robert Harmon, Jr.

Robert Harmon, Jr., was born in 1941 in Portland, Oregon. He received an M.A. from Cape Cod Community College, Massachusetts, in 1982, with a major in theater lighting and set design and a minor in sculpture. In 1986 he earned a second M.A. in sculpture from the School of the Museum of Fine Arts, Boston. He has shown extensively in Massachusetts since 1982. Harmon incorporates welded steel, carved wood, paint, tape, cloth, found objects, and cast epoxy materials into his mixed-media constructions, creating images of animals,

figures, or tools that blend humor and an almost primitive quality in their depiction of a spiritual quest.

LOOKING FOR SPIRITS. 1986. PAGE 152

PHILIP HAZARD

Philip Hazard was born in Toledo, Ohio, in 1950. In 1975 he began creating sculptures in neon, which he finds symbolic of American popular culture. Many of Hazard's sculptures combine neon forms and painted backgrounds and refer in form and imagery to the early neon signs of the 1940s and 1950s. His work has been exhibited in France, Sweden, Germany, and the United States. Hazard is also a playwright and has had two plays produced off-Broadway.

BLUE WIGGLE. 1987. PAGE 165

TOM HEBERT

Tom Hebert was born in Madawaska, Maine, in 1947. He attended Manchester Community College from 1969 to 1971 and earned a B.F.A. from the University of Connecticut in 1974. His work has been shown in New York, Connecticut, and Arizona. Hebert's abstracted trompe l'oeil still-life paintings of the 1980s recall the sharp precision of Charles Sheeler's work. His earlier, mixed-media works contain industrial and lumberyard materials—including firing strips and asphalt roofing shingles—that are laid into a wood construction. Most recently he has been making lithographs of his geometric abstractions.

UNTITLED #4. 1985. PAGE 140

TONY HEPBURN

Tony Hepburn was born in Manchester, England, in 1942. He received degrees from the Camberwell College of Art in 1963 and London University in 1965. His work has been exhibited internationally, including shows at the Museum of Contemporary Art, Seoul, the Museum of Fine Arts, Boston, the American Craft Museum, New York, and the Renwick Gallery, Washington, D.C. He has received awards from the National Endowment for the Arts and the New York State Council on the Arts. Hepburn makes sculptures combining found objects and clay elements that are often interpretations—or "evocations"—of objects that have intrigued him. His earliest works were large-scale sculpted gates and totems, and in the mid-1980s he began a series of rural elegiac allegories based on the environment and people of upstate New York, where he resides.

WORK BENCH. 1988. PAGES 50–51

ROBERT HERHUSKY

After studying at the Penland School of Crafts, North Carolina, Robert Herhusky earned a B.S. from California State University at Chico in 1981 and an M.F.A. from the California College of Arts and Crafts in Oakland in 1985. Herhusky has been an instructor at California State University, the California College of Arts and Crafts, and the Pilchuck Glass School, Washington. His work has been exhibited at the Sierra Nevada Museum, Reno, and in Japan. He has completed a large-scale commission for the San Francisco Airport.

H.O.M.E. 1987. PAGE 149

CHARLES HOBSON

Born in 1943 in Bridgehampton, New Jersey, Charles Hobson received a B.A. from Lehigh University, Bethlehem, Pennsylvania, in 1965, a Bachelor of Law from the University of Virginia, Charlottesville, in 1968, and a B.F.A. from the San Francisco Art Institute in 1988. Hobson's prints have been shown in solo and group exhibitions in California. He uses the monotype primarily as an underpainting or sketch upon which he builds his images with pastel and graphite. In the late 1980s Hobson explored the theme of tools in a series of monotypes.

SIX HAMMERS #4. 1988. PAGE 147

WERNER HOEFLICH

Werner Hoeflich was born in 1957 in Eugene, Oregon. He received his B.F.A. from the University of Colorado, Boulder, in 1979. Hoeflich has been awarded two scholarships from the University of Colorado and has received the Sean Driscoll award. His work has been exhibited in several solo and group shows, including solo exhibitions in the United States and France. Hoeflich began painting tools in 1984, and his fascination with the subject continues; tools and hardware form the basis for many of his painterly explorations. Although the tools remain recognizable, they are often shown from unusual angles, thus altering the viewer's perception of these mundane objects. The artist depicts the tools against painterly, non-objective backgrounds, which brings to the fore the tension between the surface and the subject of the work.

FLYING CLAMPS. 1986. PAGE 153
THREE PLANES. 1986. PAGE 145

LOU HORNER

Lou Horner was born in Nashville, Tennessee, in 1954. She holds a B.A. from George Peabody College in Nashville. Her

work has been shown at the National Museum of Women in the Arts in Washington, D.C., the Charles A. Wustum Museum in Racine, Wisconsin, and at galleries in Tennessee. In the late 1980s Horner became intrigued with the shape of saws; since then she has produced paintings on wood cut into saw shapes. Her figurative imagery represents a personal kaleidoscope of the memories, desires, hopes, and fears that result from everyday experience.

DREAMTIME. 1991. PAGE 57

MANUEL HUGHES
Born in 1938 in Forest City, Arkansas, Manuel Hughes received his B.A. in 1965 from the University of Missouri at Columbia. His work has been exhibited at the High Museum of Art, Atlanta, the Carnegie Institute, Pittsburgh, and the Whitney Museum of American Art, New York. He is largely a still-life painter, and his first series of paintings contained images of draped fabrics. In the late 1980s he began to paint still lifes of household objects he had collected over many years. Hughes focuses on the details of the objects and the formal relationships between the pieces in each arrangement. In his straightforward portrayal of tools and other mundane items set against nondescript backgrounds, the artist asks the viewer to share in the pleasure he takes in each quirky and unique form.

WORK DANCE I. 1988. PAGE 145

NANCY IRRIG
Born in Nahant, Massachusetts, in 1932, Nancy Irrig received a B.F.A. from the Massachusetts College of Art in 1952. A schoolteacher, Irrig paints murals and easel paintings. She also paints on saws that she purchases from farm sales in the Shenandoah Valley.

UNTITLED. 1989. PAGES 56–57

STEVEN JONES
Steven Jones was born in 1952 in San Francisco. He received his B.A. in fine art in 1974 and his M.F.A. in 1981 from Southern Illinois University at Carbondale. His work has been exhibited at the Chicago Botanic Gardens, Glencoe, Illinois, and the Galerie Jean-Pierre Lavigne, Paris. He has been a painting instructor at Southern Illinois University and at Lake Forest College, Illinois. His still-life paintings draw on the tradition of seventeenth-century Dutch painting, going beyond mere accumulations of objects to function as social commentaries.

NESTING. 1992. PAGE 120

MARIA JOSEPHY
Maria Josephy was born in New York City in 1933. She studied painting and printmaking at Sarah Lawrence College, receiving a B.A. in 1954. She has worked as a free-lance graphic designer in Chicago and Washington, D.C., from 1957 to the present. Josephy began making collages and assemblages in 1962. She has participated in shows in New York, Chicago, and Washington, D.C., and had a solo exhibit at the Hampton Institute College Museum in Hampton, Virginia, in 1989. Josephy's whimsical narratives often draw on classical themes and are marked by an uncanny sense of invention and detail.

PROMETHEUS. 1980. PAGE 54

JACOB J. KASS
Jacob J. Kass was born in Brooklyn in 1910. From 1922 until his retirement in 1972, he worked in his father's firm, which specialized in painting commercial signs on the sides of trucks—images of everything from bridges to beer. Upon his retirement he divided his time between Florida and Vermont, where he began to paint old milk cans that he bought at local auctions and yard sales. In 1977, taking up a venerable folk art tradition, he began painting landscapes on antique saws. Since 1981, when the Allan Stone Gallery in New York gave Kass his first show, he has had exhibitions at the Lowe Art Museum, University of Miami, Florida, and the Federal Reserve, Washington, D.C. Kass has received a National Endowment for the Arts Fellowship. His panoramic bucolic landscapes are imbued with a simple nostalgic charm that is at one with the antique saw blades on which he paints.

UNTITLED. 1981. PAGE 16

MARILYN KEATING
Marilyn Keating was born in Camden, New Jersey, in 1952. She received a B.F.A. in sculpture from Moore College of Art in Philadelphia in 1974. Over the past twenty years, Keating has supported her pursuit of sculpture by working as a telephone installer, an electrician, and a carpentry teacher. Since 1983 she has exhibited her work extensively in New Jersey, New York, and Philadelphia. Her sculptures are narratives that deal with the plight of women, domestic violence, and other difficult contemporary issues. She also creates toys in collaboration with Debra Sachs, an artist who makes nonrepresentational, architectural sculpture. The toys, which often address the role of women in the trades, transcend the traditional definition of a toy and function as objects of art.

TWO CARPENTERS. 1989. PAGE 100

BAYAT KEERL

Bayat Keerl was born in Basel, Switzerland, in 1948. He earned a B.F.A. from the Layton School of Art, Milwaukee, Wisconsin, in 1970, and an M.F.A. two years later from Rutgers University, New Brunswick, New Jersey. He received awards from the National Endowment for the Arts in 1981 and 1987. He has exhibited in Switzerland, Sweden, and throughout the United States, and his work is included in the collections of the American Express Company and the Union Bank of Switzerland, among others. Keerl started his career as a performance artist, and he carried his interest in movement into his later work, which consists of large photo enlargements of objects and figures in motion, overlaid with painting. The resulting blurred and shifting images explore culturally constructed ways of seeing and fabricating reality.

FATAL METAL MARK #1. 1979. PAGE 77

PATRICK KIRWIN

Patrick Kirwin was born in Columbus, Ohio, in 1959. He received a B.F.A. in 1983 from the Columbus College of Art and Design and an M.F.A. in 1987 from George Washington University, Washington, D.C. He continued his studies with a fellowship at the Skowhegan School of Painting and Sculpture, Maine, in 1991. He has been artist-in-residence at the Griffis Art Center in New London, Connecticut, and the Hambridge Center in Rabun Gap, Georgia. His work has been exhibited throughout the mid-Atlantic area. Kirwin explores a variety of subjects and styles and is equally comfortable working in oil, tempera, pastel, acrylic, and watercolor.

HAMMERS INSIDE. 1991. PAGE 124

LEONARD KOSCIANSKI

Leonard Koscianski was born in Cleveland, Ohio, in 1952. He attended the Skowhegan School of Painting and Sculpture, Maine, in 1976, and earned a B.F.A. from the Cleveland Institute of Art in 1977. In 1979 he completed an M.F.A. at the University of California, Davis, where he was Wayne Thiebaud's teaching assistant. Since then he has pursued a teaching career in conjunction with his own art making. He has been the recipient of several awards, including three National Endowment for the Arts Fellowships in 1983, 1985, and 1989, and was a Rockefeller Foundation Scholar in Italy in 1989. His work has been exhibited throughout the United States and can be found in the collections of the Metropolitan Museum of Art in New York, the Philadelphia Museum of Art, the Cleveland Museum of Art, and the Federal Reserve Board in Washington, D.C. While finishing his studies at Davis, Koscianski began a pastel series that exploited the dual nature of tools as beautiful, utilitarian objects that can also harm. A strong sense of drama is evident in the high-keyed, saturated palette, the oblique angle of representation, and the exaggerated chiaroscuro of these early drawings, qualities that also appear in his more recent paintings. These techniques complement Koscianski's interest in creating threatening, quasi-Surrealist images to evoke the implied or actual power of his oversize subjects.

NEEDLENOSE PLIERS. 1979. PAGE 75

MARK KOSTABI

Mark Kostabi was born in Los Angeles in 1960 and grew up in Whittier, California. After studying at California State University at Fullerton from 1978 to 1981, he moved to New York City in 1982. Kostabi had his first New York exhibition at the Ronald Feldman Gallery in 1986 and has exhibited internationally since, including shows at the Metropolitan Museum of Art and the Museum of Modern Art, New York, and the Mitsukoshi Museum in Tokyo. All of his work, which is primarily painting, is created at his "factory" in Brooklyn, known as Kostabi World, where he employs artists to design and paint images that he then signs. He is known for faceless "Everyman" figures, which he places in simply depicted settings. His work often includes art historical references and images from earlier periods of art.

POWER TOOL BABY. 1989. PAGE 128

OLEG KUDRYASHOV

Oleg Kudryashov was born in Moscow in 1932. He attended the Moscow State Art Studios in 1942–47 and the Moscow Art School in 1950–51. In 1974 he emigrated to London, where he has lived ever since. Before his departure from the Soviet Union, he destroyed the thousands of works he had created. Kudryashov has exhibited extensively in Europe and the United States, including shows at the Tretyakov Gallery, Moscow. His work is included in the collections of the Pushkin Museum, Moscow, the Tate Gallery, London, the Museum Boymans-van Beuningen, Rotterdam, the National Gallery of Art, Washington, D.C., and the Hirshhorn Museum and Sculpture Garden, Washington, D.C. Kudryashov works primarily in the medium of drypoint etching, a technique favored by the seventeenth-century Dutch masters. The artist draws expansively with a burin, a printmaking tool, directly onto a zinc plate. He then prints these "drawings" on paper on which he has already worked in a free-form style with a variety of media, including gouache,

watercolor, and charcoal. In the late 1970s he began to cut up his work and reconstruct the elements, creating three-dimensional artworks that blur the lines between drawing, sculpture, and printmaking. The combination of hard-edged geometric forms with painterly abstraction points to the influence of early-twentieth-century Russian Constructivism and Cubism, as well as the Abstract Expressionism of New York in the 1950s. Among the recurring references in his work is a broken saw, which has been said to find its roots in childhood experiences in the freezing Russian winters.

BROKEN SAW. 1987. PAGE 17
TWO-HAND SAW. 1979. PAGE 43

GARY KUEHN

Gary Kuehn was born in Plainfield, New Jersey, in 1939. He completed a B.A. in art history at Drew University, Madison, New Jersey, in 1962 and an M.F.A. at Rutgers University, New Brunswick, New Jersey, in 1964. He has exhibited widely in the United States and Europe. Kuehn plays with basic definitions of primary forms and found objects, fusing them at the moment of transition. An interest in finding parallel psychic states complements this fascination with the phenomenology of materials. A sense of immediacy and of Duchampian irony mark his sculptures, which often point to a struggle or to sexual release.

LADDER PIECE. 1986. PAGE 61

SHELLEY LAFFAL

Born in Washington, D.C., in 1952, Shelley Laffal studied at the Maryland Institute of Art, Baltimore, and the California Institute of Arts, Valencia. A sculptor and a draftsman, Laffal has exhibited her work at galleries and art centers in Florida and Washington, D.C. Her work has been influenced by the colors and patterns of the places she has visited in the Southwest and Florida. In 1985 she began an ongoing series of garment sculptures that explore the layers of personal and historical references implied in clothing. The fiberglass and resin sculptures are molded to suggest that each piece is inhabited by a moving figure, swirling, turning, reaching. The energy of this movement is enhanced by her use of vibrant colors.

HOUSE COAT. 1988. PAGE 113

OSCAR LAKEMAN

Oscar Lakeman was born in Hamilton, Ohio, in 1949. He received a B.F.A. from Kent State University, Ohio, in 1972. His work can be found in several private and corporate collections and has been shown in galleries in New York, Miami,

Los Angeles, Boston, and Dallas, as well as at the Tampa Museum of Art, the Butler Institute of American Art in Youngstown, Ohio, and the Isetan Gallery in Tokyo. Lakeman, who has been painting since he was twelve years old, achieved overnight success with his exhibition at OK Harris Gallery in New York in 1984. Typical subjects of his realistic, oversize still lifes are the paintbrushes, jars, cans, and mugs that populate his studio. Striking in visual impact, the works are done partly with an airbrush and partly by slinging or dribbling paint onto the canvas.

CONTAINERS #222. 1987. PAGE 96

FRAN LARSEN

Born in Chicago in 1957, Fran Larsen received a B.A. from Michigan State University in 1959. She also studied at the Kalamazoo Institute of Arts, Michigan, in 1967–69. Larsen has exhibited her paintings and watercolors at art centers and galleries in the United States. Influenced by German Expressionist landscape paintings of the late 1920s and 1930s, Larsen's images of the Southwest depict the landscape in an almost primitive manner, pared down to areas of color and pattern.

LIGHT AND SHADOWS, TAOS. 1986. PAGE 143

JACOB LAWRENCE

Jacob Lawrence was born in Atlantic City, New Jersey, in 1917. He moved with his family to Easton, Pennsylvania, and to Philadelphia before settling in Harlem, New York, in 1931, when he began studying with the painter Charles Alson at the WPA Harlem Art Workshop. In 1936 he was awarded a scholarship to the American Artists' School in New York City, and in 1938 he was hired by the WPA Federal Art Project. During this period the artist began his best-known series, "The Migration," which he completed in 1941. Consisting of sixty panels with accompanying texts, the series depicts the movement of African-Americans from the farms and rural communities of the South to the industrial cities of the North after World War I. "The Migration" was exhibited at the Downtown Gallery, New York, and was then purchased by the Museum of Modern Art, New York, and the Phillips Collection, Washington, D.C. In 1943 Lawrence was drafted into the Coast Guard. He was awarded a Guggenheim Foundation Fellowship in 1946; that same year he produced the "War" series. In 1947 *Fortune* magazine commissioned him to paint a series of ten images of the South after World War II, for which Walker Evans wrote an accompanying text. Lawrence revisited the migration theme in a series of illustra-

tions he did for a book of poetry by Langston Hughes, *One-way Ticket*. Lawrence, who has been described as a painter of the American scene, an American modernist, and a social realist, was given his first retrospective, at the Brooklyn Museum, in 1960, and has since had numerous exhibitions around the world. Lawrence moved to Seattle, Washington, in 1970. This chronicler of American life began his most recent series, "Builders," in the mid 1970s.

BUILDERS THREE. 1991. PAGE 46
CARPENTERS. 1977. PAGE 47
THE BUILDERS. 1974. PAGE 47

FERNAND LÉGER

Fernand Léger was born in Argentan, France, in 1881 and died in Grif-sur-Yvette, France, in 1955. One of the great masters of the twentieth century, Léger continues to exert a lasting influence on generations of younger artists. After being apprenticed to an architect in Caen from 1897 to 1899, Léger worked as an architectural draftsman in Paris from 1900 to 1902. He spent the next year in military service. In 1903, although he was refused regular admission to the École des Beaux-Arts in Paris, he took classes there, as well as studying art in Jean-Lèon Gérôme's studio at the Académie Julian. The 1907 Cézanne retrospective had a powerful effect on Léger, contributing to his nascent interest in light and in manufactured objects. By 1910 he had met most of the Parisian avant-garde and had joined Robert Delaunay, Albert Gleizes, and others in the creation of La Section d'Or group of Cubist artists. The following year he exhibited in the Salon des Indépendants in Paris. Léger's version of Cubism emphasized bold designs of primary, tonal colors and streamlined forms suggestive of machines. His fighting experience in World War I prompted a return to a more concrete subject matter and a stricter formal order that was a contrast to the chaos of human life and the vicissitudes of nature. Along with members of De Stijl and the Purist movements, he envisioned a positive social function for art. Léger called his metallic style the "new realism" because it reduced all forms, including the human body, into machinelike images. At the same time, he endowed his everyday, quasi-cartoonish figures with a heroic sense. An extremely versatile artist, he also worked as an illustrator and set designer. In the 1930s he made two visits to the United States, and he lived in self-imposed exile in New York from 1940 to 1946. In the 1930s and 1940s he exhibited at the Museum of Modern Art, the Art Institute of Chicago, the San Francisco Museum of Art, and the Fogg Art Museum, Cambridge, Massachusetts. Following his return to France, he had exhibitions at the Musée National d'Art Moderne and

the Tate Gallery, London. He became involved in numerous large-scale projects, creating murals and stained-glass windows for secular and religious buildings. He also turned his artistic energies increasingly to ceramics, mosaics, and sculpture, addressing the themes of peace and love. Since his death, he has been the subject of numerous exhibitions worldwide.

LES CONSTRUCTEURS. 1951. PAGE 139

SCOTT LESIAK

Scott Lesiak was born in Glenn Ridge, New Jersey, in 1968. He holds a B.F.A. from the School of Visual Arts, New York, with an emphasis on three-dimensional design and illustration. Lesiak also studied drawing at Parsons School of Design, New York. His work has been included in exhibitions at the Art Director's Club and the Visual Arts Gallery in New York. In 1989 he co-founded Air-Tec Designs, which specializes in airbrush murals and sign fabrication.

INSOMNIAC BED. 1990. PAGE 111

PATRICK LOCICERO

Patrick LoCicero was born in Youngstown, Ohio, in 1959. He attended Youngstown State University, Ohio, and the Columbus College of Art and Design. He completed a B.F.A. at Ohio State University in 1982 and an M.F.A. at the San Francisco Art Institute in 1986. His paintings, installations, prints, and multimedia work have been shown in California, Pennsylvania, and Ohio. LoCicero's richly layered imagery is characterized by unusual juxtapositions of everyday objects and classical motifs, which play with the viewer's perception of materials and subjects.

CHINESE CRUTCH RAKE. 1986. PAGE 148
WINDOW ON A PEDESTAL. 1986. PAGE 148

DALE LOY

Dale Loy was born in Los Angeles in 1934. She received a B.A. in history from Stanford University in 1955 and an M.F.A. in painting from American University, Washington, D.C., in 1974. In addition to painting, Loy has held several editorial and reporting positions for the *New York Herald Tribune, Mademoiselle*, and Horizon Books, among other publications. Her work can be found in several private collections and has been included in exhibitions at the Corcoran Gallery of Art in Washington, D.C., the Mississippi Museum of Art in Jackson, and the Southeastern Center for Contemporary Art in Winston-Salem, as well as in Baltimore, Los Angeles, and Plainfield, Vermont. Both in her early abstract collage paintings and in her more recent landscape paintings, Loy

proves herself a master of the brushstroke, applying paint with energy and power. Her landscapes are haunting evocations of the perennial, often contentious, relations between man and nature.

FLASH L.T.G. 1978. PAGE 156

DANIEL MACK

Daniel Mack was born in 1947 in Rochester, New York. He earned a B.A. in anthropology in 1970 and an M.A. in media studies in 1975. He has been awarded a Mid-Atlantic Foundation Fellowship and two grants from the New York Foundation for the Arts. Mack's work is included in the collections of the Cooper-Hewitt Museum, New York, the American Craft Museum, New York, and the Museum of Fine Arts, Boston. The artist has published a book, *Making Rustic Furniture*, that surveys the work of contemporary furniture makers and explains the techniques of rustic furniture fabrication. Mack's chairs are made from tree limbs stripped of their bark. He began incorporating other objects into his chairs in 1989 when he created a series of chairs that included antique tools and tools used in making furniture. In 1992 Mack started a series of nautical chairs that incorporate objects relating to boating, sailing, and fishing. The artist feels that reusing discarded objects and unused bits of wood renews and prolongs their life and function.

CHAIR MAKER'S CHAIR. 1989. PAGE 49

MICHAEL MALPASS

Michael Malpass was born in New York City in 1946. He died in 1991 at the age of forty-four. He received his B.F.A. in 1969, his M.F.A. in 1973, and a B.S. in welding in 1979, all from the Pratt Institute, New York. He continued there as a professor of sculpture and welding until moving to Rutgers University in New Jersey. He had his first one-man exhibition at the Betty Parsons Gallery, New York, in 1977. His work has been exhibited at several New York galleries, as well as at the Philadelphia Museum of Art, the Albright-Knox Art Gallery, Buffalo, and the Brooklyn Museum. Malpass's work can be found in the collections of the Mint Museum of Art, Charlotte, North Carolina, the Vassar College Art Museum, Poughkeepsie, New York, the National Museum of Art, Warsaw, Poland, and the National Art Museum, Sofia, Bulgaria. His work is also included in major corporate collections, including those of TRW, the Ford Foundation, and General Electric Corporation. He has completed major commissions for the State of Connecticut and the New Jersey State Council of the Arts. Malpass created his sculptures from

found objects and often used discarded tools, hardware, and building materials. He shaped these objects on a bandsaw, reducing the volumetric forms to linear elements that he then interlocked into complex geometric patterns, forming spheres. During the course of his career, Malpass's work became increasingly complex and the patterns and grids that comprised his spheres became more intricate. Among his early influences were the found-object sculptures of Richard Stankiewicz and the work of Theodore Roszak, who, like Malpass, worked with molten steel.

BIG MIKE. 1985. PAGE 132
GLOBE. 1981. PAGE 170
NEWTONIAN SPHERE III. 1989. PAGE 27

JOHN MANSFIELD

Born in 1943 in Milton-Freewater, Oregon, John Mansfield spent his formative years in Japan and various parts of the United States, including Hawaii. He earned his B.F.A. in 1966 from the College of Arts and Crafts, Oakland, California, and his M.F.A. in 1970 from the University of Oregon. In 1973, after a long hiatus, Mansfield returned to making art while living in Colorado. He has since exhibited on the West Coast and in the Southwest. Mansfield's sculptures focus on the relationship between Eastern and Western cultures, exploring the differences in the way each culture visually represents the world. Mansfield reinforces the differences by contrasting traditional Eastern and Western materials within his artworks.

EAST MEETS WEST. 1987. PAGE 68
ZEN SAW II. 1986. PAGE 69

MANUAL

MANUAL is the pseudonym for husband-and-wife photographers Edward Hill and Suzanne Bloom. Edward Hill was born in Springfield, Massachusetts, in 1935. He received a B.F.A. from the Rhode Island School of Design, Providence, in 1957 and an M.F.A. from Yale University in 1960. Suzanne Bloom was born in Philadelphia in 1943. She earned her B.F.A. from the Pennsylvania Academy of Fine Arts, Philadelphia, in 1965 and her M.F.A. from the University of Pennsylvania in 1968. MANUAL's work has been widely exhibited in museums and galleries throughout the United States. Both Hill and Bloom have been awarded individual fellowships from the National Endowment for the Arts, as well as a joint award from the NEA/Rockefeller Interdisciplinary Fellowship. The two have worked together since the mid-1970s, creating manipulated photographs and videos. In the 1980s they produced a series

of photographs that explored pop-culture icons. They have begun to address environmental issues in a recent series of computer-generated photographs.

CURE ALL. 1987. PAGE 90

MARX/ENGELS (GERMAN IDEOLOGY), FROM "VIDEOLOGY SERIES." 1984. PAGE 90

JOSEPH MARESCA

Joseph Maresca was born in 1946. His paintings and drawings have been exhibited at the Aldrich Museum of Contemporary Art, Connecticut, and New York University, and he is represented in many private and corporate collections.

MODERN PAINTING #7. 1986. PAGES 124–25

HARLAN MATHIEU

Harlan Mathieu was born in Fort Dodge, Iowa, in 1953. In 1976 he received a B.A. in art from Grinnell College, Grinnell, Iowa. He was awarded an M.A. in 1979 and an M.F.A. in 1981 from the University of Iowa, Iowa City. He is also a designer for theatrical productions and has been a visiting instructor at Grand Valley State University in Allendale, Michigan. Harlan's sensitive studies of tools, carefully laid out on a work table, draw on the formal qualities of Japanese woodcuts. The images become a powerful testimony of the artist's trade and, with their reference to a calendar form, a kind of personal diary.

TSUKI-KANNA I. 1989. PAGE 166
TSUKI-KANNA II. 1989. PAGE 166
TSUKI-KANNA III. 1989. PAGE 166

MICHAEL MAZUR

Michael Mazur was born in New York City in 1935. He attended the Horace Mann School in New York and Amherst College before completing a B.F.A. in 1959 and an M.F.A. in 1961 at the School of Art at Yale University. He has exhibited widely throughout the United States and Korea and is included in several corporate collections. His graceful work encompasses folding screens, monotypes, pastel drawings, and other works on paper. His painterly technique perfectly complements his images, which are often of plants and trees, or of tools.

LADDER. 1974. PAGE 79

JIM MCCULLOUGH

Jim McCullough was born in Chicago in 1924. He holds a B.S.M.E. from the University of New Mexico and an M.B.A. from the University of Southern California. A retired colonel who spent thirty years as an air force pilot, engineer, and logistician, he began making dioramas in 1974. Titled "American Heritage Dioramas in Perspective," the ongoing series painstakingly re-creates the interiors of such architectural icons as the one-room schoolhouse, the post office, and various stores and churches, each complete with hand-carved furnishings.

HECHINGER GEORGIA AVENUE STORE IN 1927. 1983. PAGE 54

MIKE MCDONNELL

Mike McDonnell was born in Muskegon, Michigan, in 1937. From 1956 to 1958 he studied with W. H. Moshy at the American Academy of Art in Chicago. He continued his classes from 1958 to 1960 with Sidney E. Dickinson at the Art Students' League of New York. In 1959 he also completed a year of study at the National Academy School of Fine Arts in New York with Robert Phillip and Dean Cornwell. He received additional training in portraiture, initially in oil. While he still does noncommissioned portraits, for the past ten years he has concentrated on painting still lifes and interiors, primarily in watercolor. In his recent work, he strives to idealize his everyday subjects while emphasizing clean, precise colors and details.

TABLE SAW BLADE. 1987. PAGE 121

MARK MCDOWELL

Mark McDowell was born in Pennsylvania in 1954. He earned a B.F.A. in drawing and printmaking from Pennsylvania State University and did graduate work at Arizona State University. McDowell has shown his paintings and prints throughout the United States, particularly in the Southwest, including the Tucson Art Institute and the Scottsdale Center for the Arts. In 1983 he received a fellowship in printmaking from the Arizona Commission on the Arts. His work can be found in the collections of Chase Manhattan Bank and the University of New Mexico. In the mid-1980s McDowell began a series of paintings on the Industrial Revolution in America as a kind of homage to tools that "make our lives on this planet a bit easier."

HOMAGE TO THE AMERICAN INDUSTRIAL REVOLUTION #2—DRILL PRESS. 1986. PAGE 157

ED MCGOWIN

Ed McGowin was born in Hattiesburg, Mississippi, in 1938. He completed a B.S. at the University of Southern Mississippi in 1961 and an M.A. at the University of Alabama in 1964. He received National Endowment for the Arts grants in 1967

and 1980 and has exhibited widely, including at the Center for the Fine Arts in Miami, the Institute of Contemporary Art in Philadelphia, and the Fort Worth Art Museum. His art can be found in the collections of the Hirshhorn Museum and Sculpture Garden in Washington, D.C., the Whitney Museum of American Art in New York, the Museum of Contemporary Art in Chicago, and the Kunstmusette Collection in Lund, Sweden. He has been a professor at several universities and art schools since 1963. McGowin's series of paintings with hand-carved frames depicts a dense, menacing world given over to the human primordial instinct to dominate. A dark, absurd humor adds tension to these twisted narratives, which recall earlier historical treatments of battles or crowd scenes. His figures, typically engaged in such mundane activities as checking the time or tying ties, cross cultural and economic lines.

WORKERS WAVING GOODBYE. 1991. PAGE 102

JOHN MCINTOSH

John McIntosh was born in Port Huron, Michigan, in 1950. He completed an A.B. at Whittier College, California, in 1973 and an M.F.A. at the Yale University School of Art in 1977. He has exhibited in Washington, D.C., Los Angeles, Houston, and Rochester. His work can be found in the collections of the Corcoran Gallery of Art in Washington, D.C., and the Museum Ludwig, Germany. McIntosh's elegant, highly saturated color photographs tread the line between art and commercial advertising. With references to art history and a nod to Walker Evans, his clever compositions using ordinary objects and tools are psychologically loaded commentaries on taste and other aspects of contemporary life.

FUSE. 1989. PAGE 87
MASTER PADLOCK. 1989. PAGE 87
PAINT BRUSH. 1989. PAGE 87

JUDITH MCKELLAR

Judith McKellar is a longtime resident of Fairfax, in northern Virginia, where she is an active member of the arts community. She is primarily a sculptor and a printmaker and uses photography as her sketchbook. For a number of years she has been creating prints that explore the abstract patterns resulting from detailed observations of such mundane objects as stacks of lumber or shadows cast by rolls of wire.

BRICKYARD. 1975. PAGE 147

JOHN MCQUEEN

John McQueen was born in Oakland, Illinois, in 1943. He studied at Florida State University, Tallahassee, in 1961–63 and the University of Indiana in Bloomington in 1964–65 before completing a B.A. at the University of South Florida in Tampa in 1971 and an M.F.A. at Tyler School of Art in Philadelphia in 1975. He has received three National Endowment for the Arts Visual Artist Fellowships and a United States/Japan Friendship Commission Fellowship. He has participated in several exhibitions, including shows at the Renwick Gallery in Washington, D.C., the Kansas City Art Institute, the Albright-Knox Art Gallery in Buffalo, the Craft and Folk Art Museum in Los Angeles, and the Nordenfjedske Kunstindustrimuseum in Trondheim, Norway. Although McQueen originally created conventional works using sod and adobe clay, in 1975 he started making meditational baskets. This momentous shift made him a leading figure of the movement that questioned the traditional distinction between craft and art. At the same time, he revolutionized the conventional definition of a basket. Issues of containment, isolation, security, and control are central to his work. He deftly weaves his baskets out of bark, twigs, vines, and burrs, using self-taught or invented patterns. Their highly original forms often explore the connections between nature and man. In 1979 he began incorporating words into his baskets, establishing a fertile dialogue between a basket as a container of space and language as a carrier of thought.

JUST PAST DEAD CENTER. 1991. PAGE 108

MINEO MIZUNO

Mineo Mizuno was born in Gifu Prefecture, Japan, in 1944. From 1966 to 1968 he studied ceramics at the Chouinart Art Institute in Los Angeles, where he was exposed to the almost machine-perfect, "fetish finish" style of the West Coast potters under Ralph Bacerra. He worked as a ceramics designer for Interpace China Corporation in Glendale, California, for ten years, establishing his own studio in 1978. In 1981 he received a National Endowment for the Arts Award. His work has been widely shown at venues including the Craft and Folk Art Museum in Los Angeles, the American Craft Museum in New York, and the Muscarelle Museum of Art in Williamsburg. Profoundly influenced by Josef Albers, Mizuno explores color and texture through various glazes and gestural brushstrokes in his exquisitely crafted pieces, which he sometimes combines into series for added compositional effect.

SCREW. 1974. PAGE 130

MR. IMAGINATION

Mr. Imagination was born in 1948 and has lived most of his life in Chicago. Although he has no formal artistic training, he has always been creatively inclined. In 1978, while in a coma after being critically wounded by a gunshot, he had visions of himself as an Egyptian pharaoh; these images inspired the work that he began to create during his recovery. He also draws on Christianity, contemporary events, and public figures as sources for his imagery, and he often incorporates African patterns and motifs into his work. The artist begins with found objects and materials, which he carves and paints, using simple tools, often other found objects. He thinks of the process as bringing new life to objects that have lost their original usefulness. The paintbrush portraits, a continuing series, grew out of his reluctance to discard the brush he had used to create his early works. Having grown attached to it, he said, "Finally, I thought of this idea of bringing it back to life in another way."

PAINTBRUSH PORTRAITS. 1991. PAGE 100

AMY MUSIA

Amy Musia was born in Dallas, Texas, in 1950. After graduating from North Texas State University, she moved to Evansville, Indiana, where she continued her art instruction in wood sculpture. Since the early 1980s she has maintained Lone Star Studio. Her sculptures and drawings have been exhibited widely in Evansville, Indianapolis, Dallas, Atlanta, Louisville, and Washington, D.C. Musia is best known for her imaginative and humorous wood-and-Plexiglas sculptures of water faucets. Another series features large-scale mixed-media versions of fishing flies.

OHIO RIVER FAUCET. 1981. PAGE 111

FRED NAGELBACH

Fred Nagelbach was born in Liebling, Banat, Romania, in 1943. He earned a B.A. from Valparaiso University, Indiana, in 1965 and an M.F.A. from the Rhode Island School of Design, Providence, in 1967 before continuing his studies at the Akademie der Bildende Kunste in Munich, Germany. His work has been shown in Chicago and New York. Combining the lyricism of English sculptor David Nash and the direct carving technique of Constantin Brancusi, Nagelbach creates dreamed architecture and tool sculptures that transport the viewer to a different time and place. His materials are a mixture of traditional roofing materials and bronze, foam rubber, and polyester resin. The decorative cupolas of his towers can be read as primitive guardians or as giant tools that might cut

a mortise in the sky. His mallet sculptures are large-scale interpretations of ancient and contemporary implements of construction.

UNTITLED, FROM "TURM" SERIES. 1987. PAGE 68

HANS NAMUTH

Hans Namuth was born in Essen, Germany, in 1915 and died in East Hampton, New York, in 1990. He was a photojournalist, portrait photographer, and documentary filmmaker. Originally trained as an actor, he fled Germany in 1933 when Hitler came to power. He moved to Paris and began taking photographs. His photographs of the Spanish Civil War, taken in collaboration with George Reisner, were his first published photographs; some of them were printed in *Life* magazine. Namuth moved to New York City in the 1940s and studied photography at the New School for Social Research. Photographs he took while traveling in Guatemala were exhibited in 1949 in Washington, D.C. Namuth is perhaps most renowned for his photographic portraits of postwar American painters, especially Jackson Pollock. His photographs of Pollock, published in *Artnews* in 1951, were the first to show the artist at work in his studio, dripping and splashing paint onto unstretched canvas. His photographs of Pollock and other Abstract Expressionist painters were published in *Artists 1950–1981: A Personal View* (1981). In the early 1970s Namuth created a portfolio of early American tools; these were published in a book produced by Olivetti in 1975. He continued to explore tool imagery in photographs that communicate a preciseness of vision as well as a reverence for the objects.

BOW SAW. 1975. PAGE 45
COOPER'S WINDLASS. 1975. PAGE 45
DRILL. 1975. PAGE 44
JACK PLANE. 1975. PAGE 44

MARTE NEWCOMBE

Marte Newcombe was born in Zurich, Switzerland, in 1948. The daughter of a Swiss mother and a Yugoslav father, she is an Australian citizen. She holds a B.A. and a Diploma of Education from the University of Tasmania, Australia, as well as an M.A. from Australian National University. She lived in New Guinea and Hong Kong before moving to Washington, D.C., in 1982, where she obtained a B.F.A. from the Corcoran School of Art in 1985. Her sculptures and prints have been exhibited in Boston and throughout the mid-Atlantic region. She is known for creating figurative microcosms out of rusted tools and bits of broken farm machinery.

These nightmarish allegories address war, power, and the absence of leadership. Her related works on paper, with aboriginal and pre-Columbian references, are highly expressive and dramatically colored.

THE METROPOLITAN. 1989. PAGE 147

BEN NICHOLSON

Ben Nicholson, son of the painter Sir William Nicholson, was born in Denham, England, in 1894 and lived in Hampstead, England, until his death in 1982. He attended the Slade School of Fine Art, London, in 1910–11, and in 1912 he began traveling. After World War I he made frequent trips to Paris, where he was exposed to Cubism, which inspired his first abstract paintings of 1924. He was a guiding member of the 7 & 5 Society, a group of abstract artists, from 1924 to its disbanding in 1936. In 1933 he joined the Abstraction-Creation group and made his first abstract relief at the end of that year. The following year he married sculptor Barbara Hepworth. After he visited Piet Mondrian in Paris, his reliefs evolved into strictly geometric compositions of white forms. In 1935–36 he produced *Circle*, a journal dedicated to Constructivist art, in collaboration with Naum Gabo and J. L. Marting. A move to the Cornish coast in 1939 inspired an outburst of color and an interest in landscape in his art. From 1945 to 1949, he explored still life. In 1950 he began producing his famous large color reliefs. He had his first solo show at the Adelphi Gallery in London in 1922, and his first show in America at the Durlacher Gallery in New York. He is now considered one of England's greatest twentieth-century artists. Retrospectives of his work were held at the Tate Gallery, London, in 1975 and at the Albright-Knox Art Gallery, Buffalo, which subsequently toured the United States. His long-standing interest in naive treatment belied an assured and often playful line. In the still lifes from the 1970s, which incorporated tools, as in his architectural studies, the variety of linear expression ranged from careful description to swift characterization.

SPANNERS TWO. 1974. PAGE 141

CLAES OLDENBURG

The son of a diplomat, Claes Oldenburg was born in Stockholm, Sweden, in 1929. He was raised in Chicago, becoming a naturalized American in 1953. A master of transformation, Oldenburg is considered the classic Pop artist, garnering attention for both his soft sculptures and his large-scale public projects based on everyday objects. Oldenburg received his B.A. from Yale University in 1950. He then worked in Chicago as a newspaper reporter while studying at the Art Institute of Chicago from 1952 to 1954. In 1956 he moved to

New York, where he and his wife and frequent collaborator, Coosje van Bruggen, currently reside. Initially interested in drawing and painting, he became involved with downtown "happenings" and environmental artworks. In 1959 he had his first show at the Judson Gallery, along with Jim Dine. The following year he concentrated on drawing store goods and incorporating used consumer goods in his art. His handmade objects were sold in The Store and the Ray Gun Manufacturing Company, both part of his studio shop on East Second Street, from 1961 to 1962. The first of his signature oversize soft sculptures appeared in 1963 for his "theater of objects." Starting with his "Proposed Colossal Monuments" in 1965, he produced plans for city sculptures of quotidian objects that combine humor with a serious, often political edge. Over thirty have been realized as large-scale public monuments; the giant *Lipstick*, for example, was installed at Yale. Since 1970 his work has been exhibited throughout the United States and Europe, including shows at the Philadelphia Museum of Art, the National Gallery of Art in Washington, D.C., and the Nelson-Atkins Museum in Kansas City, as well as the Stedelijk Museum in Amsterdam, the Kunsthalle in Düsseldorf, and the Tate Gallery in London. In recent years Oldenburg has returned to soft fabric sculpture and continues his long-standing relationship with Gemini G.E.L. in printmaking and cast sculpture. In 1994 he received the Lifetime Achievement Award from the International Sculpture Center.

KNIFESHIP. 1986. PAGE 119
SCREW ARCH BRIDGE. 1980. PAGE 119
THREE WAY PLUG. 1965. PAGE 158

DUSAN OTASEVIC

Dusan Otasevic was born in 1940 in Belgrade, former Yugoslavia. He graduated from the Academy of Fine Arts in Belgrade in 1966. He has participated in numerous exhibitions since 1963, including the Venice Biennale in 1972. In his lyrical compositions, which juxtapose such mundane objects as pliers, saws, and electric bulbs with primal elements of landscapes, Otasevic is searching for a broadened consciousness and a new order.

SAW. 1983. PAGE 153

DAVID PARTRIDGE

David Partridge was born in Akron, Ohio, in 1919. He became a naturalized Canadian in 1944, and is considered one of Canada's leading artists. He studied art at Hart House, University of Toronto, Queen's University in Kingston, Ontario, the Art Students' League in New York, the Slade

School of Fine Art in London, and Atelier 17 in Paris. His sculptural reliefs have been exhibited widely in the United States, Canada, and England. In addition, he has received several large-scale public commissions. Partridge's abstract compositions, often set against a background of polished aluminum, feature shimmering waves of thousands of common nails.

TRI-REFLEX. 1983. PAGE 67

CARLOS RAUL PEREZ

Carlos Raul Perez was born in Los Angeles in 1953. He apprenticed in photography under Norman Frimkess and later worked at the Elson-Alexander Studio as a portrait photographer. Perez is also a self-taught painter. In 1973 he started painting commissioned portraits based on photographic studies. He gradually began to experiment with colors, textures, and perspectives. His recent studies of people or still-life objects strike a balance between realist representation and mystical impressionism.

THE CARPENTER. 1988. PAGE 155

MICHAEL ROCCO PINCIOTTI

Michael Rocco Pinciotti was born in Toledo, Ohio, in 1950. After completing his undergraduate studies at the University of Toledo, he moved to New York, where he received his M.F.A. in printmaking from the Pratt Institute. At that time, he also began designing at Let There Be Neon, where he worked for five years. Today he is internationally recognized as a major neon artist. His work has been exhibited in Europe, South America, and throughout the United States. He has taught and given guest lectures in New York, New Jersey, Pennsylvania, Ohio, and Argentina. At times humorous and always provocative, his art combines neon with drawing, photography, and found natural materials. His multilayered, mixed-media constructions, which often refer to architectural elements, houses, temples, and birds' nests, address the poetry of place and the anatomy of spirituality.

THE NEST. 1989. PAGE 123

CHRISTOPHER PLOWMAN

Christopher Plowman was born in Hampshire, England, in 1952. He received a diploma in art and design from Wolverhampton Polytechnic in Wolverhampton, England, in 1973, and an M.A. from the Royal College of Art, London, in 1976. His work has been exhibited in Europe and the United States and is in the collections of the Tate Gallery and the Victoria and Albert Museum, London, the Arts Council of Great Britain, and the New York Public Library. He has taught in Britain and at the University of Houston. Plowman works in a variety of media, including sculpture, drawing, and printmaking, and he has won many awards. In the 1980s he produced an extensive series of still-life sculptures and prints about tools. In many of the prints, Plowman uses the objects to define the pictorial space, filling the compositions so that the image expands visually into the viewer's space, calling to mind a jumble of tools in an overflowing toolbox.

CUT. 1986. PAGE 74
HAND TOOLS. 1982. PAGE 107
STILL LIFE WITH TENON SAW. 1985. PAGE 92

LEAH POLLER

Leah Poller received an associate degree in fine arts from Dade Junior College in Miami, Florida, and went on to study sculpture at the École des Beaux-Arts in Paris. She has exhibited throughout the United States as well as in Tokyo and Madrid. In addition to creating monumental and timeless portrait sculptures, Poller has also created works in cast bronze that make striking visual puns on the subject of the bed. Taking inspiration from Max Ernst and other art historical and literary sources, Poller fashions unique interpretations of one of humanity's most intimate and significant places.

BED OF NAILS. 1993. PAGE 112

CLAYTON POND

Born in 1941 on Long Island, New York, Clayton Pond received a B.F.A. from Carnegie-Mellon University, Pittsburgh, in 1961 and an M.F.A. from the Pratt Institute, Brooklyn, in 1966. His work has been exhibited at the Whitney Museum of American Art, New York, the Museum of Modern Art, Mexico City, and the Delaware Museum of Art, Wilmington. His work is included in the collections of the Museum of Modern Art, New York, the Los Angeles County Museum of Art, and the Art Institute of Chicago. A second-generation Pop artist, Pond uses a great deal of high-energy color in his paintings and his prints, often outlining his objects in contrasting colors. Pond is interested in recording the obsessions and possessions of Americans. His early prints were close-up depictions of domestic objects such as toasters, telephones, and toilet seats; a later series involved leisure activities, humorously depicting people golfing and skiing. His most recent pieces are large-scale constructions of high-tech machines and printing presses.

HOT WATER HEATER. 1981. PAGE 122
SELF-PORTRAIT IN THE BATHTUB. 1981. PAGE 122
TOILET SEAT. 1981. PAGE 122

MARIA PORGES

Maria Porges completed a B.A. in art history at Yale University in 1975, and in 1979 she earned an M.F.A. in sculpture and drawing from the University of Chicago. She also attended Grinnell College in Iowa, and the San Francisco Art Institute. She has exhibited her sculptures, drawings, prints, and ceramics widely, including shows in the Bay Area, Los Angeles, Reno, Nevada, and New York. She is also a frequent contributing editor to several art publications and was curator of the traveling exhibition "The New Narratology: Examining the Narrative in Image/Text Art." Irony and postmodernism come together in Porges's work, where the recurring themes of tools and books serve as metaphors for knowledge. At times narrative and at other times conceptual, her imagery plays with the inherent meaning, association, and structure of her found objects. Her titles often explore the inverse: the idea of words and language as tools.

HOMONYMOUS. PAGE 99
TABLE SAW. 1983. PAGE 101
THE BIRTH OF POWER TOOLS. 1984. PAGE 101

KAISA PUUSTAK

Kaisa Puustak is an Estonian artist and printmaker.

SAW & AXE. 1987. PAGE 107

MICHAEL RAMUS

Michael Ramus was born in 1917 in Naples, Italy. He studied lithography at the Art Students' League, New York, and at Yale University. Throughout his career as an illustrator, he also made drawings, paintings, and sculptures. Ramus's illustrations have been published in *American Heritage, Audubon, Sports Illustrated,* and *Smithsonian.* Many of his sculptures, such as the large-scale tool series of the late 1980s, are constructed of cardboard and then painted to simulate the textures and surfaces of actual objects.

NEEDLE NOSE. 1989. PAGE 130

MEL ROSAS

Mel Rosas was born in Des Moines, Iowa, in 1950. He earned a B.F.A. from Drake University, Des Moines, in 1972 and an M.F.A. in painting from Tyler School of Art, Philadelphia, in 1975. Rosas creates prints as well as works on paper in charcoal and acrylic. His work has been exhibited in galleries and art centers throughout the United States, and he has been awarded two Creative Artist Grants from the Michigan Council for the Arts. In the late 1970s Rosas produced a series

of drawings of construction sites, furnace rooms, and pipes featuring tightly cropped compositions and lush surfaces.

CONSTRUCTION II. 1979. PAGE 163

ROD ROSEBROOK

Rod Rosebrook was born in Masonville, Colorado, in 1900 and worked as a cattleman and farmer most of his life. He started collecting old tools and antique wrought iron in the 1950s for his Old Time Museum of ranching and pioneer life. A self-taught artist, Rosebrook learned blacksmithing on cattle drives and began welding pieces from his collection to make fences and gates in the late 1970s. His work was first shown by the Ricco-Maresca Gallery in the 1980s. It is included in the Hemphill Folk Art Collection and has been exhibited at the National Museum of American Art, Washington, D.C.

GATE. 1982. PAGE 64

JAMES ROSENQUIST

James Rosenquist was born in Grand Forks, North Dakota, in 1933. He moved frequently throughout the Midwest with his parents, who shared with him their interest in airplanes and mechanics. He began taking art classes in junior high school. He earned his B.A. from the University of Minnesota in 1948 and studied painting under Cameron Booth. In the summer, he painted signs and bulk storage tanks in Iowa, Wisconsin, and North Dakota. In 1954 Rosenquist painted his first billboard, and a year later, on scholarship to the Art Students' League in New York, he studied with Edwin Dickinson, Will Barnet, Morris Kantor, George Grosz, and Vaclav Vytacil and shared a studio with Robert Indiana, Robert Rauschenberg, and others. In 1957 he joined the sign painters' union, and in 1958 he went to work painting billboards for ArtKraft Strauss Company and creating window displays for Bonwit Teller and Tiffany & Company. Two years later he had saved up enough money to paint full-time in his studio in Coenties Slip near the East River in Manhattan. He progressed from Abstract Expressionism and Pop Art to exploring the application of commercial materials and techniques in his painting. The resulting montagelike compositions of deliberately fragmented images from popular culture quickly became his signature. He sold out his first solo exhibition at the Green Gallery in New York in 1962. The first of his truly colossal paintings, *F-111,* a visual digest of mid-1960s conflict, cemented his reputation. Major exhibitions of his work have been held at the Museo d'Arte Moderna in Turin, the National Gallery of Canada in

Ottowa, the Wallraf-Richartz Museum in Cologne, the Whitney Museum of American Art in New York, the National Gallery of Victoria, Australia, the Denver Art Museum, and the National Museum of American Art, Washington, D.C. Since the early 1960s Rosenquist has also been actively involved with printmaking workshops, and numerous exhibitions have been devoted to his graphic production. The visceral imagery of his mature style, with its jarring juxtapositions of cropped close-ups of figures and representations of consumer and industrial products, speaks to the changing fabric of American society.

PULLING OUT. 1972. PAGE 137

TRASH CAN IN THE GRASS—CALIX KRATER. 1978. PAGE 84

VLADIMIR SALAMUN

Vladimir Salamun was born in New York City in 1942. In 1963 he earned a B.A. from Rutgers University in New Brunswick, New Jersey. He studied with Nicholas Carrone in 1964–65 and with George Spaventa at the New York Studio School in 1965–67. He received an M.F.A. from the Pratt Institute in 1976. In the last several years, Salamun has focused on the hammer as the subject of his neo-Dadaist sculptures, which are meticulously crafted out of carved stone, wood, and cast metal, using assemblage techniques. Some are oversize visual puns, while others are tongue-in-cheek portraits of art-world figures like Salvador Dalí and Julian Schnabel.

SIAMESE HAMMER JOINED AT THE HANDLE. 1982. PAGE 97

LUCAS SAMARAS

Lucas Samaras was born in Kastoria, Macedonia, Greece, in 1936. He came to the United States in 1948 and was raised in West New York, New Jersey. He became a naturalized American in 1955, the same year he entered Rutgers University, New Jersey. There he studied under Allan Kaprow, graduating in 1959. From 1959 to 1962 he took classes in art history at Columbia University under Meyer Shapiro, majoring in Byzantine art. During those years he became actively involved in the emerging Pop Art scene and participated in "happenings" with Jim Dine, Claes Oldenburg, and Allan Kaprow at the Reuben Gallery. After some early work in pastels and oils, he began a series of boxes. His autobiographical imagery first appeared in his environment at the Green Gallery in 1964, a re-creation of his bedroom in New Jersey. Two years later he created his famous *Mirror Room*. Since his retrospective exhibitions at the Museum of Contemporary Art in Chicago in 1971 and the Whitney Museum of American

Art, New York, in 1972, Samaras has been the subject of numerous exhibitions. Today he is recognized as one of the most distinctive and protean artists of his generation. His highly idiosyncratic art, which includes assemblages, figurative sculpture, manipulated autobiographical photographs, box construction, pastels, cut-paper drawings, prints, and books, eludes easy categorization and interpretation. Signature traits include a penchant for mirrors and reflections, a taste for soft and prickly textures, and intense, spectral colors, as well as materials such as beads, jewels, and foils.

BRUSH. 1968. FRONTISPIECE

JOHN SCHLESINGER

John Schlesinger was born in New York City in 1955. He has a B.S. in art education and a B.A. in philosophy and photography from the University of Minnesota in Minneapolis. He has received several awards, including two National Endowment for the Arts Fellowships. He has exhibited throughout the United States, the Netherlands, Scotland, Germany, and France. In the Surrealist tradition, Schlesinger draws on film and television, as well as staged and random elements from everyday life, to construct multilayered dreamlike images that address issues of alienation from self and society. Surrounded with areas of darkness, his forms seem to float freely in space, lending an unsettling presence. In 1991 Schlesinger began a series of mostly figurative photographs mounted on circular saw blades that exploit the constructive and destructive qualities of the implement.

UNTITLED (HAND/EYE). 1992. PAGE 81

JOSEPH R. SCHUBERT

Joseph R. Schubert was born in Newark, New Jersey, in 1932. He received his formal training in realist watercolor painting under Margaret Graham Kranking, and has been actively painting in the watercolor medium since 1983. His works have been featured in *American Artist* and *Modern Maturity* magazines and accepted in national, regional, and local juried exhibitions. Schubert's still lifes explore the special qualities of light and color values found in the musky, cluttered rooms of curio shops and old barns, or the random formal settings of more gracious antique rooms. His landscapes capture the silent moods of New England coastal villages and the deserts and mountains of the West and the Southwest.

YELLOW LINKS. 1990. PAGE 154

LEE A. SCHUETTE

Lee A. Schuette was born in Berlin, New Hampshire, in 1951. In 1971 he apprenticed with Jack O'Leary at Tariki Stoneware in Meriden, New Hampshire. The following year he attended the Pilchuck Glass School in Stanwood, Washington. He received a B.F.A. from the University of New Hampshire in Durham and an M.F.A. in industrial design from the Rhode Island School of Design, Providence. For the next three years he taught at the Wendell Castle Workshop in Scottsville, New York. A recipient of several awards, Schuette has been an instructor and an architectural designer in addition to a creator of highly innovative sculpture and furniture. His work has been exhibited at the Southeastern Center for Contemporary Art in Winston-Salem, the Museum of Contemporary Crafts in New York, the Rhode Island School of Design, and the Renwick Gallery in Washington, D.C. Drawing directly from nature and everyday life, Schuette challenges conventional ideas of furniture and materiality in his whimsical, masterfully crafted works.

CROSSCUT SAW. 1982. PAGE 16
RAKE BACK CHAIR #2. 1981. PAGE 59

MADELAINE SHELLABY

Born in 1947, Madelaine Shellaby received a B.A. from Scripps College, Claremont, California, in 1966 and an M.A. in painting from the University of California at Berkeley in 1976. Shellaby's work has been exhibited at museums and art centers throughout the United States, including the Crocker Art Museum, Sacramento, California, the Hanson Gallery, New Orleans, and the University of California, Davis. She has been a guest lecturer and artist at the University of California at Berkeley and the California College of Arts and Crafts, Oakland. She begins her drawings with photographic images, which she then transfers to paper by means of a photo-emulsion process and works with graphite and pastel. Shellaby's work focuses on construction sites and architectural details of interior spaces.

BATHTUB. 1981. PAGE 142

ROGER SHIMOMURA

Roger Shimomura was born in Seattle, Washington, in 1939. He received his B.A. in graphic design from the University of Washington, Seattle, in 1961. He continued his studies at the Cornish School of Applied Arts in Seattle, Stanford University, and Cornell University before earning an M.F.A. in 1969 from Syracuse University. A recipient of numerous fellowships and grants, he has exhibited his paintings and prints throughout the United States since 1965. He has also had a distinguished teaching career and has written, directed, and produced a number of performances. In his multilayered, action-packed paintings, which are rendered in flat, bright colors, politics are combined with *ukiyo-e* imagery, pop-culture clichés, and everyday consumer products. The resulting juxtapositions reflect his own personal history as a third-generation Japanese-American and also address the broader social and cultural conflicts between the two countries.

RINSE CYCLE. 1988. PAGE 128

HOLLIS SIGLER

Hollis Sigler was born in Gary, Indiana, in 1948 and raised in New Jersey. In 1970 she graduated from Moore College of Art in Philadelphia, where she studied figure drawing and worked in an Abstract Expressionist mode. While studying at the Art Institute of Chicago in 1971–73 she became exposed to the power of untrained, visionary artists and to the city's dominant movement, the Chicago Imagists, who were influenced by comic books, carnival imagery, and outsider art. At the same time, she was affected by feminism's validation of personal and emotional content in art. After earning her M.F.A. in 1973, she continued to work in a realist style until she turned to drawing, which inspired a new "faux-naive" style ideally suited to her inner aesthetic impulses. Since her first exhibition of drawings in 1977 at the Nancy Lurie Gallery in Chicago, Sigler has received numerous grants and awards. Her work has been exhibited widely, including exhibitions at the Art Institute of Chicago, the Seattle Art Museum, the Kunstmuseum in Lucerne, Switzerland, and the National Museum of Women in the Arts in Washington, D.C., and can be found in collections worldwide. Her narratives are personal and collective metaphors for devastation and hope. Enhanced by hand-written titles, her haunting, otherworldly images of largely unpopulated domestic interiors and fanciful landscapes disarm the viewer with their high-keyed palette, expressionist gesture, and skewed perspectives. Her recent work, which explores pain and healing, reflects her ongoing battle with breast cancer and a new, transcendent relationship with nature.

THE PERFECT HEART IS ONLY A DREAM. 1990. PAGE 65

JIM SMITH

Jim Smith has a B.F.A. in painting and printmaking from the University of Kansas in Lawrence and an M.F.A. from the University of Illinois in Champaign. He has participated in numerous exhibitions in New York, Chicago, and elsewhere in

the United States, and his work can be found in several corporate and public collections. Smith uses his skills as sculptor and painter to create mixed-media architectural ensembles as well as oversize school rulers and other mundane items that play with the viewer's sense of reality and memory.

ESMERALDA. 1984. PAGE 126

RICO SOLINAS

Rico Solinas was born in Oakland, California, in 1954. After studying at the Corcoran School of Art, Washington, D.C. in 1970–72, he received a B.A. in art from the University of California at Santa Barbara in 1977 and an M.F.A. from the San Francisco Art Institute in 1988. Solinas's figurative and landscape paintings and prints have been exhibited in Ecuador, Mexico, and California. In 1987–88 he painted a series of landscapes with trucks on saw blades, playing against the bucolic images most often associated with the genre of saw paintings.

SAW #10. 1988. PAGE 57

JEFF SPAULDING

Jeff Spaulding was born in Ann Arbor, Michigan, in 1947. He received a B.A. from Central Michigan University in 1970 and an M.F.A. in 1974 from Pennsylvania State University. Since the mid-1970s he has received several awards and has exhibited his work at the Southeastern Center for Contemporary Art in Winston-Salem, the New Museum of Contemporary Art in New York, and the Corcoran Gallery of Art in Washington, D.C. In his early sculptures and drawings Spaulding explored the energy and movement of objects, including hammers. Around 1984 he began using trees—cedars and firs, which he gathers every summer in the woods of northern Michigan, and discarded Christmas trees—as his primary medium. His recent indoor and outdoor installations of trees probe the subject's primal life force while playing with viewer expectations. Intensely physical in their creation, his organic, abstract images also serve as a lyrical metaphor for the human condition.

HAMMER HEAD III. 1983. PAGE 161

DAVID STROMEYER

David Stromeyer was born in 1946 in Marblehead, Massachusetts. He received his B.F.A. from Dartmouth College and also studied at the University of California at Los Angeles. Stromeyer creates large-scale sculptures which he installs within the landscape of the Vermont farm where he lives. He has exhibited widely in galleries and museums,

including exhibitions at the National Museum of American Art, Washington, D.C., the Museum of Art, Fort Lauderdale, Florida, and the DeCordova Museum, Lincoln, Massachusetts. Stromeyer's work is included in the collections of the Delaware Museum of Art in Wilmington and the State University of New York at Potsdam, as well as many corporate and private collections. The artist has participated in "one-percent for art" programs in Massachusetts, Connecticut, and Maryland.

TOOL DE FORCE. 1983. PAGE 31

EVAN DAVID SUMMER

Evan Summer was born in Buffalo, New York, in 1948. He earned a B.S. in chemistry from the State University of New York at Cortland in 1970, a B.F.A. from the State University of New York at Buffalo in 1973, and an M.F.A. in printmaking from Yale University in 1975. Summer has taught at Wesleyan University, Middletown, Connecticut, and the State University of New York at Buffalo. His work has been exhibited at the Albright-Knox Art Gallery, Buffalo, the Brooklyn Museum of Art, and the Library of Congress, and is included in the collections of the Corcoran Gallery of Art, Washington, D.C., the Philadelphia Museum of Art, and the National Museum of American Art. Summer's depictions of piled objects and jumbled environments, abstractions of light and dark, are vehicles for formal explorations of pictorial space, volume, and texture.

NOCTURNE II. 1980. PAGE 162

ROY SUPERIOR

Born in 1934 in New York, Roy Superior earned a B.F.A. in illustration from the Pratt Institute, New York, in 1956 and an M.F.A. in painting and printmaking from Yale University in 1962. Superior's small-scale machine constructions have been included in gallery and craft exhibitions throughout the United States, including shows at the American Craft Museum, New York; "New Art Forms," an exhibition in Chicago; and "American Craft at the Armory." He has been awarded several grants from Hampshire College and was a Massachusetts Foundation for the Arts sculpture finalist. His highly detailed miniaturized machines offer social commentary, reflecting the absurdity of some of contemporary society's technological advances that seek to relieve individuals from the necessity of performing even the most basic tasks. Superior's witty and ingenious constructions combine skilled craftsmanship with references to tools and machines of earlier periods in history.

MR. GOODY TWO SHOES' TOOL SHED. 1989. PAGE 55

JAMES SURLS

James Surls was born in Terrel, Texas, in 1943. He holds a B.S. from Sam Houston State College in Hunstville, Texas. He studied with Julius Schmidt at Cranbrook Academy of Art in Bloomfield Hills, Michigan, where he received an M.F.A. in 1969. Since catching the eye of the art world in the 1970s with his tree-creature sculptures, which combined folk-art traditions with surrealist overtones, Surls has become recognized as a leading contemporary sculptor and has had numerous museum exhibitions throughout the United States. He received a National Endowment for the Arts Fellowship in 1979 and was honored as the Texas Artist of the Year in 1991. His work can be found in the collections of the Stedelijk Museum in Amsterdam, the Seattle Art Museum, the Museum of Modern Art in New York, and the Dallas Museum of Art. Surls draws on formative childhood experiences in his highly expressive work, which he sees as a form of self-portraiture. Manipulating various native woods with hand and power tools, Surls creates fetishistic, anthropomorphizing imagery that celebrates the forces of nature and is inspired in part by Southwest Native American and Mexican cultures. Various symbols such as the spiral, the house, and the eye recur in his work, which addresses personal growth, gender relations, and the cosmos. Lately he has collaborated with poet Robert Creeley on a series of prints that combines poems and images.

REBUILDING. 1991. PAGE 53

LINDA THERN-SMITH

Linda Thern-Smith was born in Omar, West Virginia, in 1946. She completed a B.F.A. in painting at Florida International University, Miami, in 1975 and an M.F.A. in ceramics at George Washington University in Washington, D.C., in 1977. Her work has been exhibited in the mid-Atlantic region, as well as in Kenya and Lithuania, and can be found in several collections, including the National Museum of Women in the Arts, Washington, D.C., the Hunter Museum of Art in Chattanooga, Tennessee, and the Butler Institute of American Art in Youngstown, Ohio. She has also served as a curator and an independent critic for many art publications. Since 1978 her art has explored the concepts of the fetish and the totem, objects that embody supernatural power, and she has skillfully exploited the natural beauty of her materials. She initially wrapped copper wire around bundles of nails, twigs, and clay tubes; later she incorporated tool handles and slate into her sculptures, sometimes inscribing

them with drawings and ideograms. Her recent work features carved stone.

PHOENIX. 1987. PAGE 62

WAYNE THIEBAUD

Wayne Thiebaud was born in Mesa, Arizona, in 1920 and raised in Long Beach, California. From the mid-1930s through the late 1940s he pursued a career as a cartoonist, an illustrator, and a muralist, and held a position at the Disney studios for a year, until he decided to become a painter in 1949. He enrolled at California State College, receiving a B.A. in 1951 and an M.A. in 1953. In 1951 he had his first exhibition of paintings, at the Crocker Art Gallery. That same year, he began a long teaching career, which has included positions at several colleges and art schools throughout the United States. In 1954 he established his own company to produce educational art films. Thiebaud's big break came in 1956–57, when he lived in New York and met the de Koonings, Franz Kline, Barnett Newman, and Philip Pearlstein. Allan Stone gave him his first New York show in 1962, and Thiebaud went on to gain notoriety in the 1960s for his paintings of pies and other all-American foodstuffs, rendered in bold colors and a lavish impasto technique. Beginning with an exhibition at the Pasadena Art Museum in 1968, his work has been the subject of several major exhibitions, including touring shows at the Whitney Museum of American Art, New York, the Phoenix Art Museum, and the San Francisco Museum of Modern Art. Thiebaud has also pursued an interest in printmaking, and in 1983 he traveled to Japan to work with traditional woodblock printers. Although often associated with Pop Art and the work of Bay Area artists Richard Diebenkorn and David Park, Thiebaud's distinctive still lifes, as well as his figure compositions and landscapes, are more akin to Impressionism filtered through the paintings of Edward Hopper. Light dominates and unifies Thiebaud's oeuvre: vibrant, palpable shadows are as important as the harshly lit forms of his objects, which include neckties, shoes, and paint cans.

PAINT CANS. 1990. PAGE 58

JEAN TINGUELY

Jean Tinguely was born in Fribourg, Switzerland, in 1925 and died in Bern, Switzerland, in 1991. Best known for his whimsical motorized constructions, he was also a painter, a draftsman, and a designer of stage sets. From 1941 to 1945 he took classes at the Basel School of Fine Arts, and in 1945 he made

his first constructions, executed in wood, paper, and wire. He also produced a series of "edible" pieces made out of grass. In 1953 he moved to Paris, where he was a principal participant in the city's postwar art scene. In the late 1950s he joined the Nouveau Réalisme movement, which also included Yves Klein, Arman, and theorist Pierre Restany, exhibiting at the Iris Clert Gallery in 1958. His clattering machines from this period, among the major examples of kinetic art, typically unite wheels, electric motors, bathroom fixtures, welded girders, and scrap-heap scavengings, mocking the trappings of consumer society. In 1960 he captured the attention of the art world with his self-destructing mechanical piece, *Homage to New York*, which destroyed itself in the garden of the Museum of Modern Art. In 1961 and 1962 he participated in "happenings" with Robert Rauschenberg, Jasper Johns, and his wife, French artist Nike de Saint-Phalle. Throughout his life he continued to execute large-scale commissions, including the fountain outside the Centre Pompidou in Paris (in collaboration with his wife) and a gargantuan sculpture in the Fontainebleau Forest. A 1990 show in Moscow featured a seventeen-foot-high piece called *Altar of Western Affluence and Totalitarian Commercialism*.

TOOLS 85. 1985. PAGE 39

JOHN VAN ALSTINE

John Van Alstine was born in Johnstown, New York, in 1952. Before moving his studio to the Adirondacks, he lived in New Jersey, Washington, D.C., and Wyoming. In 1970–71 he attended St. Lawrence University, Canton, New York, and in 1973 the Blossom Festival School in Cleveland-Kent, Ohio. He received a B.F.A. in sculpture, ceramics, and glass from Kent State University in Kent, Ohio, in 1974 and an M.F.A. from Cornell University in 1976. He has exhibited widely in the United States and Japan, and his work can be found in the collections of the Baltimore Museum of Art, the Hirshhorn Museum and Sculpture Garden in Washington, D.C., the Museum of Modern Art in Lisbon, Portugal, and the Denver Art Museum. He has received several awards, including a National Endowment for the Arts Fellowship in 1986 and two New Jersey State Council on the Arts Fellowships in 1984 and 1988. His large welded-steel, cast-bronze, and carved-granite sculptures, as well as his charcoal and pastel drawings, celebrate raw dynamism and precarious balance. His rugged primary forms reflect aspects of Minimalism and process art, yet his sense of materiality and his use of found tools and objects reflect a strong poetic urge, as well as an interest

in astronomy, physical science, geology, archaeology, and art history.

KOUROS. 1989. PAGE 15

F. L. WALL

F. L. Wall was born in Dover, Delaware, in 1947. He received a B.A. from the University of Delaware in 1969. From 1978 to 1982 he participated in workshops and seminars with Sam Maloof, Robert Whitley, and James Krenov. He also studied sculpture at the Corcoran School of Art in Washington, D.C., in 1980–81. Wall started his career restoring antiques and building eighteenth-century reproductions in Williamsburg, Virginia. He eventually began designing his own furniture, which was inspired by the Scottish Arts and Crafts artist Charles Rennie Mackintosh and the twentieth-century Japanese-American wood master George Nakashima. In 1975 he began to carve a series of overscale, recognizable objects, such as tools and a gas pump, in wood. While their play with scale and medium recalled the Dadaist experiments of Man Ray and the work of Pop artist Claes Oldenburg, their exquisite craftsmanship encouraged viewers to see the inherent beauty of their shapes and materials. Since 1979 he has exhibited his work widely, including shows at the Corcoran Gallery of Art in Washington, D.C., the Virginia Museum of Fine Arts in Richmond, and the Gallery of Functional Art in Santa Monica, California. Humor and surprise continue to be guiding elements in his more recent work, which includes purely sculptural pieces. The latter range from abstracted chair forms to tabletop sculptures that incorporate various woods and steel and function as three-dimensional still lifes.

HACKSAW. 1984. PAGE 16
ONE ROOM EFFICIENCY. 1983. PAGE 110
PLANE. 1978. PAGE 19
SCREWDRIVER. 1979. PAGE 37
SUMMER TOOL. 1983. PAGE 34

SILAS WEST

Silas West, a folk artist from Havervill, Massachusetts, was active around the turn of the century. He is known for his realistic, pressed-metal figures of billposters painted in bright colors. Some of these appear to be witty interpretations of advertising stunts. In 1897 West obtained patents for many of his designs, some of which have been located on buildings and barn sides in Ohio, Pennsylvania, Massachusetts, and upstate New York.

ADVERTISING SIGN. C. 1895. PAGE 101

H. C. WESTERMANN

H. C. Westermann was born in Los Angeles in 1922 and died in 1981. The early work of this master of assemblage, which embodied a Dada-Surrealist ethos, anticipated Pop Art by nearly a decade. He studied at the School of the Art Institute of Chicago from 1947 to 1954, working off and on as a carpenter, a plasterer, and a general handyman. In 1953 he began making sculptures. His works from the early 1950s, such as a series of carved "Death Ships," were inspired by his war experiences. Around 1956 he started a series of eccentric "houses" or "towers" that served as containers for feelings and dreams. In the 1960s he explored mock-heroic imagery, like his deified Coca-Cola bottle. Other sculptures depict sinister robot gods or refer to such diverse elements as ships' helms, tables, and boxes. After 1957 he exhibited frequently in the United States, especially in Chicago, New York, and on the West Coast. His work appears in numerous museum collections, including the Museum of Modern Art in New York, the Art Institute of Chicago, the Los Angeles County Museum of Art, and the Corcoran Gallery of Art in Washington, D.C. His mature work continues to be marked by irony and paradox as well as exquisite craftsmanship.

THE SLOB. 1965. PAGE 98

ROBERT WIDEMAN

Robert Wideman was born in Albany, New York, in 1953 and studied at the State University of New York. Since 1976 he has designed and created objects in ferrous materials while teaching metalsmithing on his own and in association with such institutions as the Hancock Shaker Museum and the Old Chatham Shaker Museum. In addition to making his own sculptures, he works on commissions and develops armatures and components for other sculptors. In one series, he transformed recognizable tools and mechanisms into new dynamic objects that have great beauty and wit but still retain their original, functional design.

TOOTHPICK. 1986. PAGE 62

WILLIAM T. WILEY

William T. Wiley was born in Bedford, Indiana, in 1937. He studied at the San Francisco Art Institute, earning his B.F.A. in 1961 and his M.F.A. a year later. Since 1960 he has participated in numerous exhibitions at the San Francisco Museum of Modern Art, the Philadelphia Museum of Art, and the Corcoran Gallery of Art, Washington, D.C., among others. His work can be found in collections worldwide, including the Art Institute of Chicago, the Hirshhorn Museum and Sculpture Garden in Washington, D.C., the National Gallery of Victoria, Australia, the Stedelijk Museum in Amsterdam, and the Whitney Museum of American Art in New York. Like Robert Arneson and other California funk artists of the 1960s, Wiley delights in the absurd and the incongruous, while his sense of fantasy recalls the pre-Surrealist dreamscapes of Giorgio de Chirico. His densely layered paintings and prints depict imaginary worlds and cosmic struggles, complete with hermetic symbols and often humorous observations scrawled within the images and in the margins. His equally inventive sculptures also address the enchantment of the mundane. Over the years, Wiley's influence has been pervasive, especially with the New Image generation of the 1970s and 1980s.

EERIE GROTTO OKINI. 1982. PAGE 118

BILL WILSON

Bill Wilson was born in 1931. He holds a B.A. from William and Mary College in Williamsburg, Virginia. He attended the Art Students' League in New York and studied with George Grosz and Reginald Marsh. He then spent three years traveling in the South Pacific. In 1959 he received an M.F.A. in painting from Cranbrook Academy of Art in Bloomfield Hills, Michigan. He has exhibited throughout the United States and is included in the collections of the Albany Museum, the Schenectady Museum, and the Munson-Williams Proctor Institute of Art. Wilson's prints and mixed-media works present striking, illusionistic twists on Action Painting and challenge conventional perceptions of mundane objects.

PAINTBRUSH. 1978. PAGE 164
PLIERS AND NAIL. 1987. PAGE 99
STAPLE GUN. 1989. PAGE 161

DINA WIND

Dina Wind received a B.A. from Hebrew University in Jerusalem and a Certificate of Art Appreciation in 1972 from the Barnes Foundation in Merion, Pennsylvania. She continued her studies at the University of Pennsylvania in Philadelphia, where she completed an M.A. in 1974. A winner of several awards, she has exhibited her sculptures throughout the mid-Atlantic region, including the Allentown Art Museum, the Woodmere Art Museum in Philadelphia, and the Three Rivers Arts Festival in Pittsburgh. Wind creates her welded-steel sculptures, which she likens to three-dimensional still-life paintings, by using a TIG welding machine to combine discarded farm implements and other metal scraps into

flowing, organic compositions that are often tinged with
humor.

WHEELBARROW. PAGE 146

PHYLLIS YES

Born in Redwing, Minnesota, in 1941, Phyllis Yes received an
M.A. from the University of Minnesota in 1969 and a Ph.D.
from the University of Oregon in 1978. Although primarily a
painter, Yes also makes sculptures and videos. She has been
awarded a National Endowment for the Arts grant and an
Oregon Arts Commission Fellowship. Her work has been
widely exhibited in the United States, Japan, and South
America. She is a professor of art and Dean of Arts and
Humanities at Lewis & Clark College, Portland, Oregon.
Yes's work addresses the issues of femininity and gender iden-
tification. She uses tools to symbolize masculinity in her
paintings and objects, then sabotages them by overlaying
them with webs of lacy patterns and motifs traditionally
thought of as feminine. Yes once gave a lace paint job to a
Porsche, and in the 1980s she "decorated" a variety of tools
with her floral and lace patterns. In a series of paintings,
"Mixed Metaphors," Yes depicted detailed table settings
where tools replaced silverware, thus contrasting men's and
women's traditional family roles.

PAINT CAN WITH BRUSH. 1981. PAGE 95
UNTITLED. 1980. PAGE 16

ANDY YODER

Andy Yoder was born in Cleveland, Ohio, in 1957. He attended
Dartmouth College and the Skowhegan School of Painting
and Sculpture, Maine, before receiving a B.F.A. from the
Cleveland Institute of Art in 1982. His work has been included
in several shows in New York, at the Cleveland Center for
Contemporary Art, and at the Portland Museum of Art,
Maine, and he is the recipient of several awards and commis-
sions. Yoder's offbeat imagery, with its Dadaist overtones,
plays with viewers' associations with everyday objects and
cultural icons.

UNTITLED. 1988. PAGE 115

CREDITS

The collector and publisher would like to thank the following for helping to make this book possible: Addison Ripley Gallery, Washington, D.C.; Allan Katz Americana, Woodbridge, CT; Allan Stone Gallery, New York, NY; American Art, Inc., Atlanta, GA; Andre Emmerich Gallery, New York, NY; Anne Berthoud Gallery, London; Arthur Roger Gallery, New Orleans (Debbie Caffery); Artspace Enterprises, Washington, D.C.; Dianne Beal, Washington, D.C.; Commerce Graphics Ltd., Inc., East Rutherford, NJ (Berenice Abbott); Sandra Berler, Chevy Chase, MD; Bernice Steinbaum Gallery, New York, NY; Bess Cutler Gallery, New York, NY; Brody's Gallery, Washington, D.C.; Broomfield Gallery, Boston; Carl Hammer Gallery, Chicago; Crown Point Press Gallery, San Francisco; Cumberland Gallery, Nashville, TN; Decorama Arts, North Potomac, MD; Fendrick Gallery, Chevy Chase, MD; William L. Floyd, Alexandria, VA; Francine Seders Gallery, Seattle, WA; Franz Bader Gallery, Washington, D.C.; Gallery K, Washington, D.C.; Gallery NAGA, Boston; Gemini G.E.L., New York, NY; Jane Haslem, Washington, D.C.; Herbert Palmer Gallery, Los Angeles; Humphrey Gallery, New York, NY; Jack Tilton Gallery, New York, NY; Jayne H. Baum Gallery, New York, NY; Krakow Gallery, Boston; Lone Star Studio, Evansville, IN; Margaret Roeder Gallery and Editions, New York, NY; Markel Sears Art Gallery, New York, NY; Marlborough Gallery, New York, NY; Maxwell Davidson Gallery, New York, NY; Meredith Palmer Gallery, Ltd., New York, NY; Miller/Block Gallery, Boston; Moody Gallery, Houston; OK Harris Works of Art, New York, NY; Osuna Gallery, Washington, D.C.; Pace Editions, New York, NY; Palm Press, Inc., Concord, MA; Pyramid Atlantic (Ke Francis, *Tornado*); Robert Brown Gallery, Washington, D.C.; Robert Miller Gallery, New York, NY; San Francisco Museum of Modern Art, San Francisco; Sherley Koteen Associates, Washington, D.C.; Susan Cummins Gallery, San Francisco; TABA, Inc., Potomac, MD; Tartt Gallery, Washington, D.C.; The American Hand, Washington, D.C.; The Judge Gallery, Durham, NC; Paul Lebaron Thiebaud, San Francisco; Touchstone Gallery, Washington, D.C.; Troyer Fitzpatrick Gallery, Washington, D.C.; Viridian Gallery, New York, NY; Waddington Gallery, London; Washington Project for the Arts, Washington, D.C.; William Sawyer Gallery, San Francisco; Charles A. Wustum Museum of Fine Arts, Racine, WI; Zenith Gallery, Washington, D.C.

All photographs by Joel Breger except for the following: Bobby Hansson, NYC, 49; Judy Olausen, 31; Edward Owen, frontispiece, 16 (except Wall's *Hacksaw*), 18, 21, 24, 32–33, 34, 35, 39, 40–41, 42, 52, 64, 79 top, 80 bottom, 86 bottom, 92, 93, 94 left, 96, 119 top, 122 top left, 132 bottom, 136, 138, 161 bottom right, 165 left, 170; Courtesy of Spanierman Gallery, 114

The following biographies were written by Jane Levine: Abbott; Adams; Alward; Arnold, B.; Arnold, C.; Ashton; Avvakumov; Bader; Barrow; Barry-Wilson; Bellan-Gillen; Beneš; Blumenstein; Borofsky; Bronk; Bui; Butler; Butt; Caffery; Carter; Chapline; Chase; Chermayeff; Christopher; Crowley; Dann; Davis; Edgerton; English; Evans; Flandreau; Francis; French; Furman; Garde; Geiger; Goodwin; Gray; Grazier; Gryzybowski; Gustafson; Hansen; Hanson; Hazard; Hepburn; Herhusky; Hobson; Hoeflich; Hughes; Irrig; Jones; Kass; Kostabi; Kudryashov; Laffal; Larsen; Lawrence; Mack; Malpass; Mansfield; MANUAL; Mr. Imagination; Namuth; Plowman; Pond; Puustak; Ramus; Rosas; Rosebrook; Shellaby; Solinas; Stromeyer; Summer; Superior; Yes

The following biographies were written by Sarah Tanguy: Arman; Caro; Conderacci; Cowan; Deal; De Jonge; Delvoye; Dine; Drake; Drasler; Eggleston; Estes; Fantazos; Finster; Firestone; Frabel; Grooms; Gutzeit; Harmon; Hebert; Horner; Josephy; Keating; Keerl; Kirwin; Koscianski; Kuehn; Lakeman; Léger; LoCicero; Loy; Mathieu; Mazur; McCullough; McDonnell; McGowin; McIntosh; McKellar; McQueen; Mizuno; Musia; Nagelbach; Newcombe; Nicholson; Oldenburg; Otasevic; Partridge; Perez; Pinciotti; Poller; Porges; Rosenquist; Salamun; Samaras; Schlesinger; Schubert; Schuette; Shimomura; Sigler; Smith; Spaulding; Surls; Thern-Smith; Thiebaud; Tinguely; Van Alstine; Wall; West; Westermann; Wideman; Wiley; Wilson; Wind; Yoder

The following biographies were written by Carolyn Laray: Altina; Bergfors; Brouwer; Collicott; Lesiak; Maresca; McDowell